WOMEN, UNIONISM AND LOYALISM IN NORTHERN IRELAND

WOMEN, UNIONISM AND LOYALISM IN NORTHERN IRELAND

From 'Tea-Makers' to Political Actors

RACHEL WARD

IRISH ACADEMIC PRESS
DUBLIN • PORTLAND, OR

First published in 2006 by
IRISH ACADEMIC PRESS
44, Northumberland Road, Dublin 4, Ireland

and in the United States of America by
IRISH ACADEMIC PRESS
c/o ISBS, Suite 300, 920 NE 58th Avenue
Portland, Oregon 97213–3644

WEBSITE: www.iap.ie

British Library Cataloguing in Publication Data
A catalogue entry is available on request

ISBN 0–7165–3339–1 (cloth)
ISBN 0–7165–3340–5 (paper)

Library of Congress Cataloging-in-Publication Data
An entry can be found on request

Typeset in 11.5 on 14.5pt Ehrhardt
by Carrigboy Typesetting Services, County Cork
Printed by in Great Britain by MPG Books Ltd., Bodmin, Cornwall

Contents

Tables and figures

Foreword

The image of tea-making, often used to capture the essence of women's civic and political role in Northern Ireland, presents a picture of domesticity, subordination and powerlessness. It suggests that the public space is imbued with norms, values, and practices that render women silent and subservient, deferential to the needs of their politically-empowered menfolk. As with all stark images, it embodies an element of truth. What it does not reveal is the extent to which women uphold or undermine the image chosen to describe their political role.

Rachel Ward places this image under scrutiny. Finally, we have a volume that studies one of the most complex of political relationships in the dense weave of Northern Ireland's politics: unionist and loyalist women and their scope for political expression. Through the themes of political identity, personal motivation for public engagement, and forms of political action, Ward reveals unionist and loyalist women to be highly engaged in political acts that involve the interests of their national community.

The striking feature of this closely-argued analysis is the resistance of unionist and loyalist women to seeing their identities as 'gendered', or their action and space for participation as bounded by gendered notions of civic roles. Yet, each and every aspect of their public and political experiences is grounded in the gendered expectations of Protestantism, unionism, and loyalism. The space available for political expression is determined by the gendered boundaries to participation drawn by each of these aspects of their lives.

Many books have been written on the subject of national identity, on the competing identities that characterise a fractured society, and on the boundaries nationalism and identity place on women's public action. In this significant contribution to the scholarship, Rachel Ward finds that while unionist and loyalist politics may appear monolithic to outsiders, national identities among women in this community are more layered than might appear, shaped by nation, culture, class and gender.

Indeed, as Ward rightly points out, to understand the political role of unionist and loyalist women, one must appreciate the intensity of the interaction of two potent ideologies that have been given a conservative construction – nationalism and religion – that shape the space for, and boundaries of, women's political participation. A conservative nationalism mobilises women as protectors of the family and community, while conservative Protestantism reinforces and validates this form of civic and political engagement. These combined views have practical consequences in keeping regional and national politics a predominantly male unionist haven. The visible cultural markers for unionist and loyalist women are male, the visible political imagery is male, and the visible unionist politician is male.

Being situated in this context, where masculinity is deeply celebrated, fashions unionist and loyalist women as the 'other' within their own community. Some of them recognise this marginalisation, in their recounting of difficulties of winning political recognition within their parties. Others see no incongruity in their positioning. Many are inherently suspicious of supportive interventions such as women's networks or quotas in addressing their gender disadvantage. Their internalisation of the norm of masculine predominance is substantial, and in adopting this position, unionist and loyalist women often unwittingly contribute to the perpetuation of their gendered subordination.

Nonetheless, although unionism and loyalism may present few opportunities for women's political advancement, Ward shows that tea-making is not their single, or dominant, contribution to the political life of their community. Instead, they demonstrate involvement on different levels within formal and community politics. Nor were these women blind to the sexism of party members or sections of the electorate. Many of their reflections are similar to those of women in other highly patriarchal societies who have yet to challenge the status quo. This does not necessarily imply an anti-feminism on the part of unionist and loyalist women – though some would adopt that position – but rather a 'pre-feminist' view. To risk challenging the status quo could also mean risking a questioning of the very thing that unionist and loyalist women act to protect: their community, with its cultural and political heritage.

In this respect, unionist and loyalist women seem to be standing on, or close to, a threshold of change. The major political and constitutional questions that shape unionist and loyalist political identities have been subject to negotiation since the signing of the Belfast Agreement. The peaceful resolution of these issues has its own inexorable logic, if we are to assume that the days of the 'Troubles' are over. As Northern Ireland's politics moves closer to that of a more conventional liberal democracy, as social attitudes become more pluralistic, and indeed as the population follows international trends in becoming less engaged with politics, unionism and loyalism will confront the question being faced by all democratic parties – how to remain relevant to their electorate once the defining issues have been dealt with. It is at this point that unionist and loyalist women could come forward with an answer that brings them and their parties a new salience. Given their political resilience and their connectedness with their community, unionist and loyalist women have much to offer politics in today's and tomorrow's Northern Ireland. They only need to find the voice that enables them to make this contribution.

YVONNE GALLIGAN
February 2006

Abbreviations

APNI	Alliance Party of Northern Ireland
DOE	Department of the Environment
DUP	Democratic Unionist Party
EPIC	Ex-Prisoners Interpretative Centre
FAIR	Families Acting for Innocent Relatives
MLA	member of the Legislative Assembly
NIUP	Northern Ireland Unionist Party
NIWC	Northern Ireland Women's Coalition
PAPRC	Prisoners' Aid, Post-Conflict and Resettlement Centre
PR	proportional representation
PRG	Peace and Reconciliation Group
PUP	Progressive Unionist Party
SCP	Shared City Project
SSTG	Shankill Stress and Trauma Group
STV	single transferable vote
UDP	Ulster Democratic Party
UKUP	United Kingdom Unionist Party
UUP	Ulster Unionist Party
UWUC	Ulster Women's Unionist Council
WOAI	Women's Orange Association of Ireland

Acknowledgements

This book could not have been written without the help, support and encouragement of many people. I would like to thank my academic advisors Dr Alan Greer and Dr M. K. Flynn at the University of the West of England (UWE) for their supervision of my PhD research. I also acknowledge the encouragement of Professor Jon Tonge who taught and supervised me when I first became interested in Northern Irish studies. Dr Andrew Denham of the University of Nottingham was a good friend and colleague and provided sound advice during my search for a publisher. In turn I thank Lisa Hyde at the Irish Academic Press.

I am indebted to the many individuals and organisations in Northern Ireland who gave up their valuable time for me. The organisations include those shown in the list of abbreviations overleaf and I also acknowledge the help of the Centre for Social Research (CSR) at Queen's University, Belfast. Special thanks are due to Paula Devine and Lizanne Dowds of the CSR. Financial support was given to me in the form of a bursary from UWE and the British Federation of Women Graduates, for which I am extremely grateful. The image for the jacket and cover of the book is taken from the Ulster Society website and I acknowledge the help of Andrew Castles in attempting to establish original copyright.

I would like to thank the women who agreed to be interviewed. In particular I would like to thank Dawn Purvis, who gave me some fantastic insights and showed me friendship and support during the times I spent in Northern Ireland. I also acknowledge the help of David Hoey of the Apprentice Boys of Derry, who made it possible for me to have access to the Memorial Hall in (London)Derry, the Women's Orange Association in Belfast and to Families Acting for Innocent Relatives (FAIR).

I must also thank my colleagues, family and friends who supported me during my time as a graduate student and encouraged me to persevere. I thank my Mum and Dad for always believing in me. I would also like to thank David Brockington who has given me love and support, which has helped me to get this book into the form you find it in today. I am, of course, responsible for the contents of this book and any errors therein.

RACHEL WARD
February 2006

Introduction: Infusing for the Nation?

Politically active unionist and loyalist women in Northern Ireland are rendered relatively invisible because of the predominantly male public faces of unionism and loyalism. This is evident in the media images of the male-dominated annual parades by organisations such as the Orange Order, statements by mostly male political party spokespersons, and the murals of loyalist paramilitaries that designate territorial possession and seldom depict female involvement. There is also a stereotype attached to the image of unionist and loyalist women: they are perceived as mere 'tea-makers' with little significant input into the political process. I encountered this stereotype on a number of occasions during my research[1]—for example, the derisory comment of 'What women? There aren't any, are there? They just make the tea!'[2]

The tea-making stereotype may be derived from the position of unionist women in the auxiliary Ulster Women's Unionist Council (UWUC), which is supportive of the unionist cause through activities such as fund-raising. Early in its history the organisation understood unionism in gendered terms, claiming in 1919 that 'there were social and domestic aspects to unionism "which none but women can understand"'.[3] However, to focus on the social and domestic aspects of women's input into unionist and loyalist politics is to underplay the extent of their participation in the late twentieth and early twenty-first centuries. Indeed, there are signs that the women in question feel constrained by the stereotype: a newspaper report about women in the Ulster Unionist Party (UUP) referred to their 'festering resentment . . . at the stereotypical taken-for-granted role of 'tea and cake-makers' [that is] foisted upon them'.[4]

There is some support in the literature for the perception of unionist and loyalist women having a marginal political role. Cynthia

Cockburn, who conducted research into women and cross-community political activity, found that the 'old Unionist parties have no apparent interest in either women's votes or women's political energy. Women are there to make the sandwiches. The nationalists are little better.'[5] Carol Coulter argues that unionism is 'deeply inimical to all progress for women' and that they have only the 'role of teamakers in any of the major parties'.[6] Linda Racioppi and Katherine O'Sullivan See consider loyalist parades, through which, as spectators, the normative femininity of unionist and loyalist women is reinforced. This is 'to be supportive of their men's political and cultural leadership and their expressions of Ulster Protestantism: women are there to cheer on the brethren and/or the bands'.[7] Racioppi and O'Sullivan See note that the 'stereotype of unionist women as "tea-makers" has not been problematized in the parades'[8] and suggest that 'the generally conservative political ideology of unionism leaves little space for feminist reconstructions of unionist identity and politics'.[9] Arguably, the stereotype has also contributed to unionist and loyalist women's invisibility—why investigate the political activity of these women if all they do is make the tea? In focusing on the parades, Racioppi and O'Sullivan See have taken a specific aspect of unionism to give a generalised account of gender and unionism. The real picture, of course, is far more complex, as this book will demonstrate.

RESEARCH AIMS AND METHODOLOGY

My aim is to shed light on the form and extent of unionist and loyalist women's political participation. The research I conducted shows that unionist and loyalist women are more active political participants than the tea-making stereotype suggests; they have varied political roles, although these are often invisible. The book will also explore the women's identities and the motivations behind their political action. My research strongly suggests that unionist and loyalist women identify with 'their nation' and are motivated to participate in defence of its interests. From this starting point, it

follows that the political activism of unionist and loyalist women can be explained using nationalist theory. My argument is grounded in the assumptions that unionism and loyalism are varieties of nationalism,[10] and nationalism is gendered. Consequently the established literature on political participation, while valuable, cannot fully explain the political action of unionist and loyalist women.

The parameters of the research were set by considerations of what is 'legitimate' political activity. While there are women loyalist para-militaries, as evidenced at a summer festival on Shankill Road, Belfast in 2000,[11] the investigation of direct paramilitary activity was excluded because the central concern in this book is with legitimate politics rather than 'extra-political' activity. In addition to women from mainstream political parties, I interviewed women involved with community politics such as prisoners' support groups, along with representatives of the smaller loyalist political parties, and this gave me an appreciation of the spectrum of political stances. Furthermore, the role of women paramilitaries has been considered elsewhere.[12]

The literature searches I conducted revealed that that while some historical and contemporary accounts of the involvement of women with Irish nationalism had been written, little research had been done specifically on unionist and loyalist women.[13] Aside from overviews of women in Northern Ireland detailing the lack of unionist and loyalist women in contemporary politics, there was nothing more than anecdotal references to them. The Linen Hall Library in Belfast, which has been collecting political ephemera since the start of 'the Troubles', also had few references of any substance to women's involvement with unionism and loyalism.

The lack of balance in the existing literature suggested that evi-dence of the identities, motivations and political actions of unionist and loyalist women would be found primarily through interviews conducted in the field. I took a qualitative approach because the type of data needed in order to address the research questions is not easily quantifiable; indeed, the answers given to interview questions were often detailed, complex and multi-faceted. The data I collected

provide insight into a group of women political actors who are subject to intra-group differences and this limits the generalisability of the results. However, the semi-structured style of questionnaire facilitated an element of comparability between the interviews, enabling me to draw out recurrent themes. In taking a qualitative approach, it was possible to develop some understanding of the political life of the subjects. It has been claimed that research using a qualitative method provides 'valuable understanding of the social world, unlike much of the work of quantitative researchers. This is because it respects the nature of the world, which the indiscriminate application of quantitative method does not.'[14] Hence there is great value in qualitative data when asking who? what? where? when? and why? The latter question can be more comprehensively addressed through this approach, 'where meanings rather than frequencies assume paramount significance'.[15]

In order to identify my case study group, I drew potential inter-viewees from a list of candidates for the Northern Ireland Assembly election on 25 June 1998 and contacted unionist and loyalist parties to ask for assistance. Although the study was primarily élite-driven, targeting women holding elected positions and/or party office, political activity was broadly defined in order to include those women active in groups outside of party politics.[16] To this end I made enquiries with organisations such as the Unionist Information Office in London, the Women's Orange Association of Ireland and the Women's Support Network in Belfast, along with a number of academics working in Northern Ireland,[17] which resulted in some useful contacts. I also used a 'snowballing' technique, which involved asking respondents to suggest other potential interviewees.

Initially there was some difficulty in negotiating access to inter-viewees. This was partly to do with the political context. At the beginning of my fieldwork, parties were involved with campaigning for the European elections. Subsequently, attention was focused upon problems over the question of 'decommissioning' in the post-Belfast Agreement (1998) political process. My difficulties also came in the

shape of 'gatekeepers' at some political party offices. The 'gatekeepers' who stood in the way of the women respondents were the secretaries or party administrators, male and female. As Stedward warns: 'You may well encounter a Personal Assistant whose primary purpose appears to be to deflect people like you. Gatekeeping is one of the roles of a PA, and you have to seek admission.'[18] Some gatekeepers provided the telephone number of a political woman's husband, because often in Northern Ireland politics husbands and wives join a party together. One gatekeeper commented: 'If you speak to Mr X he might let you talk to his wife.' Another gatekeeper asked me: 'Why are you just looking at women—you're not a feminist, are you?' My answer to this question, which focused on the lack of attention paid by academia to the women in unionism, must have satisfied him because I gained access to interviewees in that particular party. Perseverance in the field resulted in a total of thirty-seven interviews.

The opportunity to do some participant observation arose on several occasions, largely through contacts made with key players within unionism and loyalism. One key informant or 'sponsor'[19] was Dawn Purvis of the Progressive Unionist Party (PUP) who, following her interview, had agreed to meet on a more informal basis. Once we had developed a relationship of trust, the door was opened to a closer view of a loyalist community. Purvis facilitated my attendance at a community meeting in a working-class loyalist area, and the Eleventh Night and Twelfth Day celebrations in July, which celebrate the Battle of the Boyne. David Hoey of the Unionist Information Office obtained agreement from the Apprentice Boys of Derry so that I could spend time with unionist women involved with the August 'Maiden City Festival' in Londonderry. Hoey also provided the contact that enabled my attendance at the Orange Women's Day in Belfast. Notes about the events were taken afterwards to avoid being obtrusive and/or arousing suspicion. Indeed, there was a certain amount of curiosity about the identity of the outsider at the community meeting, hence the importance of having a sponsor in such situations who can vouch for the credentials of the observer.

Being a participant observer meant that I could form impressions of unionist and loyalist culture, which added further contextualisation to the interview responses, especially regarding participants' sense of identity. The complementary nature of such observation has been noted by Robson, who argues that if 'the main effort in a particular study is devoted to a series of interviews, [then] observation might . . . be used to validate or corroborate the messages obtained in the interviews'.[20]

The type of participant observation depended upon the context but can be categorised as lying between the 'observer as participant', where the observer 'interacts with subjects, but does not take on an established role in the group', and the 'participant as observer', where the observer takes an 'established, or certainly a more participant, role in the group'.[21] For example, it was not appropriate to declare that a researcher was present at the community meeting and a 'back seat' was taken. When observing the Eleventh Night and Twelfth Day, which were social occasions, my presence was as 'guest' and the role became more 'participatory' in terms of engaging with subjects in a social setting. At all other occasions the role of researcher was overt. A good example of this was at the Women's Orange Day, at which it was initially supposed by some of the members that I was a 'sister' from England. Permission for access to the event had been agreed in advance with Susan Neilly, Deputy Grand Mistress, and I quickly corrected any misconception about who I was. Thus I was able both to observe the day's events and to engage with some of the 'sisters' in a discussion about their culture and identity.

Using observation in the research provided several advantages. In observing and engaging with subjects in a naturalistic environment, it was possible to understand the sense of community, identity and the importance of culture. Being in the position of 'guest' or having sought permission to attend events, it was possible to engage with the sponsor in question and ask questions to clarify the meanings of observations made. Dargie notes that: '[b]uilding trust is an important part of observing research subjects; if it is accomplished, the researcher

benefits from the natural responses, opinions and insights of their research subject.'[22] Furthermore, events are observed in their correct context so that the 'researcher is part of the process he or she is observing'.[23]

A key issue, however, concerns the validity of qualitative data. While there is a potential for observer bias in the interpretation of events, the arguments I make here are informed largely by the interview evidence: the observations were a supplementary source of data regarding culture and identity. Another problem is that subjects may react personally to the researcher due to the latter's characteristics or behaviour. They may also behave differently because they are aware of being scrutinised for research purposes.[24] In this case, the subjects were of the same gender, nationality and religious background, which may have facilitated my access to these groups. As Foster notes, 'sometimes age, gender or "racial" characteristics can aid in the construction of certain types of identity and relationship'.[25] It is sometimes necessary to play down the researcher's own political views and be less explicit about the research in order to gain access. To this end, I avoided use of the term 'nationalism', which has negative connotations in this context, and placed emphasis upon 'identity' and forms of participation.

THE LITERATURE

Searching through the literature on the politics of Northern Ireland reveals that only a few texts consider the roles played by unionist and loyalist women, and that this lack of attention by academia arguably contributes to their relative invisibility. Within his ideological analysis of unionism, Feargal Cochrane devotes some space to the gender imbalance. A number of reasons are given for the lack of women in positions of significance in unionism, including the prejudice of the selectorate; the danger of being a public person in a conflict society; and patriarchal and conservative attitudes regarding a woman's place in society. Furthermore, evangelical religion and culture perceives women as:

inherently different 'creatures' whose function in society should reflect that fact. They should be home-makers rather than house-builders, nurses rather than mechanics, whose God-given function is to look after their husbands and rear their children rather than build independent careers. Those women who subscribe to this agenda (and obviously many do not) are unlikely to build profiles within unionist politics.[26]

For those who do not view themselves as homemakers, or who aspire to a career in politics in addition to that role, the aforementioned hurdles must be cleared in order to build the necessary profile.

A number of edited collections on Northern Ireland politics include a chapter on women and politics that refers to unionist and loyalist women. For example, Rick Wilford[27] notes the macho character of national identity, with the interests of 'the nation' prioritised over those of women. In terms of unionist and loyalist women this was evidenced in a separate Women's Declaration during the protests against Home Rule along with the establishment of the Ulster Women's Unionist Council, both of which cast the women in a supportive role.[28] It is the national question that sets the scene for the politics of Northern Ireland and the role that women play in it. Wilford shows that there is a low level of female representation in local government, Stormont and Westminster, although this is slightly offset by appointed office. He discusses political participation of women in general terms and communitarianism whereby there are common interests that women with different national identities acknowledge. Wilford also considers women in the political parties through looking at the offices they hold and the policies that relate to women. The chapter provides a useful starting point in the examination of women and politics in Northern Ireland.

Other examples of edited collections that include a chapter on women and politics, addressing at least in part the roles of unionist and loyalist women, include Carmel Roulston in Aughey and Morrow; Rachel Ward in Gilligan and Tonge; Rosemary Sales in

Shirlow and McGovern; Sales in Anderson and Goodman, and a chapter by Christine Bell in the same volume.[29] Roulston and Sales[30] give an overview of women from nationalist and unionist backgrounds by looking at their employment, and political participation in formal and community contexts, feminism and the peace process. Ward looks at the peace process from the perspective of women political activists from across the community divide. Sales[31] focuses particularly on gender and Protestantism but again provides an overview in that she covers identity, religion, paramilitarism, employment and politics. Bell's chapter is notable for its discussion of the lack of a 'unionist feminism'.[32] She points to the different political persuasions within unionism and that 'feminist unionism has had most space' within the 'socialist' PUP.[33] The articulation of feminist unionism more generally is arguably inhibited by the 'difficulties of right-wing feminism'.[34] There is some reference to Protestant women in terms of the domestic violence faced by both Catholic and Protestant women[35] and the involvement of women in loyalist organisations.[36] Loyalist women were active in protests about the status of their interned husbands and 'from time to time, the wives of Loyalist and Republican internees joined forces to make their protests heard'.[37] Women's sections of unionist political parties and the Orange Order were involved with the

> organisation of jumble sales and refreshments, while throughout the annual 12th (*sic*) of July celebrations the women's role is confined to that of cheerleaders. Despite this, in recent years an increased number of female candidates have been put forward at elections by the different Unionist parties. Such women, however, are never noted for their feminism, and tend to be more vehemently conservative than their male colleagues.[38]

Evidence of these women candidates' 'vehement conservatism' is not provided. That they have not been 'noted for their feminism' appears to be a reason to dismiss the political activism of these women. Yet

they clearly have been politically active to some extent in order to be selected as a candidate for election. Indeed, as Rooney argues, '[t]he notion that women's active participation in politics is necessarily or essentially progressive or emancipatory for women *qua* women is fallacious. Women evidently see their political activity as valuable in promoting the interests of their collectivity.'[39] However, regarding the question of feminism and unionism, it was only in the early 1990s that a consideration of 'female identity within unionism or the possibility of unionism accommodating any form of feminism' began.[40]

While unionist and loyalist women may have been politically active within their communities, the literature suggests that this involved no challenge to the establishment. Any protest regarding 'women's issues' would imply a 'threat to the existing structures; in addition there is deep suspicion of any consideration of gender equality because of perceived links between feminism and nationalism'.[41] This per-ception served to structure the activities of the Socialist Women's Group (SWG), which split from the Northern Ireland Women's Rights Movement (NIWRM), established in 1975. The SWG assumed that: 'Catholic women, having experienced a tradition of rebellion and resistance to unionism and imperialism, would be more receptive to radical ideas about gender roles than their Protestant sisters, whose defence of a conservative ideology—unionism—was assumed likely to make them resistant to feminism.'[42] Splits occurred in the NIWRM because of differences of which the 'troubled question of nationalism became the central one'.[43] The NIWRM, which had a broad membership, including women nationalists and unionists, 'agreed that opinions about the politics of nationalism or unionism should be a private matter which would not be allowed to conflict with the women's movement'.[44] For some women avoidance of such questions was '*de facto* a Unionist position'.[45]

Women have often been depicted as 'peacemakers', a notion that derives from an essentialist perception of women's inherent qualities and also, perhaps, from 'their relatively low visibility'.[46] This idea has been reinforced by the women's peace movement, which was formed

during the 'Troubles' and placed a spotlight on the women founders. The 'Women for Peace' group, founded by Margaret Dougherty in 1972, played a part in securing the thirteen-day ceasefire in August 1972.[47] The founders of the Peace People (1976), Mairead Corrigan and Betty Williams, received the Nobel Prize for Peace. While such groups have been effective in drawing attention to how communities are affected by the ongoing violence, they have been peripheral to formal politics[48] and hence have had a limited impact. Women's community groups have also attempted to search for some sort of 'peace' or accommodation, a challenge that not all have survived. The broader women's movement was riven by the question of whether to support the women political prisoners in Armagh prison who were on a 'no-wash' protest against the removal of political status and harassment by male prison officers.[49] The NIWRM refused to support the Armagh women's protest, as they saw it as 'not a feminist issue but a sectarian one, dividing catholic from protestant women'.[50]

Roulston argues that cooperation between women's and feminist groups is further hampered with the emergence of women's groups in loyalist areas.[51] However, there is a network of community based women's groups linked by organisations such as the Women's Information Group and the Women's Support Network. This appears vibrant when compared to the lack of female representation in formal politics. Indeed, there is a sense that women are 'exploring different forms of political action possibly in response to the "closed shop" operated by men and possibly also in an attempt to break out of the rigid forms of political debate in Northern Ireland'.[52] Cockburn[53] investigated this alternative approach to politics by women's groups in Northern Ireland, Israel and Palestine, and the former Yugoslavia. Women, divided by competing nationalisms, have found a means of cooperation. Cockburn describes the 'oppressively patriarchal' nature of the Catholic and Protestant Churches and the Loyal Orders, which combined with the lack of female representation in formal politics means women are marginalised in society.

The Women's Support Network (WSN) was formed in 1990, following cross-communal challenge to the Belfast City Council's sectarian decision not to renew the grant to the Falls Women's Centre. The WSN approach is to seek a 'tactical *common ground* while maintaining political differences', and to engage in *elective and selective speech and silence* on potentially divisive issues'.[54] Hence women with differing national and other identities can come together without denying the validity of another's identity. Cockburn detects a 'cultural imbalance' in the Network as Catholic women have been active in their community for longer and so have more skills, confidence and propensity to celebrate their culture. The Protestant women, in contrast, are:

> less interested in celebrating their culture. The one they have inherited they tend to subdue in their own lives, because it has historically been domineering—not only over Catholics but also over dissenters within . . . Protestant women have only recently looked for feminist role models in their communal history. Women's rights oppositionalism sits comfortably with Catholic rights oppositionalism, uncomfortably with the Protestant defensive posture.[55]

In rejecting the dominant Protestant culture, these women do not appear to have a positive sense of identity. This impression is supported by Campbell,[56] writing from an ambivalent insider perspective, who states: 'Now when I hear *We are the people*, that I first heard on my father's knee, my gut wrenches. I want to spit out: "Not my fucking people"'.[57] From interviews with other Protestant women, and referring to Moore,[58] she notes a 'confusion of identity, shame, fear, ignorance and longing—lives that do not fall easily into the stereotyped image of the Protestant woman'.[59]

The logic of this alternative 'transversal'[60] approach to politics has been taken forward by the Northern Ireland Women's Coalition (NIWC), which was formed to ensure that women were elected to

the Northern Ireland Forum in 1996.[61] Its members include 'nationalist, unionist, socialist, unaligned and agnostic women',[62] and differences in attitude to policy are debated with a view to finding compromise. The core values and principles of the NIWC include a 'commitment to respect for human rights and civil liberties', 'social equality', 'justice' and an inclusive dialogical process.[63] Adhering to these principles in the Forum has meant that both unionists and nationalists have considered the NIWC to be sympathetic to the 'other'.[64] Its ongoing success is seen in the influence it has had on the content of the Belfast Agreement, which refers to 'equality issues', 'gender-proofing', 'victims' issues', and a 'Civic Forum',[65] and in getting two representatives elected to the Belfast Assembly. The political dialogue in which the NIWC has engaged is a means of moving politics forward in Northern Ireland;[66] indeed, there is a 'need for *a middle ground between commonality and diversity*'[67] that 'affirms gender, religion and cultural identity, as well as the need to transcend the constraints of identity'.[68]

In concluding her chapter on the women's movement in Northern Ireland, Roulston notes that a feminist movement that does not take account of the prior national question will have only a minority appeal.[69] Therefore women in Northern Ireland 'will have to be "qualified feminists", fighting for space within and against their communities and hoping to be ready for the new political order'.[70] This label, however, even when 'qualified', would be rebutted by some of those women, although they may appear to be 'feminist' in their actions, as the empirical evidence will reveal later in this book.

Writers who make limited reference to the role of unionist and loyalist women include Roger Sawyer, Catherine Shannon, Carol Coulter and Constance Rynder.[71] Shannon, for example, detects some grassroots pressure on unionist political parties to bring a gender dimension to their policies:

during the past four years there has been a rising political consciousness among protestant working-class women which is

putting pressure on both the Official Unionist Party and the Democratic Unionist Party to address critical issues for women, especially in the areas of childcare, education and training and social security benefits. Increasingly they have become aware that main-line unionism has little to offer their class and gender.[72]

This pressure would seem to be having an impact on the parties that 'are becoming sensitised to the question of "women" in politics. All want to be seen to be woman-friendly.'[73]

Rynder's provides political biographies of the women elected to the Northern Ireland Assembly in 1998, hence included are details of the careers of Pauline Armitage (UUP), Joan Carson (UUP) and Iris Robinson (DUP). Rynder highlights the continuing low representation of women and comments favourably of the Northern Ireland Women's Coalition (NIWC) that 'the other women Assembly members owe their now-audible political voice to the NIWC'.[74] The NIWC made it their policy to 'name and shame' those politicians who behaved in a sexist manner towards women representatives. She notes that: 'DUP delegates regularly interrupted their speeches with overtly sexist remarks and shouts of "moo, moo".'[75]

Notable exceptions to a failure in the literature to seriously address the political participation of unionist and loyalist women are Rhonda Paisley, Ruth Moore, Mike Squires, Annie Campbell, Sammy Douglas, Rosemary Sales, and Linda Racioppi and Katherine O'Sullivan See.[76] Paisley, Campbell and Douglas provide 'insider' accounts. Paisley, who was the DUP's spokesperson on women's issues (1987–92), concludes that the 'majority of male elected representatives' regard feminist issues with 'superficial' interest. This is partly to do with the women who 'gave [their] votes too readily and there is, as a result, no serious competition for the female vote right across the board, not just within unionism'.[77] Within the DUP, attitudes towards women in politics span from 'dismissive' to 'chauvinistic', and women progressing in their political careers represent a 'threat' to the 'majority of men' in the party.[78] While

Paisley contends that '[f]eminism and Unionism remain miles apart' and, to address this, women must reassess their involvement in unionist politics,[79] Douglas argues the stereotypical image of loyalism as a 'male dominated macho culture' is changing.[80] This is through the involvement of working-class loyalist women in women's community groups, from which there will be the 'emergence of a future articulate and highly politicised female leadership in the loyalist community'.[81]

Sales considers gender, religion and politics in Northern Ireland, and provides both a general account of the position of women and a specific account of unionist and loyalist women.[82] Of the latter, she examines their participation in the Church, the conflict, the labour force and political organisations. For Sales, 'contested national identity' is at the 'heart of the conflict', and there is a certain ambiguity in Protestant national identity because Britain comprises England, Scotland and Wales.[83] Women are constrained by the conservative influence of the Churches on society[84] and, while Catholic women have been able to take advantage of the 'tradition of struggle' to be active in community politics, Protestant women have 'remained much less visible'.[85] Sales credits a Protestant feminist informant with the view that: 'Feminism is seen as alien, and even associated with Republicanism.'[86] She argues that: 'women's lives have been shaped by sectarian divisions and that these have been experienced differently by women from the two communities'.[87] This is seen in the gendered symbolism, in which republicanism has drawn upon the 'tradition of strong Gaelic women' to depict a more active role for women, while there 'is no equivalent symbolic role for women in Protestantism'.[88]

Beyond the symbolism, Protestant women predominate in the congregations rather than in the clergy, which is 'almost exclusively male'.[89] They have played a 'vital support role within the political parties' and those who have stood for elected office 'have rarely pursued an independent agenda'.[90] For those Protestant women engaged in more progressive politics, it has been difficult to have a positive

Protestant/unionist identity because of the dominant conservatism. Drawing upon Moore,[91] however, Sales notes that they are beginning to 'reclaim a positive identity for themselves which is not based purely on negating their own background and experience.[92] This demonstrates the variety of political persuasions held by women within unionism and loyalism, but also appears to devalue the participation of those women who do not have an 'independent agenda'.

Sales also deals with the attitude of the political parties to the participation of women and legislation that particularly affects women, women's community activism and women and the peace process. She notes that: 'Commitment to a political party inevitably means that gender issues take second place to party loyalty. In general, nationalist women have experienced less conflict than unionists in pressing for a women's agenda.'[93] The first part of this statement is highly relevant regarding the participation of unionist and loyalist women, who were deemed to have no 'independent agenda'. The second part of the statement relates to the under-standing that 'feminism is alien to Unionism',[94] an assertion that is repeated throughout the book. The contention that 'nationalist women have experienced less conflict' appears to be rather sweeping. In referring to the 1986 reversal of the Sinn Féin *ard fheis* (party conference) resolution which recognised a woman's right to choose an abortion, Shannon notes that 'there is often a huge gap between stated party policy on women's equality and its acceptance by the male rank and file in daily life'.[95]

This survey of the literature has shown that while there has been some attention to the roles played by unionist and loyalist women, the picture presented is somewhat negative: it conveys an impression of conservatism, anti-feminism and marginalisation. By the end of this book, I hope to have demonstrated that there are progressive elements within unionism and loyalism. The picture is rather more complex, and the political action of unionist and loyalist women should not be dismissed as tea-making.

CONTENT AND KEY ARGUMENTS OF
SUBSEQUENT CHAPTERS

In Chapter 2 the theoretical context for the subsequent empirical and analytical chapters is set. I discuss nationalist theory with a view to demonstrating that unionism and loyalism are varieties of nationalism. I also consider key arguments that are made in the literature on gender and nationalism in relation to Northern Ireland, especially with regard to the symbolic representations of the nation in murals, poetry and song. Here there is further discussion of the 'invisibility' of unionist and loyalist women being due to the fact that visible cultural markers are largely male. The chapter ends with an examination of the questions of identity, motivation and political action in the gender and nationalism literature.

The focus for Chapter 3 is 'identities'. The chapter begins with a broad look at national identity in Northern Ireland, through drawing on the Northern Ireland Social Attitudes Surveys and the Northern Ireland Life and Times Surveys. I then consider the identities of unionist and loyalist women. The research evidence demonstrates the complexity of identity: unionist and loyalist women interviewees held a number of identities that they defined and prioritised differently depending on background and circumstance. I also examine the intersection of gender and community identity, which will enable a greater depth of understanding of the significance of identity processes. In the final section, I utilise the literature on gender and nationalism to analyse the evidence of unionist and loyalist women's identities. Here I draw upon Michael Billig's notion of 'banal nationalism'.[96] Billig argues that we are reminded daily of our membership of the nation and that this 'deixis' addresses men and women differently. The foregoing evidence shows that although the respondents identify themselves in part in terms of their national identity there is an underlying gendered understanding of how they are positioned by that identity within the national project. The importance of symbols, rituals and in-group cognisance that work to

reinforce national identity are analysed, along with the both active and passive involvement of women in the reproduction and maintenance of the nation and national identity.[97]

Chapter 4 delves into the personal histories of the unionist and loyalist women respondents to provide understanding of what motivated them to become politically active. In this chapter I argue that nationalism is a key motivating factor and discuss other 'motivational categories' that are linked to nationalism. These are 'family and/or social background', 'dissatisfaction with politicians and/or the policies of political parties', and the 'direct or indirect effect of "the Troubles"'. In the final section, I analyse the evidence of unionist and loyalist women's motivations to political action through drawing on the literature on gender and nationalism. I discuss the instrumentalism behind group mobilisation and the rhetoric of nationalism that acts to mobilise the group.[98] The reproductive role of women is further discussed in relation to the fear of being demographically overrun by the 'other'.

In Chapter 5, I begin by discussing unionist and loyalist women's political participation both within 'formal' politics and at the community level. I also examine the policies of unionist and loyalist political parties regarding gender issues. The chapter moves on to consider the political roles that unionist and loyalist women play through drawing mainly on interview material with politically active unionist and loyalist women. The roles are divided into four categories: party activists, party representatives, community activists and community representatives, but it should be noted that several of the interviewees played more than one political role. Political action is the most difficult to explain using gender and nationalism. In the analysis section, I consider the limitations of my approach and refer to the literature on women and political participation,[99] which, when used in conjunction with an exploration of the gendered nature of nationalism, will provide greater understanding of unionist and loyalist women's political roles.

In the sixth and final chapter, I draw together the themes of identity, motivation and political action. The chapter returns to the

stereotype of unionist and loyalist 'women-as-tea-makers' that I discussed in the introduction. I argue that the evidence presented shows that, while tea-making does happen, the roles played by unionist and loyalist women in Northern Ireland politics are more varied than the stereotype allows. The chapter looks for generalisations between the case of unionist and loyalist women and other case studies in the gender and nationalism literature. I close with suggestions for further research in this area.

NOTES

1 Interviews were conducted between May and August 1999 with women from political parties and community organisations.
2 This comment was made to me during a conversation with a local Belfast man of 'nationalist' political persuasion.
3 D. Urquhart, 'In defence of Ulster and the empire: the Ulster Women's Unionist Council, 1911–1940', *UCG Women's Studies Centre Review*, 4 (2000), p. 38.
4 G. Walker, 'Gail Walker talks to Unionist women demanding parity of esteem', *Belfast Telegraph* (29 March 2000), http://www.belfasttelegraph.co.uk/cgibin/archive/showdoc?docloc=2000/March/29.
5 C. Cockburn, *The Space Between Us: Negotiating Gender and National Identities in Conflict* (London: Zed Books, 1998), p. 59.
6 C. Coulter, 'Feminism and nationalism in Ireland', in D. Miller (ed.), *Rethinking Northern Ireland: Culture, Ideology and Colonialism* (Essex: Addison Wesley Longman, 1998), p. 164.
7 L. Racioppi and K. O'Sullivan See, 'Ulstermen and loyalist ladies on parade: gendering unionism in Northern Ireland', *International Feminist Journal of Politics*, 2, 1 (2000), p. 13.
8 Ibid., p. 20.
9 Ibid., p. 22.
10 J. McGarry and B. O'Leary, *Explaining Northern Ireland: Broken Images* (Oxford: Blackwell).
11 O. Montgomery, 'Mad dogs eating their own', *Fortnight* (2000).
12 See E. Fairweather, R. McDonough and M. McFadyean, *Only the Rivers Run Free: Northern Ireland: The Women's War* (London: Pluto Press, 1984) and E. Macdonald, *Shoot the Women First* (New York: Random House, 1991).
13 For examples of historical accounts of unionist women's political activity, see N. Kinghan, *United We Stand: The Story of the Ulster Women's Unionist Council, 1911–1974* (Belfast: Appletree Press, 1974); D. Urquhart, '"The female of the species is more deadlier than the male"? The Ulster Women's Unionist Council, 1911–40', in D. Urquhart and J. Holmes (eds), *Coming into the Light: The Work, Politics and Religion of Women in Ulster, 1840–1940* (Belfast: Institute of Irish

Studies, Queens University, 1994) and D. Urquhart, *Women in Ulster Politics, 1890–1940: A History Not Yet Told* (Dublin: Irish Academic Press, 2000).

14 M. Hammersley, *The Dilemma of the Qualitative Method: Herbert Blumer and the Chicago Tradition* (London: Routledge, 1989), p. 180.

15 J.V. Maanen, P. K. Manning and M. L. Miller (eds), 'Series introduction', in N. G. Fielding and J.L. Fielding, *Linking Data: The Articulation of Qualitative and Quantitative Methods in Social Research* (London: Sage, 1986), p. 5.

16 R.L. Miller, R. Wilford and F. Donoghue, *Women and Political Participation in Northern Ireland* (Aldershot: Avebury, 1996).

17 Thanks, in particular, are due to Dr R. L. Miller, Dr E. Rooney, Ms C. Roulston, Dr D. Urquhart, Professor R. Wilford and Dr N. Yeates.

18 G. Stedward, 'On the record: an introduction to interviewing', in P. Burnham (ed.), *Surviving the Research Process in Politics* (London and Washington: Pinter, 1997), p. 154.

19 P. Foster, 'Observational research', in R. Sapsford and V. Juppor (eds), *Data Collection and Analysis* (London: Sage, 1996), p. 69.

20 C. Robson, *Real World Research: A Resource for Social Scientists and Practitioner Researchers* (Oxford: Blackwell, 1993), p. 192.

21 Foster, 'Observational research', p. 75.

22 C. Dargie, 'Observation in political research: a qualitative approach', *Politics*, 18, 1 (1998), p. 66.

23 Ibid.

24 Foster, 'Observational research'.

25 Ibid., p. 72.

26 F. Cochrane, *Unionist Politics and the Politics of Unionism since the Anglo-Irish Agreement* (Cork: Cork University Press, 1997), p. 50.

27 P. Mitchell and R. Wilford (eds), *Politics in Northern Ireland* (Boulder, CO: Westview, 1999).

28 R. Wilford, 'Women in politics' in P. Mitchell and R. Wilford (eds), *Politics in Northern Ireland* (Boulder, CO: Westview, 1999), p. 198.

29 C. Roulston, 'Equal opportunities for women', in A. Aughey and D. Morrow (eds), *Northern Ireland Politics* (Essex: Longman, 1996); R. Ward, 'The Northern Ireland peace process: a gender issue?', in C. Gilligan and J. Tonge (eds), *Peace or War? Understanding the Peace Process in Northern Ireland* (Aldershot: Ashgate, 1997); R. Sales, 'Gender and Protestantism in Northern Ireland', in P. Shirlow and M. McGovern (eds), *Who Are 'The People'? Unionism, Protestantism and Loyalism in Northern Ireland* (London and Chicago: Pluto Press, 1997); R. Sales, 'Women, the peace makers?', in J. Anderson and J. Goodman (eds), *Dis/agreeing Ireland: Contexts, Obstacles, Hopes* (London: Pluto Press, 1998); C. Bell, 'Women, equality and political participation', in Anderson and Goodman, *Dis/agreeing Ireland*.

30 Sales, 'Women, the peace makers?'.

31 Sales, 'Gender and protestantism in Northern Ireland'.

32 Bell, 'Women, equality and political participation', pp. 223–6.

33 Ibid, p. 225.

34 Ibid.

35 L. Edgerton, 'Public protest, domestic acquiescence: women in Northern Ireland', in R. Ridd and H. Callaway (eds), *Caught Up in Conflict: Women's Responses to Political Strife* (London: Macmillan, 1986).

36 Fairweather et al., *Only the Rivers Run Free*; Edgerton, 'Public protest, domestic aquiescence'; C. B. Shannon, 'Women in Northern Ireland', in M. O'Dowd and S. Wichert (eds), *Chattel, Servant or Citizen: Women's Status in Church, State and Society* (Belfast: Institute of Irish Studies, Queen's University, 1995).

37 Edgerton, 'Public protest, domestic aquiescence', p. 75.

38 Ibid., pp. 75–6.

39 E. Rooney, 'Women in Northern Irish politics: difference matters', in C. Roulston and C. Davies (eds), *Gender, Democracy and Inclusion in Northern Ireland*, Hampshire: Palgrave, 2000), p. 168.

40 E. Rooney, 'Political division, practical alliance: problems for women in conflict', *Journal of Women's History*, 6, 4/7, 1 (1995), p. 42.

41 V. Morgan and G. Fraser, 'Women and the Northern Ireland conflict: experiences and responses', in S. Dunn (ed.), *Facets of the Conflict in Northern Ireland* (London: Macmillan, 1995), p. 85. See also R. Sales, *Women Divided: Gender, Religion and Politics in Northern Ireland* (London: Routledge, 1997); and E. Porter, 'Identity, location, plurality: women, nationalism and Northern Ireland', in R. Wilford and R. L. Miller (eds), *Women, Ethnicity and Nationalism: The Politics of Transition* (London: Routledge, 1998).

42 C. Roulston, 'Women on the margin: the women's movements in Northern Ireland 1973–1995', in L. A. West (ed.), *Feminist Nationalism* (London: Routledge, 1997), pp. 48–9.

43 C. Roulston 'Gender, nation, class: the politics of difference in Northern Ireland', *Scottish Affairs*, 18 (1997), p. 60. See also C. Loughran, 'Armagh and feminist strategy: campaigns around Republican women prisoners in Armagh Jail', *Feminist Review*, 23 (1986), pp. 59–79.; E. Rooney, 'Women in political conflict', *Race and Class*, 37, 1 (1995), pp. 51–6; V. Morgan, *Peacemakers? Peacekeepers? Women in Northern Ireland 1969–1995*, Occasional Paper 3 (Londonderry: INCORE, 1996); Roulston, 'Women on the margin'.

44 Roulston, 'Gender, nation and class', p. 61.

45 Roulston, 'Equal opportunities for women', p. 143.

46 Morgan, *Peacemakers? Peacekeepers?*, p. 6.

47 Ibid., p. 10.

48 Morgan and Fraser, 'Women and the Northern Ireland conflict'.

49 Roulston, 'Women on the margin', p. 52; Loughran, 'Armagh and feminist strategy'. See also B. Aretxaga, 'Dirty protest: symbolic overdetermination and gender in Northern Ireland ethnic violence', *Ethos*, 23, 2 (1995); and B. Aretxaga, *Shattering Silence: Women, Nationalism and Political Subjectivity in Northern Ireland* (Princeton, NJ: Princeton University Press, 1997).

50 C. Loughran, '10 years of feminism in N.I. Part 4: 1980–85', *Women's News*, March/April, 15 (1986), pp. 6–7.

51 Roulston, 'Gender, nation, class', p. 63.

52 Morgan and Fraser, 'Women and the Northern Ireland conflict'.

53 Cockburn, *The Space Between Us*.

54 Ibid., p. 83.

55 Ibid., p. 96.

56 A. Campbell, 'Let us be true each to the other: a covenant for a new Ireland', *Irish Reporter*, 16, 4 (1994).

57 Ibid., p. 12.
58 R. Moore (1993) 'Proper wives, orange maidens or disloyal subjects: situating the
 equality concerns of Protestant women in Northern Ireland', unpublished MA
 thesis (Dublin: National University of Ireland, 1993).
59 Campbell, 'Let us be true each to the other', p. 13.
60 N. Yuval-Davis, *Gender and Nation* (London: Sage, 1997).
61 Roulston, 'Gender, nation, class'; C. Roulston, 'Inclusive others: the Northern
 Ireland Women's Coalition in the peace process', *Scottish Affairs*, 26 (1999),
 pp. 1–13.
62 Roulston, 'Gender, nation, class', p. 65.
63 Roulston, 'Inclusive others', p. 8.
64 Ibid., p. 8.
65 Ibid, p. 10.
66 Porter, 'Diversity and commonality'.
67 Ibid., p. 91.
68 Ibid., p. 92.
69 Roulston, 'Women on the margin', pp. 56–7.
70 Ibid., p. 57.
71 R. Sawyer, '*We Are But Women*': *Women in Ireland's History* (London: Routledge,
 1993); C. B. Shannon, 'Women in Northern Ireland', in M. O'Dowd and S. Wichert
 (eds), *Chattel, Servant or Citizen: Women's Status in Church, State and Society*
 (Belfast: Institute of Irish Studies, Queen's University, 1995); C. Coulter, 'Feminism
 and nationalism in Ireland', in D. Miller (ed.), *Rethinking Northern Ireland:
 Culture, Ideology and Colonialism* (Essex: Addison Wesley Longman, 1998); and
 C. B. Rynder, 'The women of '98: gender and the 1998 Northern Ireland Assembly
 elections', paper presented to the American Conference of Irish Studies Annual
 Conference, Roanoke, VA (1999).
72 Shannon, 'Women in Northern Ireland', p. 249.
73 Rooney, 'Women in political conflict', p. 52.
74 Rynder, 'The women of '98', p. 34.
75 Ibid., p. 30.
76 R. Paisley, 'Feminism, unionism and "the brotherhood"', *Irish Reporter*, 8 (1992);
 Moore, 'Proper wives'; M. Squires, 'Ulster unionism and women's issues: a
 political and historical overview', paper presented to the Women and Politics Study
 Group of the Political Studies Association of Ireland (Trinity College, Dublin,
 1993); Campbell, 'Let us be true each to the other'; S. Douglas, 'Loyalism: male,
 macho and marching?', *Irish Reporter*, 14, 2 (1994), pp. 12–13; Sales, *Women
 Divided;* Sales, 'Gender and Protestantism in Northern Ireland; Racioppi and
 O'Sullivan See, 'Ulstermen and loyalist ladies on parade'.
77 Paisley, 'Feminism, unionism and "the brotherhood"', pp. 32–3.
78 Ibid., p. 33.
79 Ibid.
80 Douglas, 'Loyalism', p. 12.
81 Ibid., p. 13.
82 Sales, *Women Divided*; 'Gender and Protestantism in Northern Ireland'.
83 *Women Divided*, p. 3.
84 'Gender and Protestantism in Northern Ireland', p. 145.

85 *Women Divided*, p. 5. See also 'Gender and Protestantism in Northern Ireland', p. 147.

86 *Women Divided*, p. 5.

87 Ibid., p. 9.

88 Ibid., p. 63.

89 Ibid., p. 65

90 Ibid., p. 66.

91 Moore, 'Proper wives'.

92 *Women Divided*, p. 67.

93 Ibid., p. 179.

94 Ibid.

95 Shannon, 'Women in Northern Ireland', p. 247.

96 M. Billig, *Banal Nationalism* (London: Sage, 1995).

97 M. Guibernau, *Nationalisms: The Nation-State and Nationalism in the Twentieth Century* (Cambridge: Polity Press, 1996); and N. Yuval-Davis and Y. Anthias, *Woman-Nation-State* (London: Macmillan, 1989).

98 R. Hardin, *One For All: The Logic of Group Conflict* (Princeton, NJ: Princeton University Press, 1995); D. L. Horowitz, *Ethnic Groups in Conflict* (California and London: University of California Press, 1985); and Guibernau, ibid.

99 See, for example, J. Lovenduski, 'Sex, gender and British politics', *Parliamentary Affairs*, 49, 1, (1996); J. Lovenduski, 'Gender politics: a breakthrough for women?', *Parliamentary Affairs*, 50, 4, (1997); J. Lovenduski and P. Norris, *Gender and Party Politics* (London: Sage, 1993); P. Norris, 'Gender differences in political participation in Britain: traditional, radical and revisionist models', *Government and Opposition*, 26, 1 (1991); P. Norris and J. Lovenduski, *Political Recruitment: Gender, Race and Class in the British Parliament* (Cambridge: Cambridge University Press, 1995).

Gender, Nation and Northern Ireland

At a basic level, nationalism is a dialectical process because '[as] a polit-ical activity [it] always involves two types of interacting participants —those who defend a given order, and those who challenge it or are viewed as challenging it'.[1] Unionists and loyalists belong to the former group. From this starting point, themes of national identity, motivation, and the gendered nature of national movements will be drawn. Of the latter, there is an identifiable niche for women participants in the national project.

Taking account of theories of nationalism and the writings on gender and nationalism facilitates analysis of the political activism of unionist and loyalist women. This is a particularly relevant approach to take in view of the fluidity of the political context in which, for example, power has been devolved to the Scottish parliament, and Welsh and Northern Irish Assemblies,[2] and some sovereignty has been ceded upwards to the European Union. Combined with the recent national conflicts such as in the former Yugoslavia and the ongoing conflict between Israel and Palestine, this indicates that rather than declining in importance nationalism appears to have a tenacious quality. Although most states are not under the grip of nationalist fervour, the question of national identity remains a signifi-cant one, indeed '[i]n a world of nation-states, nationalism cannot be confined to the peripheries'.[3]

NATIONALIST THEORY

The term 'nationalism' is used to refer to the actions of a group united through culture, history, territorial claim and economic advantage or disadvantage. The group may feel that state policies

pose a threat to its culture and economic position. This may lead to
the formation of a separatist movement calling for political self-
determination and the right for the group to form its own nation-
state. However, heightened threat perception is not a prerequisite for
nationalism. Nationalism is not found solely in the defensive or offen-
sive actions of certain groups; it can be understood as acting as a
framework for the daily actions of individual members of the nation.

There are different varieties of nationalism: it is considered by
some writers to be 'primordial', by others 'modernist'. National history
elevates certain events over others and myths are presented as fact,
which results in the *idea* that the nation is a primordial entity.
Nationalist rhetoric can be heavily dependent upon myth to fill in the
gaps between the factual events that occurred in the nation's past.
The perceived longevity of the history of a national group is important
for the cohesiveness of its present and for its future prospects.
Hence primordialists point to blood ties, cultural distinctiveness and
historical events which stem from before the modern period.

I take the view that nationalism is a modern construct. The mod-
ernisation school of nationalism contends that the nation, nationalism
and national identity are not concepts that have always been a part of
human societal organisation. For many academics, ideas of the nation
and nationalism cannot be placed earlier than the end of the eighteenth
century following the French Revolution.[4]

'Nationalism' is often prefixed by another term, such as 'civic',
'ethnic', 'cultural' or 'political'. 'Civic' nationalism is used to infer
inclusivity, while 'ethnic' nationalism implies exclusivity. Hence
there are both 'good' and 'bad' nationalisms. However, in reality
nationalism has both civic and ethnic elements within it. Anthony
Smith argues there is an 'internal contradiction at the heart of the
national state between a universal conception of citizenship, with its
uniform rights and duties, and an inevitably particularist conception
of "the people", i.e. the community of which each citizen is a member.
Here we have to return to the ethnic basis of so many nations.'[5]
Hence civic nationalism is inclusive in so far as citizens accept the

concomitant national culture and community rights and respon-
sibilities.

According to Ernest Gellner, nationalism is 'primarily a political
principle, which holds that the political and the national unit should
be congruent'.[6] This definition does not allow for those nations who
do not have a congruent political unit. Nations can exist under such
circumstances—for example, some states operate in the interests of
more than one national group, as in the case of the United Kingdom.
A broader definition of nationalism as the 'sentiment of belonging to
a community whose members identify with a set of symbols, beliefs
and ways of life, and have the will to decide upon their common
political destiny' is therefore more appropriate.[7] Hence where a nation-
state has politically aware minority national groups within its borders,
it may allow for cultural differences, grant a certain amount of auton-
omy, adopt a federal structure, or, where there is no recognition of
the nation without a state, attempt to eradicate difference.[8] Along
similar lines, Smith views nationalism as an 'ideological movement
for attaining and maintaining autonomy, unity and identity' of the
nation.[9] 'Autonomy' relates to the concept of 'self-determination',
'unity' draws upon the notion of the national 'family' living together
in the homeland, and 'identity' includes that which makes a national
group distinctive such as language, culture and character. Rogers
Brubaker[10] suggests that a distinction between 'state-framed' and
'counter-state' nationalism will provide a more useful analytical
framework as not all nationalism is 'state-seeking'. Arguably, unionism
and loyalism can be viewed as 'state-framed' nationalisms.

Some writers focus upon how the consciousness of corresponding
individual and group interests occurred. Hence there is a psycho-
logical element in the understanding of nationalism and national
identity. For example, Benedict Anderson considers national con-
sciousness peculiarly modern because it was the technological
advances of print capitalism that facilitated a national imagining. The
Reformation and the German translations of the bible in the
sixteenth century by Martin Luther resulted in a mutually beneficial

relationship between print capitalism and Protestantism. The production of 'cheap popular editions quickly created large new reading publics—not least among merchants and women, who typically knew little or no Latin—and simultaneously mobilized them for politico-religious purposes'.[11] The spur to publish cheap books in the vernaculars had come from the saturation of the market for Latin books in Europe in the mid-seventeenth century, and economic recession.[12] Mass consumption of national news by the eighteenth century, literacy permitting, allowed individuals to imagine themselves as part of a wider nation. The nation is 'an imagined political community—and imagined as both inherently limited and sovereign', indeed, 'all communities larger than primordial villages of face-to-face contact (and perhaps even these) are imagined'.[13] The national community is viewed as a 'deep, horizontal comradeship' or 'fraternity', which has the capacity to overcome internal differences so that many will make the ultimate sacrifice.[14]

Although cognisance of the self as a national citizen has been widespread throughout the developed and much of the developing world in the late twentieth and early twenty-first centuries, the seeds of national community arguably stem from 'ethnic' or pre-national times. The term 'ethnic' is not particularly useful because it has different connotations, although Smith[15] has employed it in his approach, which has been described as 'modified primordialism'.[16] Smith is critical of the modernist perspective for its 'myopic nature', arguing that it does not acknowledge the role of pre-modern societies from which modern nations stem. Nations and nationalist movements do draw upon history and cultural traditions to strengthen the sense of identity and uniqueness, thus engendering loyalty amongst the people of that nation.

Smith has adopted a definition of the nation that combines the modernist concept of the civic nation, where membership is inclusive and involves rights and duties, and the primordial concept of the ethnic nation, where membership is exclusive and depends on birth or descent. He argues that while citizenship has a 'universal

conception', the notion of 'the people' is 'inevitably particularist'.[17] So a nation is 'a named human population sharing a myth of common descent, historical memories and a mass culture, and possessing a demarcated territory, common economy and common legal rights and duties'.[18] This definition is necessarily broad. In the case of the United Kingdom, the population shares a demarcated territory, common economy and common legal rights and duties. Historical longevity, the role of empire in integrating groups with disparate identities under one home state and the teaching of a national history endorsed by the state, have contributed to an overarching British identity. Under this arguably inclusive identity groups with specific allegiances to one of the four nations of the United Kingdom, the Commonwealth or elsewhere can reside.

Smith contends there is an 'ethnic core' to those communities with the following in common: name, myths of origins and descent, historical memories, homeland, culture and sense of solidarity.[19] These are designated 'ethnies', and, he argues, not enough account is given by modernists to the 'pre-existing "ethnic cores"' of modern nations.[20]

The question arising at this point is how do individuals form national attachments? The responsibility for this falls in large part to the intellectuals who have played an important role in 'generating cultural nationalism and in providing the ideology, if not the early leadership, of political nationalism'.[21] Intellectuals involved directly or indirectly in the national project include historians, artists, linguists, philologists and folklorists. The work they produce lends legitimacy to the political claims of nationalists. The 'state-framed' versus 'counter-state' nationalisms framework may be employed here because the discourse of intellectuals in a nation without a state is opposed by the state's intellectuals, some of whom will operate within the territory of the national minority defending the status quo, questioning its nationalist ideology and displaying a clear 'pro-state nationalist' attitude.[22] Unionist intellectuals have taken on the latter role, although this is a more recent development stemming

from the Anglo-Irish Agreement (1985), which precipitated a crisis in unionism. Certainly, in comparison to Irish nationalism, unionism is rather short of intellectual underpinning. Nationalism operates on the political, economic and social levels and, with regard to the latter, the family metaphor for the nation is used to 'inspire a spirit of national solidarity and brotherhood in the members of the nation'.[23] This, combined with national myths and memories, distinctive language traits and works of art, provides the symbolic attachments necessary for national identity to be formed and maintained.

While nation and state are not necessarily coextensive, one key factor for individuals within a nation is territory, which becomes sacralised by national history and myths.[24] The homeland is unique to the people who claim it, and, when combined with a 'legal-political community, legal-political equality of members, and common civic culture and ideology', comprises the Western or 'civic' model of the nation.[25] Identities are located in the national territory; they are 'nested identities' through which 'each person gains an understanding of who she/he is by considering "self" in relation to "others" in a variety of different ways that can and generally do include differing scales or levels of abstraction'.[26] The differing geographic scales are those of the local, regional, national, supranational and global. An individual's identification with the locality and the region may strengthen and does 'not necessarily compete with a national identity that is derived from an attachment to the nation and the associated nationalism'.[27] Furthermore, identity can be 'situational' in that there is fluidity to collective identities and individuals will prioritise certain identities at different times and contexts. This, for Smith, is the 'instrumentalist' perspective, which holds that identity 'must be analysed as a property of individuals rather than of collectivities'.[28] Smith also refers to 'concentric circles of allegiance'[29] whereby the individual draws upon regional or national loyalties depending on the situation. This point is raised by Linda Colley, who notes that a person could view themselves as 'at one and the same time, a citizen of Edinburgh, a lowlander, a Scot, and a Briton'.[30]

The importance of national territory for the location of the national culture can lead to insecurity if the territory is perceived to be under threat. Some sense of collective anxiety about the security and status of the national 'family' acts as a mobilising force on the group. For example, the question of demographics[31] is enough of a worry for some in the Northern Ireland context. Donald Horowitz notes that the 'environment of group juxtapositions may be broader than that created by formal territorial boundaries. When once this is conceded, it becomes obvious that there is a realistic component to group anxiety.'[32] Fear of being overcome by the 'other' may lead to pre-emptive action. Indeed, if the Irish Republic expanded to include Northern Ireland the result would be a 'Protestant majority in the North that would form a recalcitrant minority in Ireland as a whole'.[33]

The literature drawn upon so far in the chapter has pointed to the 'ethnic', 'civic', cultural, linguistic, political and psychological aspects of nationalism, which can all be related to the themes of national identity and motivation. The recurrence of the theme of identity in the literature discussed in the chapter is relevant in so far as it helps to validate the claim made that unionism and loyalism have the attributes of nationalism. The chapter will now move on to examine this claim further.

UNIONISM AND LOYALISM AS VARIETIES OF NATIONALISM

In general, liberal Western academics today find it easier to recognize nationalism in 'others' than in themselves. Nationalists can be identified as extremists who, impelled by a violently emotional psychology, seek irrational ends; or they can be painted as heroic figures who, in particular, are to be found overseas, battling against repressive colonialists. Nationalism can be seen almost everywhere but 'here'.[34]

The above quotation informs the contention in this book that unionism and loyalism have the characteristics of nationalism. Rather

than viewing nationalism as the exclusive tool of the separatist/
irredentist/extremist, I take the stance that nationalism is all-
pervasive and that in the contemporary world individuals understand
themselves in national terms. Unionism and loyalism are mass-based
ideologies that were developed in the nineteenth century in reaction
to political and economic circumstances.

There are several debates regarding the relationship between
unionism and loyalism, and nationalism. The first contends that
unionists and loyalists have a British national identity. This view is
problematic because not all unionists and loyalists would prioritise or
even accept a British national identity, and furthermore some other
British nationals would not see unionists and loyalists as British. In
addition, it is contended by some that British identity is a state rather
than a national identity.[35] The second perspective views unionism
and loyalism as relatively autonomous national identities and the
third considers them to be variants of British nationalism. I will
focus upon the latter perspective, which I consider to be the most
persuasive.[36]

Unionism and loyalism cannot be properly understood without
recourse to the history of Northern Ireland. It is through considering
these perspectives via a wider lens that one can see the validity of the
statement that: 'Unionism is a type of nationalism, a variation of
British nationalism, and it has both civic and ethnic dimensions, just
like its Irish nationalist counterpart.'[37] The debate should not be
examined in isolation from the rest of the United Kingdom, because
the identity of Northern Ireland unionists and loyalists has been
formed in a wider context than the six counties.

It is perhaps due to a narrow understanding of nationalism that
there is a reluctance to perceive unionism as nationalism. This
tendency has been identified by Liam O'Dowd, who argues: 'one of
the defining features of British nationalism also shared by unionists
is a refusal to see it is a nationalism at all, and the assertion that it
is opposed, and superior, to narrow, exclusivistic nationalism of all
kinds'.[38] For some, conditional loyalty to and desire for the

maintenance of the union with the British state is not nationalism *per se* as the people of Northern Ireland are part of a wider whole: Northern Ireland is not a nation, although it had state-like attributes between 1921 and 1972. However, it should be noted that unionists and loyalists are more than simply loyal to the British state, and national identity is not solely dependent on territory.

The refusal to view unionism and loyalism as varieties of nationalism is typified in the perspective of Arthur Aughey,[39] who differentiates between the terms 'nation' and 'state'. Indeed, these terms are often used interchangeably, if not concurrently, as in 'nation-state', in daily political rhetoric. The linking of these two terms can be somewhat confusing, for the state comprises the institutions that work to create and maintain the nation. It decides the rights and responsibilities of the citizens, ensures that the economy runs relatively smoothly, provides education so that the citizens learn the national language and national history, and maintains a defence force in case the territory of the nation is threatened. It also interacts with other states, as these are the recognised political units throughout the world. Ideally, the state must do all of this with the approval of the majority of its citizens, providing, of course, that it is a democratic state, because the nation comprises those citizens and it is with them that sovereignty lies. For Aughey, who argues there is no link between the modern state and a sense of nationality, unionism 'has little to do with the idea of the nation and everything to do with the idea of the state'.[40] Unionism is considered to be a rational political ideology in which all citizens under the jurisdiction of the British state should be subject to the same rights and duties. Unionists' concern for self-determination 'was a negative one . . . British citizens ought not to be compelled against their will to become part of an economically backward, politically authoritarian and religiously exclusive Irish state'.[41]

Aughey argues that unionism is an ideology that can unite people of different backgrounds under the banner of 'equal citizenship'. His project appears to be one of making an intellectual case for unionism

because 'with few exceptions, unionists have no real appetite for abstract thought'.[42] Despite this positive interpretation, a Northern Irish identity, with rights and duties upheld by a British state within a defined national territory, can just as easily be defined as a form of civic nationalism. Indeed, John McGarry and Brendan O'Leary[43] argue the call for 'equal citizenship' is a form of civic nationalism. In what appears to be a nod towards Anderson,[44] Aughey contradicts himself with the statement: 'if nationalism claims to be an ideology that transcends its social carriers—flesh-and-blood Irish Catholics— then unionism merits a similar consideration'.[45] Cochrane disagrees with Aughey's analysis of unionism. He argues that the 'majority of unionists *are* concerned about their identity, their culture, their religion, and their history, as of course are nationalists'.[46]

Unionism and loyalism are expressions of the desire of the majority in Northern Ireland that their link with the United Kingdom be maintained, a defensive position perpetuated by the ambivalence of the British state. For O'Dowd, who has detected a 'new unionism' amongst middle-class Protestants, this has led to demands for political, administrative and bureaucratic citizenship on an equal footing with the rest of the British population. Mainland political parties as a rule do not organise or campaign in Northern Ireland (although the Conservative Party has done so), so the electorate cannot vote for the party that will form the government of the UK. Despite this, the 'new unionists' have been drawn more closely into the mainstream of British socio-economic and cultural life and their career paths, be they academic, administrative or journalistic, have crossed both Great Britain and Northern Ireland. They read British newspapers, listen to British radio stations and watch British tele-vision daily, thereby partaking of a British 'imagined community'.[47] This relates to Anderson's notion of a national imagining. O'Dowd considers the perspective that unionism is not a variety of nationalism and finds it wanting. He argues that the 'new unionists' advance a 'profoundly ahistorical and idealistic understanding of the UK state', thus not accounting for the 'extent to which the British empire and

state sought to create and institutionalise a 'British world' based on an
elaborate hierarchical system of national, ethnic and racial groups.[48]

Cochrane contends that unionist ideology is a 'multilayered
phenomenon that almost defies categorisation'.[49] He argues that
the inability of unionism to develop a positive alternative to the Anglo-
Irish Agreement was because it is united in the desire to remain within
the UK but internally divided over political strategy. Following
Jennifer Todd's classification of unionist political culture into Ulster
loyalism and Ulster British,[50] he has identified three groups within the
'unionist family': devolutionist, integrationist and a combination of
legislative integration with administrative devolution. These sub-
groups all have a British and Ulster national identity, with some
weighted towards the former and some to the latter. This is supported
by the work of Sarah Nelson, who notes that the Democratic Unionist
Party (DUP) 'which had always been broadly integrationist with
loyalty to the crown a central theme . . . spoke for the extent to which
they did feel British and could not find a separate identity'.[51] The
British identity here is emphasised and DUP members would not be
amenable to an independent Ulster. The 'varieties of nationalism'
perspective allows for the multi-layering of identity.

Cochrane provides the examples of the decision by Queen's
University, Belfast, not to play the British national anthem at grad-
uation ceremonies, which was protested against by a unionist rally
and many letters to the *Belfast Telegraph*, and 'unionists chasing the
RUC across the fields' during the 'Siege of Drumcree'. These
'demonstrate that many unionists are motivated by exactly the same
symbolic forces which drive Irish nationalism'.[52]

David Mason is another commentator who has detected nationalist
characteristics within loyalism. He criticises the perspective that Ulster
Unionism is not a 'species' of nationalism, and argues that this
conclusion was reached due to 'an excessively rigid conceptualisation
of nationalism', along with too much regard placed on the union-
ist reluctance to embrace the nationalist label.[53] Despite this lack of
'self-appellation', Mason draws upon the Home Rule crisis to show the

primacy of Ulster for loyalists. He also notes the myths and symbols of loyalism that surround the Battle of the Boyne and the Siege of Derry. Economic development and the ensuing prosperity resulted in 'symbols which stressed both the historic continuity of the Loyalist cause and the dynamic modernity of Ulster'.[54]

Alan Finlayson follows Mason's stance that employing a narrow definition 'depoliticises large areas of nationalist activity'.[55] By understanding nationalism as a 'process of group mobilization', the 'two communities' can be seen as 'products of different imaginings of community', which are the 'products of discursively constructed categories of belonging'.[56]

Unionists and loyalists are aware of the historical events peculiar to Northern Ireland that help to define them, but this is set in the context of a wider British national identity. Identity does not have to be monolithic—it can be multi-faceted. This does not always follow, though, as the desire for independence may overwhelm the fact that group is within a 'secure niche', or, as in the case of the Ulster Defence Association (UDA),[57] the niche may no longer seem so secure. It may be that the state is dominated by people from another group of a different national origin or that it is supporting the culture and traditions linked to a national identity in competition with its own. On a daily basis, though, members of a nation will use their national identity to reaffirm who they are as opposed to who they are not. The 'hypothetical citizen of a nation-state will continually encounter, if not consciously register, flagged signs of nationhood. The apparent latent identity is maintained within the daily life of inhabited nations'.[58] Indeed, it is in the interest of the state to maintain the notion of national identity. As Smith notes, providing that 'states protect and fashion national identities while drawing for their power and solidarity on the mobilized historic culture-community at their core, so long will national states remain the prime political actors in the modern world'.[59]

The unionist and loyalist varieties of British nationalism have their roots in an imperial history and conservative ideas of the

organic nature of nation and state. It is the 'colonial acquisitions' and wartime victories that have 'provided convincing confirmation of national superiority'.[60] Andrew Heywood argues that this form of nationalism tends to be found in 'established nation-states', i.e. where there is an interest in protecting state integrity. The fostering of patriotic feeling can ensure this. He further contends that the 'conservative character of nationalism is maintained by an appeal to tradition and history; nationalism becomes thereby a defence for traditional institutions and a traditional way of life. Conservative nationalism is essentially nostalgic and backward-looking, reflecting upon a past age of national glory or triumph.'[61] Unionism and loyalism are most certainly defensive, appeal to tradition and history, and have patriotic qualities. Hence the ideas of the unionist community are informed by a strong tradition of conservative nationalism. From this perspective, the members of the nation understand who they are through being part of the nation. They believe that it is right to conserve what they have, maintain institutions and traditions that have stood the test of time and will react against the prospect of revolutionary change. Indeed, this understanding of unionism and loyalism corresponds to one of the types of 'non-state seeking' nationalisms identified by Brubaker. This is 'defensive, protective [and] national-populist' and 'seeks to protect the national economy, language, mores or cultural patrimony against alleged threats from outside'.[62]

Through the rhetoric of nationalism, the idea of the nation is reproduced in the minds of the people. Politicians constantly refer to the nation *vis-à-vis* other nations, and to national symbols such as the flag, the national anthem and the monarchy. The population read national newspapers, which helps to reinforce the notion of belonging to a community, and support the national team in international sporting events.[63] Unionists and loyalists are just as susceptible to nationalist rhetoric and the political context makes that rhetoric all the more pertinent.

GENDER AND NATIONALISM

The literature on nationalism often takes, at best, a gender-blind approach. An example of a statement with gendered and heterosexist assumptions behind it is from Gellner, who argues: 'Just as every girl should have a husband, preferably her own, so every culture must have a state, preferably its own.'[64] The lack of a consideration of gender in theories of nationalism has resulted in a burgeoning literature to address this gap. Here I consider aspects of this literature that relate to Northern Ireland. I focus particularly on the themes of identity, motivation and political participation in order to demonstrate that unionist and loyalist women should not be treated as an exceptional case.

In the context of Northern Ireland, a gendered understanding of nationalism is especially pertinent because '[v]iewing the conflict in Northern Ireland as one between nationalists and unionists has three main shortcomings: it oversimplifies national identity, it fails to recognize that unionism is also a form of nationalism, and it silences the extent to which nationalism is thoroughly gendered'.[65] The nationalist project constructs national identity and provides the context for the roles played by women and men who are differently positioned in and by the national discourse.

The symbolism of the national project is important for national identity and for motivating 'the people' into political action. National symbols are found in works of art, literature, poetry and songs. The images held within them can invoke strong feelings of national pride, a sense of national history, purpose and of belonging to a national community. The gendered nature of nationalism can be seen in the symbolism utilised to capture the imagination of the people of a nation. The nation itself is often symbolically a woman, and may be depicted as vulnerable and passive, and/or strong and defiant. When threatened, the 'motherland' needs the protection of her sons, who defend her honour and willingly lay down their lives for her. Ireland, India and Russia are symbolised by a mother figure, while the French

Revolution utilised the symbol of a woman giving birth known as 'La Patrie'. In Cyprus the depiction of a 'crying woman refugee on roadside posters was the embodiment of the pain and anger of the Greek Cypriot collectivity after the Turkish invasion'.[66] In the context of British nationalism, the female figure of Britannia depicted in warrior-like pose accompanied by the song 'Rule Britannia' symbolises superiority over other nations. The woman-as-nation allegory is used as a means of depicting national priorities and is part of the process of forming and maintaining a national identity

Another example of gendered national symbolism is the depiction of 'Mother Ireland' in Irish nationalist discourse. Ireland is also known as 'Dark Rosaleen' and 'Shan Van Vocht' (poor old woman). There is evidence that this gendered conceptualisation was relevant for both women and men. For example, Maud Gonne, a prominent woman of Irish nationalism in the early twentieth century, employed the metaphor when she wrote an article to protest against the visit of Queen Victoria in 1900. The purpose of the Queen's visit was to encourage Irishmen to join the British Army and fight in the Boer War. She voiced the reply of Ireland to this prospect in a distinctly maternalistic voice:

> Queen, return to your own land; you will find no more Irishmen ready to wear the red shame of your livery. In the past they have done so from ignorance, and because it is hard to die of hunger when one is young and strong and the sun shines, but they shall do so no longer; see! your recruiting agents return unsuccessful and alone from my green hills and plains, because once more hope has revived, and it will be in the ranks of your enemies that my children will find employment and honour! As to those who today enter your service to help in your criminal wars, I deny them! If they die, if they live, it matters not to me, they are no longer Irishmen.[67]

Hence the message from Mother Ireland was also directed at those sons whose loyalty was wavering—fight for another nation and you are no son of mine.

The struggle of Mother Ireland is depicted in the song 'Four Green Fields'. One of the 'fields', representative of Ulster, has been taken by 'strangers' and her 'fine strong sons . . . fought and died' in their attempt to save it. The song refers to the 'fine old woman' and the 'proud old woman', which suggests that although long suffering and grieving for the deaths of her 'children', she remains defiant:

'What did I have?' this proud old woman did say
'I had four green fields, each one was a jewel,
But strangers came and tried to take it from me
I had fine strong sons, they fought to save my jewels
They fought and died, and that was my grief' said she.

'Long time ago' said the fine old woman
'Long time ago' this proud old woman did say
'There was war and death, plundering and pillage
My children starved, by mountains, valley and sea
And their wailing cries, they shook the very heavens
My four green fields ran red with their blood.'

'What have I now?' said the fine old woman
'What have I now?' this proud old woman said
'I have four green fields, but one of them's in bondage
In strangers hands that tried to take it from me
But my sons have sons as brave as were their fathers;
My fourth green field shall bloom once again' said she.[68]

This is an idea of the nation connected strongly with territorial possession—as a mother gives birth to her children, so the mother-land bears the children of the nation. The sacrifice of sons in the attempt to reclaim the 'field' held in 'bondage' compounds the importance of this nationalist goal. To give up would make the former sacrifice meaningless.

Political events such as the death of republican hunger strikers in 1981 can be woven into the mythical notion of motherly sacrifice as

Figure 2.1. Postcard of a mural
commemorating Ulster 1914

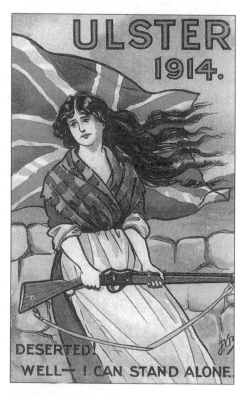

Figure 2.2. The UVF in 1912

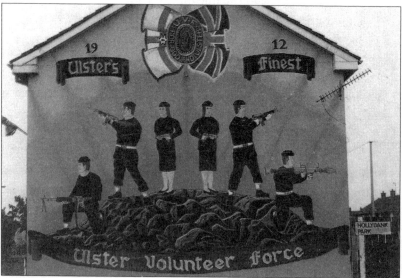

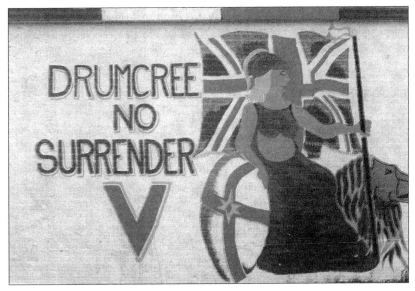

Figure 2.3. The Drumcree stand-off

it 'allegorically represents the suffering of the country inasmuch as the country is represented as a mother in republican imagery'.[69] However, as Aretxaga notes, the representation of women as suffering mothers portrays them as passive figures rather than political actors in their own right.

There is little evidence of similar use of the female allegory within unionism. The murals are predominately depictions of male loyalist paramilitaries, but women in the Ulster Volunteer Force (UVF) in 1912, a woman representative of Ulster during the anti-Home Rule campaign in 1914 and the image of Britannia have been featured (see Figures 2.1 to 2.3). The depiction of Ulster 1914 shows a mournful-looking working-class woman holding a rifle. She is meant to symbolise Ulster defending herself against her enemies. Another image (not shown) relating to anti-Home Rule is a photograph in which a man is ploughing a field, representative of homeland, while his wife stands in defence holding a shot-gun.[70]

The crude depiction of Britannia has been used in murals in connection with the contentious annual parade from Drumcree church

along Garvaghy Road to the Orange Hall in Portadown. The image has the slogan 'Drumcree No Surrender V'. The 'V' represents the fifth year that the parade was disputed. It has taken on a huge significance, such that some unionists perceive protests by nationalist residents as an attack on unionist culture and civil rights. This was evidenced in the lead-up to Drumcree VI during the summer of 1999, when there was a 'civil rights' march that started in Londonderry, crossed Northern Ireland and finished in Portadown.

These few images of women seem to be exceptional cases. Meyer argues that unionist identity 'draws heavily on masculine/warrior symbols with virtually no room for feminine symbols, thus reflecting the staunchly patriarchal values of unionism, its preoccupation with allegiance to the British state, and its exclusion of women from political leadership'.[71] In unionist and loyalist songs and poems, the males of Ulster are often exhorted to be active in defence of their country. In the following example, the female is symbolic of the nation:

> What of the men of Ulster?
> Hark to the armèd tread,
> As they turn their backs on the Province,
> And face to the front instead;
>
> The sword half drawn on her own behalf
> In Ulster's Red Right Hand
> Will leap from the scabbard and flash like fire
> For the common Motherland.
>
> And wherever the fight is hottest,
> And the sorest task is set,
> ULSTER WILL STRIKE FOR ENGLAND—
> AND ENGLAND WILL NOT FORGET.[72]

While the first verse refers to the 'men of Ulster', the second refers to Ulster as female with 'sword half drawn on her own behalf'.

Ulster as female is fighting for England, the 'common Motherland', but this is symbolic as those doing the active fighting are the 'men of Ulster'; there is no active role for the women of Ulster.

For Geoffrey Bell, Protestant women are the 'sweet-tempered, faithful lassies of the Protestant male dream'.[73] He argues that '[i]n song at least, the Protestant male reigns supreme; he deals out rough justice to the inferior Catholic; Catholic women are 'flighty' and whores; and while the Protestant women are usually virtuous and adoring they too will be quickly put in their place should any of them step out of line.'[74] Hence group boundaries are established and the women embody the differences between them. While the figure of a woman may be employed in national symbolism, women members of the national group also *represent* the nation in their daily actions. They are 'constructed as the symbolic bearers of the collectivity's identity and honour, both personally and collectively'.[75] A nation may be judged on the status of its women members but there appears to be little room for a consideration of the heterogeneity of the identities, experiences and needs of women. Rather 'women' in the nation are constructed as object rather than subject: as a metaphor of the nation itself or of the changes that must be made in order to secure national self-determination.

The female figure is passively present in the story of the Siege of Derry, the 'Maiden City', in 1688, when a group of apprentice boys closed the gates against the forces of the Catholic King James II. The city itself is female and is in danger of being violated by the Catholic enemy. Meyer notes that 'there are no heroic women actors in the drama except for the stony female figure of the walled city itself'.[76] Although the Apprentice Boys of Derry (ABOD) is a male-only organisation, contemporary re-enactments of the siege feature women and children, and emphasis is placed upon celebrating the history of the city. Alistair Simpson, ABOD governor, explained that women are not allowed to be members of the ABOD because, historically speaking, 'there were no apprentice girls'.[77] This historical perspective goes some way to explaining the active male/passive female in unionist

symbolism. Interestingly, Todd notes gendered references in the literature on Northern Ireland that point to a paranoia and siege mentality. She quotes Dewar, who states that: 'the Border is secure as a bulwark to his religious faith and his political freedom, under the ample folds of the Union Jack, as were the grey old walls of Derry beneath her Crimson Banner nearly three centuries ago'.[78] She goes on to interpret the quote as a 'clear, although paradoxical, identification of the Orangeman with the virgin threatened with violation. The Orangeman is both defender and defended, assertively male but behind the defences possessing a powerless female core'.[79]

Richard Kearney regards the uses of myths in nationalist discourse as 'more than antique curiosities; they retain a purchase on the contemporary mind and can play a pivotal role in mobilizing sentiments of national identity'.[80] He refers to the example of Padraic Pearse, who, in the Easter Proclamation of 1916, made a 'rhetorical correlation between (i) the Catholic symbolism of mystical reunion with martyrs through the sacrifice of the Mass, and (ii) the mythological idea of Mother Ireland calling on her sons to shed their blood so that the nation be restored after centuries of historical persecution'.[81] The role played by myth, therefore, should not be under-estimated. This point is echoed by Matthew Levinger and Paula Franklin Lytle, who highlight the importance of nationalist rhetoric in group mobilisation. They argue that: 'National identity (like any identity) cannot be abstracted from the idea of some appropriate action. In this sense, nationalism is inherently mobilisational in character.'[82] The mobilisational character of nationalism can be positive for women in terms of using their political agency to counter 'traditional' attitudes but it can also have a devastating impact. The use of systematic rape by enemy soldiers during national conflict is the ultimate act of power of one person over another that symbolises power of one country over another.[83]

It would seem that the use of gender in national symbolism could have a significant impact upon the lives of men and women. It is central to the way that individuals within the nation understand their

own identity and engage in actions that maintain their national membership. This leads into the question of motivation and participation within the gendered national project, to which the chapter now turns.

According to Nira Yuval-Davis and Floya Anthias, women of the nation participate in the national project in both passive and active ways. They are 'biological reproducers of members of ethnic collectivities'; 'reproducers of the boundaries of ethnic/national groups'; central participants in the 'ideological reproduction of the collectivity and as transmitters of its culture'; 'signifiers of ethnic/national difference'; and 'participants in national, economic, political and military struggles'.[84] The nation may have distinctive cultural ideas about appropriate behaviour of women, who in turn may embrace the designated role or use their agency to challenge it.

Although women are generally perceived as relatively powerless, their political actions can be symbolically powerful.[85] This includes subversive actions contrary to the gender role assigned to women in society. Women are not simply passive pawns accepting their designated position. They may be motivated into political action in specific ways by nationalism and their national identity. The sight of a large number of women demonstrating in a public place, such as the 'Women In Black' of Argentina and the former Yugoslavia[86] or that of women mourning their dead can be extremely emotive. The power of women's political action was seen in Belfast in 1970, when women from the Upper Falls Road marched to supply bread and milk to those families subject to a curfew in the Lower Falls.[87] Furthermore, women living in Catholic areas used the gender stereotype of the passive woman to their advantage. This included walking male friends home to reduce the chance of them being arrested and interned and moving ammunition for the Provisional Irish Republican Army (PIRA). Aretxaga contends that '[a]lthough internment led women into male arenas of political organization and street protest, their actions were interpreted according to the parameters of dominant gender ideology . . . The assumption that women were passive victims of war and therefore less likely to

engage in subversive activities was manipulated by both men and women during the early 1970s.'[88]

The state control of women in the nation has an impact on the form of political participation in which they engage as it may contribute to the construction of gender roles. The state may enact legislation to restrict the access of women to the public sphere—hence they may not be very visible or may have only minority representation. Women who belong to a minority national grouping that considers itself to be discriminated against may be motivated to participate in subversive activities. Yuval-Davis notes that: 'Women's citizenship in these communities is usually of a dual nature: on the one hand they are included in the general body of citizens; on the other there are always rules, regulations and policies which are specific to them'.[89] State natal policies have a huge impact on the position of women in the nation because producing the next generation of citizens is a significant national interest.

There have been many examples of state intervention in women's reproduction. Gisela Kaplan, in her discussion of feminism and nationalism in Europe during the nineteenth and twentieth centuries, argues that 'in an attempt to substantiate male white superiority, "inferior" status of race was often likened to differences between the sexes'.[90] Kaplan lays the blame for pro-natalist legislation, which 'condemned and forced millions of women for the first time in history to bear and keep unwanted children',[91] at the door of nationalism, although she acknowledges the prior role of the Church and the Vatican in this regard. While Nazi Germany enacted stringent measures to ensure that German women had children while women from other 'races' did not, other state policies have been less overt. For example, maternity leave and child allowances are not draconian. Rather, they act as an incentive by contributing to the cost of having children. Israel has used this approach, along with rewarding 'heroine mothers' bearing at least ten children.[92] Other means of natal control include the use of exhortation. Statements made by political élites may contribute to societal pressure to bear and raise children. In

Slovenia in 1991, 'the platform of the major party Demos explicitly stated that "women should not have the right to abort future defenders of the nation"'.[93]

Women are often happy to bear children and fulfil the role of motherhood, so the nationalist call for women to do their duty does not appear to be coercive. The socialisation of women in a patriarchal society is a subtle form of coercion, however. Roulston, who examined the women's movement in Northern Ireland between 1973 and 1995, notes that women's participation is encouraged through appealing to their conscience regarding family responsibilities rather than their rights as individuals.[94]

Although there is certainly a power differential, within nationalist theory the dichotomy between public and private does not exist as such, because the cultural element of nationalism is fostered within both public and private arenas—hence the political spans both spheres. As power tends to be wielded in the public sphere the access of women to power may be either constrained or perhaps temporarily facilitated by gendered nationalism. Women members of a dominant national group are favourably placed to benefit from the power of the state but may not be able to influence the way power is used. This can be seen in apartheid South Africa and the different experiences of Afrikaner and black women. The former were 'assigned to motherhood, self-sacrifice, and stoicism',[95] while among the latter were women campaigning for national liberation and women's equality. Therefore, Afrikaner women, in their position as members of the dominant national group, were constrained by a conservative nationalist outlook. Arguably there are parallels here with the experience of unionist and loyalist women.

Ideas of what is appropriate behaviour for women in the nation have an impact on how women participate in situations of national conflict. Cynthia Enloe has examined the gendered nature of national militaries and wars.[96] Women are often involved in an auxiliary capacity, from the provision of food to sexual services. Women soldiers may be subject to limitations such as not being allowed to

fight in the frontline. However, as Yuval-Davis notes, for some women joining the military has led to an improvement in their status. By joining national liberation armies they have left behind 'intolerable personal situations caused by both colonial and loyalist forces and/or their own families'.[97] Hence women's involvement in nationalist movements can have a progressive impact.

Having considered the different ways that women participate in the national project and how the state places limitations upon the agency of women, I shall now reflect upon how gender and nationalism relate to unionist and loyalist women. The variety of nationalism that is peculiar to the case study group is not normally the focus of empirical research when allied with gender. A review of the literature shows mainly a picture of women involved with irredentism struggling to liberate both their nation and their gender. Unionist and loyalist women form part of a national community and their struggle is to remain within it and counter the irredentist moves from Irish nationalism. In the Northern Ireland context unionism and loyalism have been characterised as being anti-feminist, with Irish nationalism being much more accommodating to a progressive political agenda for women. This is an exaggerated picture; rather, there has been a general persistence in 'traditional' attitudes towards women. The perceived link between feminism and Irish nationalism has led to the former being viewed in a negative light by women unionists and loyalists and hence a tendency to deny that they are 'feminists'. In a similar way that the substance of unionism and loyalism can be interpreted as 'nationalist', the substance of *some* of the political activities of unionist and loyalist women can be interpreted as 'feminist'. While conservative and traditional political attitudes are dominant there are also progressive approaches, as the evidence presented in the subsequent chapters will show.

NOTES

1 M. Beissinger, 'Nationalisms that bark and nationalisms that bite: Ernest Gellner and the substantiation of nations', in J. A. Hall (ed.), *The State of the Nation:*

Ernest Gellner and the Theory of Nationalism (Cambridge: Cambridge University Press, 1998).

2 At the time of writing, the Northern Ireland Assembly is suspended and so Northern Ireland is being governed directly from Westminster.

3 M. Billig, *Banal Nationalism* (London: Sage, 1995), p. 5.

4 See, for example, E. H. Carr, *Nationalism and After* (London: Macmillan, 1965); E. Gellner, *Nations and Nationalism* (Oxford: Blackwell, 1983); E. J. Hobsbawm, *Nations and Nationalism Since 1780: Programme, Myth, Reality* (Cambridge: Cambridge University, 1990); and B. Anderson, *Imagined Communities: Reflections on the Origins and Spread of Nationalism* (London: Verso, 1991).

5 A. Smith, *Nations and Nationalism in a Global Era* (Cambridge: Polity Press, 1995), p. 98.

6 Gellner, *Nations and Nationalism*, p. 1.

7 M. Guibernau, *Nationalisms: The Nation-State and Nationalism in the Twentieth Century* (Cambridge: Polity Press, 1996), p. 47.

8 Ibid., p. 101.

9 A. Smith, *National Identity* (London: Penguin, 1991), p. 73.

10 R. Brubaker, 'Myths and misconceptions in the study of nationalism', in Hall, *The State of the Nation*.

11 Anderson, *Imagined Communities*, p. 40.

12 Ibid., p. 38.

13 Ibid., p. 6.

14 Ibid., p. 7.

15 A. Smith, 'The myth of the "Modern Nation" and the myths of nations', *Ethnic and Racial Studies*, 11, 1 (1988), pp. 1–26.

16 W. A. Douglass, 'A critique of recent trends in the analysis of ethnonationalism', *Ethnic and Racial Studies*, 11, 2 (1988), p. 192–206.

17 Smith, *Nations and Nationalism in a Global Era*, p. 9.

18 Smith, 'The myth of the "Modern Nation" and the myths of nations', pp. 9–10.

19 Smith, 'The origins of nations', *Ethnic and Racial Studies*, 12, 3 (1989), p. 344.

20 Ibid., p. 349.

21 Smith, *National Identity*, p. 94.

22 M. Guibernau, *Nations Without States: Political Communities in a Global Age* (Oxford: Polity Press in association with Blackwell, 1999), p. 99.

23 Smith, *National Identity*, p. 91.

24 A. Smith, *Myths and Memories of the Nation* (Oxford: Oxford University Press, 1999).

25 Smith, *National Identity*, p. 11.

26 D. B. Knight (1999), 'Afterword: nested identities—nationalism, territory, and scale', in G. H. Guntram and D. H. Kaplan (eds), *Nested Identities: Nationalism, Territory, and Scale* (Oxford: Rowman and Littlefield, 1999).

27 Ibid., p. 318.

28 Smith, *Nations and Nationalism in a Global Era*, p. 30.

29 A. Smith, 'History and liberty: dilemmas of loyalty in Western democracies', *Ethnic and Racial Studies*, 9, 1 (1986), p. 57.

30 L. Colley, *Britons: Forging the Nation 1707–1837* (London: Vintage, 1996), p. 315.

31 This in terms of the higher birth rate amongst the Catholic population.

32 D. L. Horowitz, *Ethnic Groups in Conflict* (California and London: University of California Press, 1985), p. 178.

33 Ibid., p. 285.

34 Billig, *Banal Nationalism*, p. 15.

35 See, for example, A. Aughey, *Under Siege: The Unionist Response to the Anglo-Irish Agreement* (Belfast: Blackstaff, 1989) and 'Unionism and self-determination', in P. J. Roche and B. Barton, *The Northern Ireland Question: Myth and Reality* (Aldershot: Avebury, 1991).

36 For a discussion of the other two perspectives, see R. Ward, 'Unionist and loyalist women in Northern Ireland: national identity and political action', unpublished PhD thesis (Bristol: UWE, 2003).

37 J. McGarry and B. O'Leary, *Explaining Northern Ireland: Broken Images* (London: Blackwell, 1995), p. 92.

38 L. O'Dowd, 'Coercion, territoriality and the prospects for a negotiated settlement in Ireland', *Political Geography*, 17, 2 (1998), p. 241.

39 Aughey, *Under Siege*, and 'Unionism and self-determination'.

40 Aughey, 'Unionism and self-determination', p. 15.

41 Ibid., p. 9.

42 Ibid., p. 4.

43 McGarry and O'Leary, *Explaining Northern Ireland*.

44 Anderson, *Imagined Communities*.

45 Aughey, *Under Siege*, p. 28.

46 Cochrane, *Unionist Politics and the Politics of Unionism since the Anglo-Irish Agreement*, p. 346.

47 L. O'Dowd, ' "New Unionism", British nationalism and the prospects for a negotiated settlement in Northern Ireland', in D. Miller (ed.), *Rethinking Northern Ireland: Culture, Ideology and Colonialism* (Essex: Addison Wesley Longman, 1998), p. 73.

48 Ibid., p. 80.

49 Cochrane, *Unionist Politics and the Politics of Unionism since the Anglo-Irish Agreement*, p. 39.

50 J. Todd, 'Two traditions in unionist political culture', *Irish Political Studies*, 2 (1987), pp. 1–26.

51 S. Nelson, *Ulster's Uncertain Defenders* (Belfast: Blackstaff, 1984), p. 115.

52 Cochrane, *Unionist Politics and the Politics of Unionism since the Anglo-Irish Agreement*, p. 78.

53 D. Mason, 'Nationalism and the process of group mobilisation: the case of "loyalism" in Northern Ireland reconsidered', *Ethnic and Racial Studies*, 8, 3 (1985), p. 408.

54 Ibid., p. 419.

55 A. Finlayson, 'Nationalism as ideological interpellation: the case of Ulster Loyalism', *Ethnic and Racial Studies*, 19 (1996), p. 89.

56 Ibid., p. 92.

57 In the late 1970s, the UDA was in favour of an independent Northern Ireland.

58 Billig, *Banal Nationalism*, p. 69.

59 Smith, *Nations and Nationalism in a Global Era*, p. 115.

60 R. Leach *British Political Ideologies* (Hemel Hempstead: Prentice Hall, 1996).

61 A. Heywood *Political Ideologies: An Introduction* (Basingstoke: Macmillan, 1998), p. 171.

62 Brubaker, 'Myths and misconceptions in the study of nationalism', in Hall, *The State of the Nation*, p. 277.

63 Anderson, *Imagined Communities*; Billig, *Banal Nationalism*.

64 E. Gellner, 'The coming of nationalism and its interpretation: the myths of nation and class', in G. Balakrishnan (ed.), *Mapping the Nation* (London: Verso, 1996), p. 110.

65 E. Porter, 'Identity, location, plurality: women, nationalism and Northern Ireland', in R. Wilford and R. L. Miller (eds), *Women, Ethnicity and Nationalism: The Politics of Transition* (London: Routledge, 1998), p. 37.

66 N. Yuval-Davis, *Gender and Nation* (London: Sage, 1997), p. 45.

67 M. Ward, *In Their Own Voice: Women and Irish Nationalism* (Dublin: Attic, 1995), pp. 12–13.

68 Quoted in B. Aretxaga, *Shattering Silence* (Princeton, NJ: Princeton University Press, 1997), p. 109.

69 Ibid., p. 110.

70 See I. Paisley Jnr, 'The political career of Dame Dehra Parker', unpublished MSSc thesis (Belfast: Queen's University, 1994).

71 M. K. Meyer, 'Ulster's red hand: gender, identity and sectarian conflict in Northern Ireland', in S. Ranchod-Nilsson and M. A. Tétreault (eds), *Women at Home in the Nation?* (London: Routledge, 2000), p. 120.

72 A popular poem of the time quoted in P. Orr, *The Road to the Somme: Men of the Ulster Division Tell Their Story* (Belfast: Blackstaff Press, 1987).

73 G. Bell, *The Protestants of Ulster* (London: Pluto Press, 1976), p. 53.

74 Ibid.

75 Yuval-Davis, *Gender and Nation*, p. 45.

76 Meyer, 'Ulster's red hand', p. 129.

77 Personal conversation, August 1999.

78 Todd, 'Two traditions in unionist political culture', p. 7.

79 Ibid., pp. 7–8.

80 R. Kearney, *Postnationalist Ireland: Culture, Politics, Philosophy* (London: Routledge, 1997), p. 120.

81 Ibid., p. 118.

82 M. Levinger and P. Franklin Lytle, 'Myth and mobilisation: the triadic structure of nationalist rhetoric', *Nations and Nationalism*, 7, 2 (2001), pp. 177–8.

83 See, for example, W. Bracewell, 'Rape in Kosovo: masculinity and Serbian nationalism', *Nations and Nationalism*, 6, 4 (2000), pp. 563–90.

84 N. Yuval-Davis and F. Anthias, *Woman–Nation–State* (London: Macmillan, 1989), pp. 6–11.

85 R. Ridd, 'Powers of the powerless', in R. Ridd and H. Callaway, *Caught up in Conflict: Women's Responses to Political Strife* (Basingstoke: Macmillan, 1986).

86 Cockburn, *The Space Between Us*.

87 Aretxaga, *Shattering Silence*.

88 Ibid., p. 66. See also L. Edgerton, 'Public protest, domestic acquiescence', in Ridd and Callaway, *Caught up in Conflict*.

89 Yuval-Davis, *Gender and Nation*, p. 24.

90 G. Kaplan, 'Feminism and nationalism: the European case', in L. A. West (ed.), *Feminist Nationalisms* (London: Routledge, 1997), p. 11.

91 Ibid., p. 15.
92 Yuval-Davis, *Gender and Nation*.
93 Ibid., p. 30.
94 Roulston, 'Women on the margin', p. 46.
95 Z. A. Mangaliso, 'Gender and nation building in South Africa', in L. A. West (ed.), *Feminist Nationalisms* (London: Routledge, 1997), p. 132.
96 C. Enloe, *Does Khaki Become You? The Militarization of Women's Lives* (London: Pandora, 1988); and *Bananas, Beaches and Bases: Making Feminist Sense of International Politics* (London: Pandora, 1989).
97 Yuval-Davis, *Gender and Nation*, p. 102

3

Identities

In this chapter, I will demonstrate the different ways that the unionist and loyalist women interviewees employed the labels of identity. The majority (81 per cent) described themselves as British but this label was often used in conjunction with other labels, such as 'unionist' (41 per cent), 'Northern Irish' or 'Ulster' (43 per cent), and 'Irish' (14 per cent). It is therefore interesting to see how identity is prioritised and explained by the respondents. The chapter is split into several sub-sections: 'Shades of Unionism', 'Shades of Loyalism', 'Shades of Protestantism', and 'The Relevance of Gender'. I also draw upon the evidence I gathered during my participant observation, and discuss community identity. The chapter closes with an analysis section in which I consider the evidence of unionist and loyalist women's identities in relation to the literature on gender and nationalism.

The interviews revealed that some women had considered at length their national identity, their position in society, the contribution they make to the politics of Northern Ireland, and their potential to develop this further. The women who had reflected in this way were more willing to ascribe to themselves several labels. They were aware that such labels were interchangeable depending on the circumstance in which they found themselves; in other words, their identities were 'situational'. For example, a respondent noted: 'Sometimes I think I'm a *Protestant republican* and sometimes I think I'm *terribly British*, but *peculiarly Irish*, and then to the reverse. I have no problem with a double identity. If I'm away from home and somebody said 'you're Irish' I would say I am . . . I was born on the island of Ireland and I happen to be a *British citizen*, which I would like to maintain.'[1] There were many examples of 'layering', where the British label would represent one of many layers of identity. One

respondent discussed her maternal, political, religious and national identities. Of the latter she stated: 'I am British but I'm also Northern Irish and British in the same way as I would expect someone from Wales to be Welsh and a member of Great Britain and British. I've no conflict with that. I'm Irish but I'm Northern Irish and I'm also a unionist.'[2] This emphasises the perspective that people in Northern Ireland should be accorded the same national and political status as those in the rest of the United Kingdom. It recognises that there is something distinctive about Northern Ireland and that being British can be an inclusive and unifying identity. Another respondent also revealed a layering of identity when she referred to religious and political labels in addition to her national identity, which was 'as a British subject and I'm Northern Irish'.[3]

A number of respondents focused more on being British in their discussion around the issue of identity. A good example was a woman who went into detail to explain the strength of her feeling:

> I class myself very much as a British citizen. I'm very proud of my British citizenship [and have] no desire whatsoever to travel on an Irish passport. People say, 'But you're Irish.' I say, 'No I'm not, *I live in Northern Ireland but I'm British.*' I love my country, I just wish my country was at peace with itself and that if the people of Northern Ireland don't want to show allegiance to my country, well then they're quite free to leave . . . I think the people of Northern Ireland are a unique people and in that I'm including myself, because . . . in the last war and probably the previous war, the people of Northern Ireland were the first to stand up and say yes we will fight for Britain . . . *Our culture was more the British way of life,* obviously because most of us are descendants from the Scots. I am actually a descendant of England. My grandparents were from Newcastle-upon-Tyne.[4]

This statement is defiant in places and conveys a sense of national, political and familial history, which make for a strongly rooted sense of

national identity. Another respondent spoke about certain instances when her Britishness comes to the fore: 'I get terribly British when I see some things on television like a Remembrance Day parade.'[5]

Being 'British' is an important identity, which may be prioritised over other labels of identity at times. In the subsequent sections, the British label will be referred to in the discussion about some of those other identities. The picture presented by the interview evidence is one of a group that has many differences and disagreements. It is therefore understandable that some have rejected the view that unionism and loyalism are forms of nationalism.[6] The strength of nationalism, however, is its ability to draw a disparate group together in the 'national' interest. Despite intra-group differences, the respondents understand themselves as being an integral part of a British nation.

SHADES OF UNIONISM

What does it mean to be a unionist? Fifteen of the interviewees used this label to identify themselves. Their party or group affiliation was as follows: six from the Ulster Unionist Party (UUP); two each from the Democratic Unionist Party (DUP), Progressive Unionist Party (PUP) and Families Acting for Innocent Relatives (FAIR); and one each from the United Kingdom Unionist Party (UKUP), Northern Ireland Unionist Party (NIUP) and Ulster Democratic Party (UDP). They represent a cross-section of the case study group in terms of class and political persuasion, and therefore it is important to look behind the label to assess what it represents.

Ten of the respondents using the identity label 'unionist' can be viewed as stemming from mainstream unionism, in that their party affiliation was the UUP, DUP, UKUP and NIUP. The politics of the members of these groups can be expected to be liberal and/or conservative and constitutional. For many of these respondents, the label 'unionist' was their political identification and it indicated the national group they were allied with and that they were mobilised to protect the integrity of their national identity. For example, one stated:

> I always say I'm a *British citizen*, I'm proud to be an *Ulsterwoman*
> [adhering to] *Protestant faith* and *unionist culture*. I believe that I
> have my culture and I have a right to that and the nationalists have
> their culture and they have their right to that . . . When I was in
> business, some of my best customers were Roman Catholics. We
> were in the baby business mainly, like a 'Mothercare' type of shop.
> On the first of July, [commemoration of the] Battle of the Somme,
> I would put out my Union flag on the shop. People have far more
> respect for you if they know what you are, and there's no doubt,
> everybody knows exactly what I am.[7]

Here the respondent outlines her liberal credentials by emphasising
the right to culture and that she is not sectarian. She uses the labels
British citizen, Ulsterwoman, Protestant and unionist. While the
latter concerns culture, it is this aspect that she goes on to emphasise,
because it is within the group culture that one finds myths and
rituals, which reinforce a sense of belonging and uniqueness. She
also shows that she is not afraid to wear her national and political
colours on her sleeve.

Another example of 'unionist' being a political label was a
respondent who defined her nationality as British and stated
'politically I would be Ulster Unionist of course but I would not say
I am right wing in any way. I would say I am more right of centre but
maybe more centre, and certainly would be very socially conscious as
well as politically conscious in that I would want everyone in
Northern Ireland regardless of what colour or creed they are to have
the same chances in life.'[8] Again, this statement highlights an
inclusive outlook, a liberal political persuasion, and it also points to
different intra-party attitudes. Another respondent, who described
herself as a 'Christian, unionist, Ulsterwoman', commented: 'As a
unionist, I despair for my country sometimes, but if you're not in you
can't win and you have to keep fighting. I attend all the meetings as I
possibly can unless there's something dreadful that keeps me from
them. I support [the party] in every way.'[9] Here there is a clear link
between political identity and the interests of her country.

Other responses from women with a traditional unionist political background prioritised the identity labels 'unionist' and 'British'. From their perspective, being British meant being a unionist. Iris Robinson (DUP) classes herself as a 'very very strong pro-British unionist, I make no apology for that'. Valerie Kinghan (UKUP) is a 'unionist because my background is British, British-Unionist. Conservative and Unionist Party was the party of the union and it was the party that I had been brought up in.' Maintaining the union with England, Scotland and Wales and defence of identity go hand in hand. This is not to say that their identity is so transient as to be dependent on that union, however. This variety of British nationalism is strongly rooted in Northern Ireland. Concern that the British state is less than enthusiastic about the union has led to the reinforcement of an Ulster identity, which in its extreme form has entertained notions of repartition or even independence.[10] This is not the purview of traditional unionism, however. As Edward Moxon-Browne argues, it is the

> more disadvantaged groups [that] reject a British identity . . . perhaps because Britain is perceived to be acting in a way that is not conducive to the best interests of the Protestant working class. The claim to an 'Ulster' identity may be in protest against what are seen as alien 'English' policies. For the Protestant, national identity is a pragmatic issue.[11]

While an Ulster identity may be prioritised in certain situations, there is also a sense of belonging to the British national community.

The defensive nature of unionist and loyalist identities has imposed itself on the political geography of Northern Ireland, such that the symbols of a 'banal nationalism'[12] take on a heightened significance. The Union Jack and other flags, bunting, the Red Hand of Ulster, images of the monarchy and murals on gable-ends, all combine to demarcate territory to be defended against the 'other'. This need not necessarily be a defence in the physical sense of the word: language and symbolism can represent an 'imagined community'[13]

that perceives itself as an integral part of the British nation, both historically and for the foreseeable future. For the majority of the respondents from traditional unionism, paramilitarism is abhorrent, so mounting a non-combative defence of their status through political action is the best and most honourable way to proceed. One respondent, Sarah Cummings (UUP), was quick to clarify her self-identification as being a 'unionist, definitely, a loyalist, royalist . . . Loyalist not to the extremes of the paramilitaries but loyal to Northern Ireland and the Queen. British, definitely, just in my heritage and the way that I've been brought up.'[14] The meaning of being 'loyal' will be discussed in the subsequent section.

Three of the respondents who used the unionist label are members of political parties at the margins of unionism. They come from an expressly working-class constituency; hence the unionist label is linked with their political outlook. Therefore, unionism should be viewed as an umbrella term encapsulating a wide spectrum of political opinion. Dawn Purvis's (PUP) description of her identity contradicts the claim by Moxon-Browne cited earlier:

> Unionist—that is my background, that is where I come from, pro-British—I am British and I wish to remain that way. It's not just a mental state, it's also an aspiration, a way of life, a culture. I would also be socialist because I come from a poor working class background and I see the injustices and inequalities that exist for working class people. So I would see myself as a socialist unionist or a unionist socialist, whichever way you want to put it.

Again, there is a link made between national and political identity. Pointing to the complexity of national identity in Northern Ireland, another respondent used a number of labels, both political and national: 'I would identify myself as a unionist/loyalist/woman, because that's what I am. I would see myself probably first and foremost as being Irish, Northern Irish, British.'[15] She also rejected the use of a religious label.

Arguably, there is an underlying class divide to the meanings attached to these labels. Indeed, as will become clearer in the next section, some respondents explicitly disavowed the term 'unionist'. For many, 'unionism' bears all the hallmarks of middle-class politics. The antipathy between those who apparently had the same fundamental goal was evident in the interview responses, but the media's tendency to simplify the political conflict as that of 'two communities' unable to live side by side masks the extent of the fissures within unionism.

SHADES OF LOYALISM

Seven of the respondents used the term 'loyal' or 'loyalist' to describe their identity. They were two each from the UUP and UDP, and three from the PUP. The label was used in addition to, prioritised over or used instead of 'unionist'. For some, loyalism appeared, in an unspoken way, to be equated with working-class values, with the terms used interchangeably in the same context. For example: 'I'm a loyalist. I'm from a loyalist working-class community.'[16] One woman made the values attached to the terms clear in her discussion, in which she talked about the difficulty she had with the labels that tended to be attached to her by others:

> Usually I would never use the term unionist, 'I'm a unionist' . . . I think we tend to be labelled as being loyalist . . . it's just a label, it doesn't mean anything to me. I would be a working-class Protestant but not a religious Protestant. I was born and reared in the Shankill and will always be that type of person, a working-class person . . . It depends on where you are, that's the best thing about it, you can pick and choose as well. You know I can say in whatever company that I am Irish, and other people that I work with say, 'You're not Irish', and you can have a good debate about it. Other times you can say you're Northern Irish and other times British, it depends.[17]

Here national identity is clearly situational, and this impression was further developed during the interview with Green and her colleague Marion Jamison. The latter described herself as: 'British but Northern Irish as differentiating from English British. But British, I mean if anybody asked me my nationality, my first thing would be British, so it would.' Green replied: 'I wouldn't be you see—only in extremes, if you felt really insecure somewhere, you know?'

The use of 'loyalist' as shorthand for a person 'loyal' to her country was made explicit by Sarah Cummings (UUP), quoted earlier, and another respondent who distanced the label from its paramilitary connotation by stating:

> I'm a loyalist and that does not mean to say that I come from the back streets of Belfast, an uneducated military/paramilitary connected. What it does mean is that I am loyal to my country and what it stands for, so yes I would be called a unionist, loyalist, Protestant and you can use all three of those, and I don't make any apologies for either.[18]

This was a defensive explanation of what it meant to be a loyalist. May Steele (UUP) used the term in a way that did not require any subsequent justification. She described herself thus: 'Nationally British, very much so British, part of the United Kingdom of Great Britain and Northern Ireland and a *loyal* subject of the Queen.' Similarly, for Lily McIlwaine (UDP), the term was used in connection with the monarchy and the nation:

> I identify myself as a good loyalist. I believe in the crown, I think we should always be run from Westminster as long as we can put our say in there, our spoke. I would not like to see a united Ireland because I think that would be the worse thing that could happen to any of us both Catholic and Protestant. So I am a true loyalist.

Being a loyalist, then, is to be both patriotic and monarchist. Many of the respondents referred to the Queen during their interviews.

Support for the monarchy was indeed widespread; should anyone have doubts about the relevance of hereditary privilege, it is not voiced loudly. In one exceptional case, I was asked whether I had encountered any 'republican loyalists'.[19] This notion is not as contradictory as it at first appears, coming from a woman from a working-class background who voted for the PUP, which professes to have socialist credentials. It could be argued that as a socialist she would not want to support the continuance of the crown. However, the image of the monarch is a British national symbol, and the PUP has a portrait of the Queen hanging in its headquarters on the Shankill Road in Belfast. Cochrane also refers to the Queen's portrait in the PUP's headquarters, and quotes the party activist Billy Hutchinson as saying: 'I'm not loyal to any monarchy. What I'm loyal to is my class and also my political beliefs.'[20] Nevertheless, many people within the 'unionist family' declare their loyalty to Queen and country through such symbolism and flag-flying and also the ritual of standing to sing the national anthem at the end of social and political gatherings.

Loyalism is equated with paramilitarism, so some of the women who declared their identity as loyalist were quick to qualify this with the disclaimer that they did not condone paramilitary violence. Although many of the interviewees were against paramilitarism, other studies have shown certain ambivalence towards political violence. Indeed, 'opinion poll evidence in both communities about support for physical force, while intermittent, tells a remarkably consistent —and shocking—story. The results show that, however the survey question is phrased, significant minorities within each community support the use of violence for political ends.'[21] A few of the women interviewed said that they could understand why some would resort to violence. For example, one respondent stated: 'I always was a loyalist. I always wanted what loyalist paramilitaries would have proclaimed to have wanted. I always wanted the same but I could never agree to violence. I could never have gone along that path although I don't put somebody else down for having done it.[22]

Therefore, she could not condemn those who had the same objectives but had used extra-constitutional methods. A similarly ambivalent statement was: 'Nobody is born a terrorist, nobody is born that way, it was the situation that pulled people in: victims.'[23] For this respondent the paramilitaries were victims of political circumstance.

Gendered demarcation in loyalism is evident in the murals, which generally feature male paramilitaries. A key research question was how unionist and loyalist women reacted to being part of a culture that is so publicly 'male'. It would appear that little thought has been devoted to this issue and that 'things have always been this way'. It *is* their culture, despite the exclusive nature of its symbolism. A good example occurred when Jeanette Warke of the Shared City Project (SCP) treated me to a tour of the various murals in the Waterside, Londonderry. When asked why it was that none of the loyalist murals depict women in any sort of way, she replied: 'You're right! . . . I'd never even thought about that until you said. I don't know why it is.' This question led to the painting of eight murals that address the role of women.[24] Another example was in a discussion about the activities of the Orange Order, the Apprentice Boys and the Royal Black Preceptory, which are either entirely male or male dominated. It was 'just always the done thing that women made the sandwiches and made the tea and watched. I never felt excluded from it.'[25] The question of gender will be discussed later in this chapter.

SHADES OF PROTESTANTISM

The discussion in this section will be around those respondents who explicitly used the label 'Protestant' as part of their identity. While 70 per cent used a religious label in the context of the discussion on identity, which includes those who talked about their religion or church attendance but did not explicitly reflect upon the religious label, there were fifteen respondents (41 per cent) who described themselves as 'Protestants'. Of these, five were from the UUP, two each from the PUP, UDP and DUP, and one each from the

Northern Ireland Women's Coalition (NIWC), SCP, Women's Orange Association of Ireland (WOAI) and EPIC. Therefore, members of different groups and party affiliations use the 'Protestant' label.

When considering national identity in Northern Ireland, it is difficult to avoid religious labels because religion and politics are closely intertwined. While some academics view the situation in Northern Ireland as an 'ethno-national' rather than a religious conflict,[26] others argue that religion cannot be discounted. For example, Duncan Morrow notes that: 'while Church and politics cannot be separated it is also true to say they cannot be elided'.[27] For Steve Bruce, 'Christianity all too easily becomes not just a convenient distinguishing mark for an ethnic group, but a central part of its identity. Conflict, especially with an ethnic group identified by a competing religion, strengthens the religious commitment of all participants.'[28] While the validity of Bruce's contention that religious commitment becomes stronger can be questioned, it would certainly seem that the label 'Protestant' has significance even for those who are not religious. However, some respondents would not use the label. Eileen Ward (PUP) said, 'I'm an atheist, so I wouldn't see myself as being a Protestant.' Marion Green (EPIC) argued, 'I'm not a religious person, so I don't like even saying that I'm a Protestant but then in Northern Ireland, saying you're Protestant doesn't mean what it means in England, you know? You just say it just to identify yourself.' Marion Jamison (PUP), remarked, 'I think here you have to be one or the other don't you, you either have to be a Protestant or a Catholic, or they wonder what's wrong with you.' This shows an understanding of how the label has become politicised.

Religion has a role in the formation of socio-cultural identity. The term 'Protestant' was often used in response to questions about identity. The culture celebrated is 'Protestant culture' in that it is imbued with religious and historical meaning. When stripped of religious connotation, the term appears to be an essentially political one, a means of marking boundaries between one national grouping

and another. Being a Protestant makes a statement about what the individual is not—she is not a Catholic and is therefore perceived as adhering to a different set of values. While this method of identification may seem rather sweeping and simplistic, this again highlights the problem with viewing Northern Ireland politics in black and white, when the reality is many shades of grey.

The use of identity labels in Northern Ireland's political climate was problematic for three respondents from the UUP, who used 'Protestant' as a means of distinguishing themselves. The following is an excerpt from the discussion they had around this subject:

> It gets very complicated here. We sort of see ourselves as British. We're British at the start [Sylvia McRoberts]. But I'm an Ulster Protestant as well [Sharon McClelland]. British but with very much an Ulster Protestant culture [McRoberts]. What's going on here of course is . . . [we] identify ourselves as Ulster Protestants because we're not really allowed to identify ourselves as British. I do feel British but at the same time . . . [McClelland]. Well, you don't call yourself Irish [Olive Whitten]. No . . . I suppose we're Ulster Protestants the same way the Scottish are Scots and the Welsh are Welsh [McClelland].

Here the label 'Protestant' is clearly being used with reference to culture and as a signifier of the group boundary not only from the 'other' within Northern Ireland, but also from others who would consider themselves to be British from outside of Northern Ireland. The statement that they were 'not really allowed to identify ourselves as British' was interesting. It showed a sense of being different within a national identity that is often closely linked to being 'English'.

A number of respondents spoke about the importance of their religious identity. The statements they made varied in strength. For example, one respondent stated: 'I come from a Protestant tradition and my Protestantism is very important to me but it's not something I would carry on my shoulder.'[29] In contrast, another noted: 'I'd be

Protestant and I would hold that strongly . . . I would be against the Roman Catholic system . . . I don't believe in its teachings and I think it's against the will of God.'[30] The difference in attitude here is reflected in their political affiliation, in that the DUP has close links with the Free Presbyterian Church.

For those who are not religious, there is still an acceptance of the religious overtones of the marching season as 'part of my culture'. Hence the influence of religion in the formation of socio-cultural identity. The parades represent much more than a walk from a hall to church and back again, or the commemoration of a historical event. Rather parades are a ritual important for maintaining a sense of community. Although some would not go out of their way to watch an Orange parade, many reported memories of attending 'the Twelfth' with their families, and getting a new outfit for the occasion. Indeed, for many interviewees, Orange marches had become something of a political football, when in the past such events had been 'enjoyed' by the 'whole community' as a family day out. A number of respondents claimed that Catholic friends and neighbours had joined their own families in watching the parades, and so for them, in this context, the 'whole community' comprised Protestants and Catholics alike. Susan Neilly of the Women's Orange Association of Ireland (WOAI) remembered it being 'a carnival atmosphere, which got the community involved. The community all seemed to enjoy it and I mean from *both sides of the community*.' Similarly, a respondent whose father is an Orangeman told me:

> I've always gone along to the Twelfth of July. I know it is a Protestant organisation but *in years gone by everybody came out to celebrate it, Roman Catholics and Protestants, and it was just a general celebration.* But now the residents' groups have set up in these areas where parades went through fine for years . . . and even Catholics feel threatened because they don't mind the parades but they can't come out and say that because of the threat of the IRA.[31]

Irritation was expressed at the media attention on contentious parades, which presented a skewed picture because the vast majority of parades pass off without incident. May Blood (NIWC) referred to this and the media's tendency to over-simplify issues:

> There's over 3,000 marches in Northern Ireland of which about ten are contentious . . . I live on the peace line. Now what we're told by the media is the Orange Order and the residents have to talk. Now that makes the assumption that everybody in the Protestant side is going to talk through the Orange Order. I would be hard pushed to tell you five people in the Orange Order, so I'm not going to have much of a meeting. On the Catholic side it's recognised that if you're not a member of the residents' association, you're not a part of that discussion, so in a way it's disenfranchising a big part of both communities. The media picks up on it. Four or five years ago you wouldn't have heard of residents' groups or meeting the Orange Order. Today that's the big thing.

This respondent had taken a broader perspective and was aware that the 'two communities' comprise many different shades of opinion, which are obscured by media soundbites.

From the interview responses, the development of residents' groups who campaign against marches by the Orange Order, Apprentice Boys and Royal Black Preceptory appears to have precipitated a sense of injustice among even the ambivalent within unionism. When viewing the parades from the perspective of culture and history, attempts by Irish Nationalists and Republicans to prevent the passage of parades becomes a threat to that culture, reinforcing the nationalist sentiment of unionism. One respondent referred to the banners held by the Orangemen and argued that they depicted Bible stories and so could not be seen as offensive. But she conceded that:

> Things have changed as in years ago Roman Catholic people off the Garvaghy Road used to come out and watch the Orangemen

and you wouldn't have had bands in paramilitary uniforms. . . . I wouldn't be in support of them; I don't think ordinary Orangemen would either. In fact, in some of the cases, there's been parades locally and they weren't invited to come. Normally it's by invitation only but sometimes they just invite themselves and it's quite hard to get rid of someone like that with their connections.[32]

Here, then, is an acknowledgement that there is a problematic aspect to the parades from the perspective of the 'other' community, but also a distancing from that element of loyalism.

THE RELEVANCE OF GENDER

The interview question about identity resulted in a variety of responses, of which thirteen referred specifically to their gender identity. These respondents had the following affiliation: four UUP, three PUP, two UDP, and one each from DUP, EPIC, NIUP and WOAI. This section will consider this additional 'layer' of identity, which is important in view of the gendered nature of unionist and loyalist culture. A specific role for 'women' is part of that culture, and this militates against radical change.

The importance of gender identity for the respondents appeared to be generally quite low, with national, political and cultural identities tending to be prioritised. Dawn Purvis (PUP) made this plain while discussing the NIWC. She noted, 'I wouldn't be comfortable in the Women's Coalition for the very reason that I would feel my unionism was being compromised. I'm a unionist first, yes, I'm a woman, but I'm a unionist first.' Arlene Foster (UUP) referred to her colleague May Steele, who 'often says, "I am not a 'woman', I am a member of the Ulster Unionist Party"'. For Purvis there was an acknowledgement of her gender identity but her political identity took precedence, whereas for Steele there was a denial of her gender identity. This highlights a constant refrain from many of the women interviewed, which was that they were unionist or loyalists first and

women second. For some, such as Steele, to be identified as a woman was perceived as a sign of weakness. In contrast, another respondent argued: 'I'm not a second-class Englishwoman or a third-class Irishwoman. I'm a first-class Ulsterwoman.'[33] This strong statement connects national and gender identity. Rather than denying the latter, this respondent argued that being a woman made no real difference to her political convictions.

Three other respondents described themselves as Ulsterwomen, one from the UDP and two from the UUP. The use of the label 'Ulsterwoman' could be a means of reclaiming a place in the political and cultural lexicon. More negatively, however, it could be seen as a sign of a contradictory position of claiming that there is no difference between them and their male colleagues, but accepting the roles assigned by society. There is certainly evidence of prevailing attitudes that contribute to women's ongoing marginal position. One respondent noted:

> Mr Paisley has been known to say, 'Go home and breed for your country', which has always been his outcry, which is sad. It just goes to show how historically ancient he is . . . I think at that stage, women were discovering the pill . . . so of course the level of reproduction was dropping . . . His mind set is Catholics were always going to have big families . . . and that's what brought these speeches out, the fear of being overrun.[34]

More recently, this respondent had become exasperated by her experience of canvassing, where women either did not vote or voted the way their husbands did. In this she was not alone, judging by the comments of other respondents and also DUP Assembly Members Jim Wells and William Hay.[35] In addition, church ministers had been known to try to influence the political decisions of their congregations. For example, a respondent 'was at a parade and church service, and the minister more or less got up and told us we couldn't think for ourselves about the [Belfast] Agreement! I was

flabbergasted! I said to the women . . . "How dare he assume that I cannot think for myself!" It's unbelievable the way men behave in Northern Ireland.'[36] This shows that there are men in positions of influence who view women as politically naïve and therefore in need of guidance. The prevailing patriarchal attitude, which some women appear to accept or be resigned to, must be seen in the broader context of a political agenda dominated by competing nationalisms. This will be discussed at greater length in Chapter 5.

An apparently contradictory position came from a respondent who saw her identity as 'Christian, unionist, Ulsterwoman . . . politically as a unionist I would support the party . . . being an Ulsterwoman, well I'm a big family person and I keep my family together. Mothers should stay at home if possible—I did it for five years until my two sons grew up, before I went back to teaching.'[37] Here there is an acceptance of the established gender role for women. This respondent went on to say that she is 'always fighting for women's rights'. She would be classed among the 'pro-women non-feminists who wish to defend and develop women's sphere of activity' who are found between feminism and anti-feminism.[38] Three of the respondents who referred specifically to a gender identity did so with regard to their maternal role. For example, one said, 'I see myself as a mother and a grandmother. Other than that I don't see myself as anything special.'[39] Another identified herself as a 'grandmother first of all',[40] while a third prioritised her political identity over her identity as a 'mother and grandmother'.[41] The maternal role is important in unionist and loyalist culture, but it does have an impact on the political visibility of women.

REFLECTIONS ON COMMUNITY IDENTITY

So far the discussion in this chapter has focused upon the layers of national, regional, religious and gender identities expressed by the respondents. There is another layer at the root of these explicitly

stated identities, and that is a community of local identity. Within close-knit local communities, the importance of family, friends and neighbours can be understood within a wider context of the nation, in that the defence of the latter equates with defending the interests of the former. However, the intensity of local identities can also lead to intra-community rivalry.

In order to convey the strength of feeling attached to identities and the community activities that help to develop and reinforce them, the following is a portrait of time spent as a researcher in a more informal capacity. This gave the opportunity to observe and take part in the normal course of events in the unionist and loyalist community, which is not apparent from the interview process.

While the Orange Order may see itself as a Christian organisation simply going on a parade from the church back to the hall in celebration of its culture, to the Catholic and nationalist onlooker it represents an exercise in triumphalism. Some of the bands that accompany parades have loyalist paramilitary insignia and are known as 'blood and thunder' bands. Some of those who watch and follow the parades, getting drunk while they do so, may become involved in altercations with the police or members of the nationalist community. One respondent reflected upon this point:

> Somewhere Protestantism got contorted and mutated as a reaction to republicanism. But there are many things within Protestantism to celebrate. What it should be and could be in any other non-sectarian entrenched culture, is the most wonderful pageant and colourful cultural reservoir, if they could cut out the sectarianism, the anti-Catholicism, the lager louts, the 'kick the Pope' bands and this demand to walk places where they're not welcome.[42]

In an attempt to curtail this element, a community meeting was held in Donegall Pass, a loyalist area in South Belfast, at the end of June 1999. Contrary to the stereotype of the passive woman, the noises made by women at the meeting sounded much more militant.

The meeting aimed to urge the community to exercise restraint, because in previous years confrontations with the Royal Ulster Constabulary (RUC)[43] had left the area 'looking like Beirut'. The organisers wanted to consult with the Orange Order to see how they were going to keep the march under control and then liaise with the RUC to try to arrange minimal policing. One woman argued: 'You're going to make us sound like Gerard Rice [Sinn Féin spokesperson from the nearby Lower Ormeau Road], wanting the Orangemen to ask our permission before they can walk down here—we *want* them to come down here!' Some of the women at the meeting were responsible for putting 'orange footprints' on the Lower Ormeau Road before the Twelfth of July, by way of a protest at the decision of the Parades Commission to re-route the parade.

The coming together of community is evident for the observer of the activities during the Eleventh Night and the Twelfth Day. The residents of Donegall Pass get very much into the spirit of the occasion. In the lead-up to it, the whole area is decked out in flags and bunting. The bonfire is assembled from pallets, tyres, unwanted furniture and carpets, and so on, and is jealously guarded by local teenagers, who sleep out beside it in the build-up to the Eleventh Night to protect the material accumulated for burning. Donegall Pass could boast the biggest bonfire in Belfast, and was able to make a political statement with it by attaching a large tricolour[44] with the words 'These are the colours of the Parades Commission' written on it. This was in reference to the decision not to allow Orangemen to march all the way down the Ormeau Road in Belfast, nor down the Garvaghy Road in Portadown.

On the afternoon of the eleventh, the road was closed off and there was a street party for the children. The evening was spent in the local bar, there was a man playing the bagpipes, and then at midnight fireworks were let off and the bonfire was lit. The residents gathered round the bonfire to have a drink and talk with friends. The heat from the fire was intense, and this was reflected in the mood of a couple of women who started fighting each other. In the early hours

of that morning, news was received that the UDA had attacked UVF
and PUP homes. It was difficult to understand that such a thing
could happen on a night so special for the community. The reason
was 'because they think they're the best, but we're the best'.[45] This is
in reference to the intra-community feuding between the UDA and
the UVF. The PUP is the political wing of the UVF, and Donegall
Pass is UVF territory.

The following morning the community members took their place
as either part of the parade or lined the route as spectators. Some
followed the parade to 'the Field'. Large numbers of women and
children had turned out to watch. A loyalist band stall was selling
babies' bibs with 'Born to shit on the Garvaghy Road' and 'Proud to
be a baby Prod' emblazoned on them. For the older children there
were band-sticks for twirling and throwing in the air, toy drums, flags
and so on, to keep them amused. The parade itself was not entirely
male dominated. Two women's Orange lodges were marching and
there were women in colour parties, accordion bands, and in some of
the presumably smaller men's lodges, women were walking with
them. There were also many children, boys and girls, walking in the
parade. On the way to 'the Field', the parade was very orderly and
dignified. On the way back it was less so and many of the bands had
adopted 'fancy dress', such as Viking helmets. It left the impression
that the Twelfth Day is very much more than an Orange parade. For
those involved and watching it is a celebration of unionist and
loyalist culture in which the whole community can take part.

Another important day in the 'marching season' is that of the
Apprentice Boys on the Fourteenth of August, when there is a
parade to commemorate the relief of Derry in 1689. This parade is
the culmination of a week of activities in the Maiden City Festival.
Catherine Cook (PUP and PRG) referred to the Apprentice Boys
when she talked about parades:

> I am what I am and I make no apologies to anybody for it. First
> and foremost I do believe that parades are a part of my culture, my

identity, some people on this island think that it's the whole picture, but it's not. In relation to parades it is very male orientated . . . I've asked the Apprentice Boys why we don't have a women's section, like the Orange Order have, but they say there's no Apprentice Girls, just Apprentice Boys. A lot of the bands are very mixed, both male and female.

As with the Twelfth of July, the Maiden City Festival and Apprentice Boys parade are a focus for community identity. One of the events was an Ulster Scots folk night in the Memorial Hall, Londonderry, which had several groups playing and finished with everyone singing songs such as 'The Sash My Father Wore' and 'Derry's Walls'.

This represents a snapshot of life within certain parts of the unionist family and reveals the intensity of feeling linked to community identities. It suggests that national identity, community culture and gender are closely linked, with women being defensive of their community and the sense of annual parades being a family occasion.

ANALYSIS

The evidence presented in this chapter shows that the identities of unionist and loyalist women are not fixed, and that they are informed by nation, culture, class background and gender. Their identities are constructed within a political context of competing nationalisms. National identity is important for the respondents, and other identities can be seen in a nationalist context. The empirical evidence has shown that the women interviewees described their national identity through using labels that had different connotations and were differently prioritised. Hence the national identities of unionists and loyalists are complex, have a gender element to them and are influenced by gender stereotypes.

It is hardly surprising that the interviews revealed a variety of identities, from national and regional through to religious and

gender, held in differing combinations, with the latter two often informing the former. Women and men are equally receptive to nationalist rhetoric. Indeed, the 'banal reminders of the homeliness of the homeland' are not just addressed to, and tacitly absorbed by, men. The daily deixis of the homeland crosses the divides of gender. '"We" are all daily reminded that "we" are "here", living at home in "our" precious homeland.'[46] However, while men 'may be called upon to sacrifice their bodies', women must 'prepare themselves to sacrifice their sons and husbands'.[47] Hence, although the respondents identify themselves in part in terms of their national identity, there is an underlying gendered understanding of how they are positioned by that identity within the national project.

An interesting pattern in the respondents' discussions of their identities is revealed if they are divided by attitude towards the Belfast Agreement (1998). Of the thirty-seven interviewees, thirteen were either against or expressed concern about the Agreement. They were five DUP, three UUP, two FAIR, and one each from NIUP, UKUP and WOAI. The twenty-four who were in favour were seven UUP, four PUP, three UDP, two each from NIWC and EPIC, and one each from SCP, Alliance Party of Northern Ireland (APNI), WOAI, FAIR, PRG and SSTG. Those who were anti-Agreement described themselves, in each case, as British. For some, this was combined with another identity label, such as unionist, Northern Irish or Protestant. While other labels were used, such as gender-specific ones, these appeared secondary to national identity. In contrast, the pro-Agreement respondents did not describe themselves as British in every case. Here there is a much broader spread of identity labels, suggesting that there is a greater incidence of layering of identity in this group. Eleven respondents described themselves in terms of a gender identity compared to three in the anti-Agreement group.

The difference in identity patterns can be related to the differences in the perception of threat to the existence of the British unionist community in Northern Ireland. The Agreement enshrines

human rights that take account of identity differences. Although
within the pro–Agreement group, in particular, national identity is
not the only way the respondents defined themselves, it is clearly the
most significant form of identity. In Northern Ireland, where
nationalisms compete, such daily reminders take on a heightened
significance. The fears of those who feel threatened by the 'other'
regarding what the future will hold for them can be understood when
one considers the perspective of Maja Korać, who was a citizen of
Yugoslavia. Although this is a different and more extreme political
situation it does have some currency. She relates that the 'emergence
of ethnic-nationalism and the disintegration of a familiar social space
meant the destruction of the markers [note deleted] which played an
important role in locating myself. This destruction disrupted my
own sense of belonging and radically displaced me.'[48] This points to
the importance of national identity for the individual and explains
why those who feel it to be at risk emphasise this aspect of their
overall identity. The notion that Northern Ireland could one day be
no longer part of the United Kingdom represents a threat to the social
space and the markers that unionists employ to locate themselves.

The literature on unionist nationalism indicates that it is not
monolithic. Todd contends that there are Ulster British and Ulster
Loyalists, while Cochrane uses a three-fold typology: integrationist,
devolutionist and separatist.[49] The interviews with women unionists
and loyalists suggest a blurring of these distinctions. Some of those
expected to be located firmly in the Ulster Loyalist group or perhaps
standing in Cochrane's separatist camp describe themselves as
British unionists. In all but a few cases the British identity was
important. The layering of identity that was evident indicated that
the women held a specific idea of their Britishness. Some also
ascribed to an Irish identity and felt that this was being denied to
them. To call themselves British is brought into question by adherents
of both Irish nationalism and the metropolitan idea of Britishness.
To call themselves Irish puts at risk their precarious British identity.
The Ulster or Northern Irish layer of their identity adds a regional

particularism, a possessiveness of territory held under the British constitution.

The identities of unionist women may be situational, and multiple labels can be employed that are not mutually exclusive. Social attitudes surveys that include questions about national identity show a small percentage of the population who identify themselves as 'Northern Irish', or 'Ulster'. Moxon-Browne has noted that Protestants have inclined more towards a British identity since the outbreak of 'the Troubles'.[50] However, John Curtice and Tony Gallagher contend that 'neither community is *united* around either national identity: around a quarter of Protestants say they are either "Ulster" or "Northern Irish" suggesting that perhaps for them Northern Ireland is something of a separate society'.[51] An alternative explanation is that the question 'Which of these best describes the way you usually think of yourself: British, Irish, Ulster or Northern Irish?' is too crude, and that instead the wider population also holds multiple and situational identities. These identities are masked by an either/or approach, which amounts to an over-simplification of the reality of national allegiance. Therefore, while the evidence provided here was derived from utilising a qualitative method, the findings are not necessarily so very far removed from the wider population.

National identity shapes history for a nationalist agenda. It is maintained by the notion that the national community has a historical basis and that the members are different from non-members. This helps to sustain boundaries that are also reinforced by symbolism, ritual behaviour, stereotyped ideas of the behaviour patterns of outsiders, and particular use of language that insiders will understand. Symbols, rituals and in-group cognisance are part of the culture of the national community. Indeed, the 'community of culture and unity of meaning are the main sources that allow the construction and experience of national identity. As a collective sentiment, national identity needs to be upheld and reaffirmed at regular intervals. Ritual plays a crucial role here.'[52] Furthermore, individuals are loyal to their national identity because of the culture

that is 'embedded' in the 'socio-historical context' of the nation, and through which it is 'produced, transmitted and received'.[53] Hence the significance of annual parades in which many of the respondents took part, even though the majority were spectators rather than active participants. The importance of the occasion in terms of it bringing together the community, family and friends reinforces a sense of belonging.

The perceived political and cultural distinctiveness of the group acts to ground the identities of the individuals within the group. One respondent talked about the importance of culture:

> Culture is not just what you aspire to, it's what you've grown up with, it has many different facets, *it affects your way of life*. From street games you play as a child, story-telling, song, dance . . . There's another aspect of culture . . . Ulster-Scots . . . the fifes, the drums, the dance, the pipes—that's a part of my culture that was lost to me in the early 1970s and that people are slowly rediscovering now and are starting to celebrate a bit more. There's Orange culture . . . Apprentice Boys culture . . . bands, that's all part of my culture and it's all something that I would celebrate. Irishness is part of my culture too—I like Irish dancing, I like watching it.[54]

This statement points to the culture of a group acting as a device through which the individual understands who she is. Music, dance and stories, both historical and mythical, help to mark the boundaries of the 'imagined community' for which its members may be mobilised to make sacrifices, which in turn reinforces group identity. Having family members in the political parties, Loyal Orders and bands, and going to watch the parades are cultural layers that build up leading to an understanding of self and a sense of identity grounded in the national community.

Stereotypical ideas of in- and out-group behaviour are formed as part of the national imagining. Anderson described the nation as an 'imagined political community—and imagined as both inherently

limited and sovereign'.[55] Billig follows Anderson and argues that the 'imagining of "our" community involves imagining, either implicitly or explicitly, "them", from whom "we" are distinct'.[56] The evidence shows that the women are cognisant of a real or imagined difference in actions and attitudes with regard to the 'other' community. They hold a stereotyped view of how the other behaves and the type of occupation they engage in. It was not appropriate for unionist women to make a public display of their grief by following funerals, a point made by Sylvia McRoberts (UUP); rather this was something that belonged to the private sphere. Unionists were more likely to be farmers than journalists and hence they were not so good at putting their own perspective into the public sphere. Such views contribute to an imagined community boundary, within which those sharing the same national identity are situated.

The formation and maintenance of national identity occurs in both informal and formal contexts. In the latter, the role of religion and education can be significant because '[c]hurches, and their related school systems, have been powerful transmitters of nationality from one generation to the next in the nations of the British Isles'.[57] The role of women is important in the informal context as they are engaged in boundary reproduction, through societal notions of appropriate sexual and procreative behaviour, and ideological reproduction, through being the primary carers of children and transmitting the attributes of the national culture. Women also symbolise national difference.[58]

The sacrifice of the mother giving her sons to defend the nation is played out symbolically in songs, poetry and national art. For Billig, national '[i]ntegrity is frequently conveyed by metaphors of kinship and gender: the nation is the "family" living in the "motherland" or "fatherland"'.[59] Although women in the national project are often viewed as acting in a stereotypically passive way or filling powerless roles, this has not led to an upsurge of feminist activism. National identities are often prioritised over other identities in a political context of heightened nationalist tension. Also, there may be an

element of complicity in the prescribed gender roles. As Yuval-Davis and Anthias contend, 'the roles that women play are not merely imposed upon them. Women actively participate in the process of reproducing and modifying their roles as well as being actively involved in controlling other women.'[60]

National identity, then, is formed and maintained in the historical and social context of the nation, in which the self and the other are imagined to have specific positive or negative attributes. The national culture to which members of the nation attach their loyalty is transmitted both formally and informally, and women, in their role as boundary and ideology reproducers, are engaged in the latter.

References made by some of the respondents to being a mother or a family person are bounded within a personal history, of growing up and learning the cultural attributes of the community in the private and public spheres. Being an 'Ulsterwoman' declares a community boundary. Family and social background is important, as it is here that an individual begins to learn about national culture and hence the context for the political interests of the group. There is therefore an instrumentalism in the construction of national identity as it has important political implications and ensures the ongoing cohesion of the group. While family and social background rooted in a particular national tradition does not mean that national affiliation and concomitant identity is guaranteed, the influence it has in the formation of identity is significant.

Use of the label 'Ulsterwoman' could be a means of raising the political profile of the women. Songs and poems appeal to the 'men of Ulster' and any allusion to the female is in a passive capacity, symbolising the territory to be defended. Combined with political murals depicting mainly male loyalist paramilitaries, the place of women is obscured. Therefore, there are few positive forms of reference to unionist and loyalist women in the cultural and political lexicon of Northern Ireland.

The interview question asking how the respondents identified themselves elicited a variety of responses, but the most significant

form of identity was national identity. This is understandable in a political context of clashing nationalisms. In the next chapter, I turn to discuss the evidence of how nationalism acts as a motivator to political action.

NOTES

1 My emphasis. Mina Wardle, Progressive Unionist Party (PUP) and Shankill Stress and Trauma Group (SSTG).
2 Joan Carson, Ulster Unionist Party (UUP).
3 Anonymous, Democratic Unionist Party (DUP).
4 My emphasis. Myreve Chambers, DUP.
5 Mina Wardle, PUP and SSTG.
6 See, for example, A. Aughey, 'Unionism and self-determination', in P. J. Roche and B. Barton, *The Northern Ireland Question* (Aldershot: Avebury, 1991).
7 My emphasis. Pauline Armitage, UUP.
8 May Steele, UUP.
9 Irene Cree, UUP and Ulster Women's Unionist Council (UWUC).
10 J. Todd, 'Two traditions in unionist political culture', *Irish Political Studies*, 2 (1987), pp. 1–26; and F. Cochrane, *Unionist Politics and the Politics of Unionism since the Anglo-Irish Agreement* (Cork: Cork University Press, 1997).
11 E. Moxon-Browne, 'National identity in Northern Ireland', in P. Stringer and G. Robinson (eds), *Social Attitudes in Northern Ireland* (Belfast: Blackstaff, 1991), p. 28.
12 M. Billig, *Banal Nationalism* (London: Sage, 1995).
13 B. Anderson, *Imagined Communities* (London: Verso, 1991).
14 Sarah Cummings, UUP.
15 Eileen Ward, PUP.
16 Catherine Cook, PUP and Peace and Reconciliation Group (PRG).
17 Marion Green, Ex-Prisoners Interpretative Centre (EPIC).
18 Joy Fulton-Challis, UDP.
19 This question came from Marion Green, EPIC.
20 Cochrane, *Unionist Politics and the Politics of Unionism since the Anglo-Irish Agreement*, p. 57.
21 B. Hayes and I. McAllister, 'Sowing dragon's teeth: public support for political violence and paramilitarism in Northern Ireland', *Political Studies Association UK, 50th Annual Conference* (2000), p. 14.
22 Joan Crothers, PUP and EPIC.
23 Lily McIlwaine, UDP.
24 Personal conversation with Jeanette Warke, August 2000.
25 Dawn Purvis, PUP.
26 For example, J. McGarry and B. O'Leary, *Explaining Northern Ireland* (Oxford: Blackwell, 1995).
27 D. Morrow, 'Suffering for righteousness' sake? Fundamentalist Protestantism and Ulster politics', in P. Shirlow and M. McGovern (eds), *Who are 'The People'?*

Unionism, Protestantism and Loyalism in Northern Ireland (London: Pluto Press, 1997), p. 57.
28 S. Bruce, *The Edge of the Union* (Oxford: Oxford University Press), p. 26.
29 May Blood, NIWC.
30 Ruth Allen, DUP.
31 My emphasis. Sarah Cummings, UUP.
32 Ruth Allen, DUP.
33 Joy Fulton-Challis, UDP.
34 Norma Coulter, UDP.
35 Personal conversation, April 1999.
36 Norma Coulter, UDP.
37 Irene Cree, UUP and UWUC.
38 S. Walby, *Gender Transformations* (London: Routledge, 1997), p. 154.
39 Susan Neilly, WOAI.
40 Joan Carson, UUP.
41 May Beattie, DUP.
42 Olwyn Montgomery, PUP.
43 The RUC was renamed the Police Service of Northern Ireland (PSNI) in 2000, further to the recommendations made in the Patten Commission report of 1999.
44 The tricolour is the flag of the Republic of Ireland.
45 Personal conversation with a resident of Donegall Pass.
46 Billig, *Banal Nationalism*, p. 126.
47 Ibid.
48 M. Korać, 'Understanding ethnic-national identity and its meaning: questions from women's experience', *Women's Studies International Forum*, 19, 1/2 (1996), p. 134.
49 Todd, 'Two traditions in unionist political culture'; and Cochrane, *Unionist Politics and the Politics of Unionism since the Anglo-Irish Agreement*.
50 E. Moxon-Browne, *Nation, Class and Creed in Northern Ireland* (Aldershot: Avebury, 1983), p. 6.
51 J. Curtice and T. Gallagher 'The Northern Irish dimension', in R. Jowell, S. Witherspoon and L. Brook (eds), *British Social Attitudes: The 7th Report* (England: Gower, 1990), p. 198.
52 M. Guibernau, *Nationalisms* (Cambridge: Polity Press), p. 73.
53 Ibid., p. 79.
54 My emphasis. Dawn Purvis, PUP.
55 Anderson, *Imagined Communities*, p. 6.
56 Billig, *Banal Nationalism*, p. 66.
57 J. G. Kellas, *The Politics of Nationalism and Ethnicity* (London: Macmillan, 1998), p. 20.
58 N. Yuval-Davis and F. Anthias, *Woman-Nation-State* (London: Macmillan, 1989).
59 Billig, *Banal Nationalism*, p. 71.
60 Yuval-Davis and Anthias, *Woman-Nation-State*, p. 11.

Motivations

The 'mobilisational' character of nationalism,[1] employs gendered myth, symbolism and rhetoric to appeal to members of the national group. This feeds into the national identity of individuals; identification with a national community is a precondition for political activity on its behalf. Having considered the identities of the women respondents in the previous chapter, this chapter presents evidence of the motivational effect of nationalism on the case study group.

In order to ascertain how and why the respondents became politically active, they were asked what had motivated them to get involved in their party and/or organisation. This question often prompted some details from the respondents' personal histories. Analysis of these responses revealed that the respondents fall into four motivational categories, which will be outlined in order of significance.

The first motivational category is 'nationalism', into which, I argue, all the respondents fall. As members of a national group in political conflict, the women's motivation to political action must be seen in this context. Indeed the other three motivational categories are also informed by nationalism. The overarching nationalism category is an 'expressive'[2] impulse to participation, in that it involves expressing nationalist or patriotic fervour. Analysis and discussion of the interview evidence will show that nationalism is a significant motivator to political action in a society where nationalisms are in conflict, and that other agendas are sidelined. Paradoxically, however, it will also demonstrate that nationalism can act to inhibit the political participation of women.

The second motivational category is 'family and/or social background', into which twenty-three of the respondents fell. Many referred to their upbringing or their community as being a formative

influence in their political convictions and, for some, this meant that their political awareness and subsequent activism was a 'foregone conclusion'. Arguably, family and/or social background will have influenced all the respondents to a certain extent, as it is a crucial source of their sense of national identity and where the 'rules' of community membership are learnt, so outsiders are instantly recognisable. Hence it can be viewed as a 'communitarian' impulse.[3] However, those included in this category placed particular emphasis on their background in response to the question on motivation.

The third motivational category is 'dissatisfaction with politicians and/or the policies of political parties'. Eight respondents indicated that they had felt disenfranchised by the rhetoric of established politicians and parties. A sense of frustration with this had resulted in them becoming more politically active in their own right. The 'dissatisfaction' category spurs the individual on to act in her own right rather than relying on others to safeguard her national identity. Hence it can be viewed as an 'educative' impulse.[4]

The fourth motivational category is the 'direct or indirect effect of "the Troubles"'. The six respondents included in this category related life-stories that placed particular emphasis on a conflict-related event that led to the development of their political awareness. This will have acted as a trigger that made the individual realise that she needs to take political action to protect her national identity. Hence it can be viewed as an 'instrumental' impulse.[5]

In this chapter I will expand upon each of the motivational categories to explain why the respondents were motivated into becoming politically active. I will consider whether there is a pattern to the motivation by examining the extent to which different groups of women within the case study fall into particular categories.

NATIONALISM

At the root of the respondents' political activism is their nationalism. Background, dissatisfaction and the effect of the conflict are

connected to and reinforce nationalism and national identity. This is
expressed through feelings and a sense of responsibility towards the
next generation of the national community, a sense of belonging,
notions of cultural distinctiveness, perceptions of being under threat
from the 'other', and allusions to defence of the status of the
community. The section shows that élites utilise these feelings and
perceptions. It is in the political interest of the group to maintain
their status. The sense of belonging engendered through being part
of the group, the psychological interests, become bound up with the
group's political interests. Maintenance of culture and traditions is a
means of ensuring a coherent national identity, which is important if
the political interests of the group are to be protected.

There was evident dissatisfaction about how the respondents'
'nation' is perceived by outsiders from the nationalist community and
by the media. One respondent referred to differences in group
attributes. Her view is clearly informed by underlying stereotypes of
what 'type' of people the 'other' are:

> We are the engineers and the farmers and the entrepreneurs in the
> country whereas the nationalist people would be more inclined to
> the arts, acting, writing songs, singing, etc and can put their story
> over better than us, can talk better than us. But I think we're
> learning though. Over the years the Ulster people would be more
> 'thick' in their attitude in that they did not express themselves as
> well as they might do in that way and they didn't court the press
> and the media, which was very wrong of us. A lot of the
> nationalist people would go into the like of the media and our
> people wouldn't—they would think 'that's not a proper job, you
> go out and till the soil or tend the cattle or build ships'. So it's very
> much cultural difference.[6]

From this perspective, the reticence of the unionist community had
allowed the 'other' to win the media war, resulting in attacks on their
understanding of themselves. This perception was clear from the

reactive and defensive style of the respondents' statements. For another woman, even public acts of benign intent could be twisted against her community. She talked about the 'Long March' in 1999 prior to the Drumcree parade, describing it as:

> dignified, there were no flags or emblems, it was just to draw attention again to victims that have been neglected and forgot about, and the like of IRA and terrorists and prisoners getting everything . . . [The media] only want to portray us in a bad light. The other side seem to get whatever they want, when they want and it's frustrating to say the least.[7]

At least one respondent had been mobilised in part due to the realisation that the media portrayal of unionism was having an adverse effect on her community. Mina Wardle (Progressive Unionist Party/Shankill Stress and Trauma Group—PUP/SSTG) and her family had been:

> threatened out of our house one night so we came back to the Shankill . . . Going back made me realise how much more was needed to be done with the community because it seemed to have lost values and we're so easily influenced by television and the media . . . [Now] we're teaching our children and our adults the real story of the Battle of the Boyne, the real story of the Irish famine and things that we never had an opportunity to discuss before.

A number of respondents spoke about the perceived differences between their community and the 'other'. One believed, for example, of the 'Roman Catholic[s], there's quite a few of them not working. If those ones down on Garvaghy [Road] would get jobs, but you see they get plenty of allowances, it's better being able to lie in your bed than having to get up and go to work'.[8] Similarly, another stated, 'as Protestants we were brought up that this is our country, we had to work hard, we had to make the country and that's just how it is. I hate to say it but maybe the other side are just takers. I get very annoyed too when

the Dublin government has so much input into Northern Ireland.'⁹
Both these respondents view the 'other' community as work-shy.
Taking a different approach, another respondent talked about how her
community was perceived by outsiders:

> Unionist culture, particularly with parades and marches, comes
> across as being very sectarian and triumphalist and dominant. It's
> seen as an act of unionist domination—you know, we must march
> here because we have to trample these people down, and that's not
> what it's about at all. I can reverse that completely and say it's not
> a case of unionist dominance, it's a case of these people are trying
> to remove another facet of unionist culture, they're not showing
> any tolerance, they don't have any respect for unionist or
> Protestant culture, and they themselves—the nationalist and
> republican communities—are creating self-imposed apartheid.¹⁰

This shows the realisation that the way unionism is perceived by
those outside of the community is having an adverse effect on the
status of the group. In campaigning against the parades, the 'other'
is viewed as representing a threat to culture. Iris Robinson
(Democratic Unionist Party—DUP) referred to this when talking
about the Orange Order: 'From the first Drumcree stand-off they
were inundated with new recruits wanting to join. I think it really hit
a blow to the heart of the Protestant people and it was a great rallying
call for new membership who simply like myself saw our whole
culture and religious identity being put at risk.' Another respondent
described the sense of threat in much stronger terms:

> War was declared on me and all my people and we could not be
> helped by a weak government and a police force that could not
> protect its own people so basically the people had to protect
> themselves. They were being bombed, butchered and slaughtered
> because of what we believed in, because of our culture and our
> identity and being told that we're Protestants and we don't belong
> here, which is absolute nonsense . . . What the people of Ulster

have gone through is ethnic cleansing. We have been victims of apartheid in our own country, which is an absolute disgrace . . . We didn't have the voice there to say what's been going on.[11]

These statements have shown that the respondents hold distinct ideas about what it means to be a member of their group and who it is that threatens them. While some ideas about the latter are open to disagreement, they contribute to group boundaries. Boundaries in Northern Ireland are both mental and physical, as one respondent outlined:

Up until I was about 10 years old, I never went out of the area, I didn't know who lived on the other side of Donegall Pass, because you stayed within your own couple of streets . . . I didn't know what a Catholic was—I knew it was somebody bad and I was told that their eyes were close together and if you looked closely enough you could see horns growing out of their head. I met a Catholic girl when I was 17, that was the first Catholic I had ever met, and she wondered why I was looking at her head. She said to me, 'What are you looking at?' and I said, 'My mummy told me that youse have horns.' That gives you an example of how parochial Northern Ireland is, how ghettoised it is.[12]

Again, there is the influence of the mother in establishing group boundaries here.

Self-interest of the individual within the group was revealed in a statement made by an interviewee who talked about the approach taken by some of the women within unionism to important political issues:

The Good Friday Agreement and everything that stems from that—I suppose we would tend to look at it as 'Where are we going from here?' and 'What are the structures going to be in five years' time?' Women are probably looking at that much more from the family point of view. The men in politics are perhaps to a great

extent looking at that from the setting up of the structures, but we would be looking at it from the point of view of our jobs, our families and what the structures here are going to be and how it will affect us personally.[13]

This indicates an instrumental approach. There is also an element of instrumentalism behind the felt maternal responsibilities and fear for the next generation, which was evident in a number of respondents' statements. For example:

I definitely don't want a united Ireland. I was at a meeting in the Orange Hall and it was Willie Ross,[14] it was the time of the [Belfast] Agreement. He says, 'It's not my grandchildren that I fear for but my great-grandchildren.' So I have two grand-children, one's over in England and one's here. It's the future that I worry about for him. What is it going to be like in the future? My oldest boy was born in '69 and he has known nothing other than trouble and my second boy as well. And now my grandson's coming along and it's just going to be the same. There doesn't seem to be any difference now than there was then.[15]

Another respondent noted, 'I have four reasons for being here in politics, I have four granddaughters, and I don't want to have to go through what my family went through when they were born. I want a better lifestyle for them and freedom from the fear of violence.'[16] While another talked about her fears of the 'other' and the potential long-term effect. 'I don't care for myself but for the next generation. If you anger the republican community, they have long memories— as Gerry Adams says, "They haven't gone away, you know." They're regrouping, they're re-arming, we're not, we're trying to live a normal life and they don't like that.'[17]

One interviewee made a comment that highlighted the influence the older generation has in instilling fears of the 'other' in the children of the community during their socialisation. This influence ensures the maintenance of community boundaries.

My granddaughter at 12 turns around to me just before the school, 'Nanny, we're getting a new school this year, will it be a Sinn Féiner coming to open it?' 'No dear, it will be Sinn Féin/IRA coming to open it.' And she says, 'Nanny, can you make sure I don't have to go?' Now that's a 12-year-old, they know the reputation of those people and to think that those people will be the people who are taking decisions for my grandchildren makes me sick in my stomach.[18]

Here the respondent is placed in the role of protector against those who are perceived as posing a threat to her community and family. The statement suggests that the innocence of the next generation is marred by having to be afraid of those who hold power over them. Another respondent alluded to the influence of the family in developing political attitudes: 'Young women I meet . . . when I was their age it was the low wage campaign, whereas they're involved in waving a flag. I suppose its just what you're taught at home.'[19]

Many of the respondents used language that implied that they believed their culture to be under threat from the 'other', hence their political mobilisation. One noted: 'Nearly every other country around the world can celebrate their different days and it is sad that in this country here we can't celebrate the festival peaceful and everybody enjoy the magnificence of it.'[20] Another revealed her sense of being part of a beleaguered community when she talked about the European Union (EU). 'I can see us losing even more control over our country. France, Germany and so on, a lot of these countries are more Roman Catholic dominated so I would imagine we'd be even more minimised and have even less control over our country than we have at the present time.'[21] Some of the respondents' feelings about the EU were indicative of defensive nationalism in that their distinctive culture and sovereignty were now subject to the additional threat of super-state interference. For example, one stated: 'I'm not a big fan of Europe in the sense of if you're swamped in the one European identity, you lose part of your own identity. I suppose it's just tradition, really. I am a

traditionalist and find it very hard to break away from tradition and even losing the pound.'[22] While another talked about the EU and identity in a more positive way, she noted the distinctiveness of the unionist community:

> I think we can do well in a European Community, all together working for the greater good of everybody but I still think we should keep our own national identity. We say we are Northern Ireland and we are British, we're not British, we're Ulster people. We've a different identity to the British people. The Scottish are British but they call themselves Scottish! They're completely different to the English! My goodness if you know any Scots people you'll know that! My sister-in-law's English, lovely girl but she's different to us.[23]

Within these quotes are political, economic and psychological issues. Ideas of cultural distinctiveness are entwined with political and economic interests that can be drawn upon by élites to mobilise the group.

This section has shown that the respondents were motivated into political activism for a number of reasons but that the underlying factor is that of nationalism. The statements used show that the women believe their community and self-identity to be under threat from the activities of the 'other' community, who are more skilled at delivering their perception of the political situation of Northern Ireland. This was seen by some as a matter of cultural difference, as the unionist community were not in the habit of making public their 'private' affairs such as in the ways they had personally been affected by the conflict. A number of the statements presented a benign picture of their community and culture in which the family is very important. A conservative form of nationalism acts to mobilise women as protectors of family and community, as discussed in the previous chapter, and many of the respondents had a maternal basis to their activism. Nationalism can act as a motivator but it can also restrict the form the activism takes.

FAMILY AND/OR SOCIAL BACKGROUND

Family and/or social background help to form political outlook. Therefore, it is not surprising to find so many of the respondents relating details of their background to explain their political motivation. Seventeen of the twenty-three respondents in this category have traditional unionist political sympathies: nine Ulster Unionist Party (UUP), five DUP, two Women's Orange Association of Ireland (WOAI) and one United Kingdom Unionist Party (UKUP). Some of the women had a 'political' upbringing due to their parents being party members. For others, it was encouragement from their neighbours or even their peer group. Three respondents' interest in politics developed through supporting their boyfriends or husbands. This accords with the example of Dehra Parker, whose first husband Colonel Chichester was part of the Ulster Unionist Council when it was established in 1905 and through whom she 'found her way into politics'.[24]

One respondent was motivated to become involved with politics due to the influence of her father, who was a DUP councillor before her. The actions of her father and other unionist councillors resulted in them being surcharged for five years, meaning that they could not stand for election during that time. This catapulted her into local politics, as she stood for election in his stead. 'I've grown up with it, from when I was about five years of age, Daddy was involved in some way, and I joined the party and have been there ever since. He was always going out to meetings, people were always calling at the house, there were always messages being left.'[25] So through witnessing her father's political activism, this respondent grew up believing political activism to be a normal pastime. In a similar vein, Pauline Armitage (UUP) emphasised how normal it was to be involved with politics:

It was a foregone conclusion that I would be an Ulster Unionist. My mother was a very political person and she was born and reared on the County Fermanagh border. Her father, my grandfather, was head gardener for Lord and Lady Enniskillen. She would attend birthday parties. It was just a foregone conclusion,

there was never anything else talked about at home, except union-
ism and the unionist cause. My late father was an Orangeman . . .
I had two brothers who played in the pipe band . . . My mother
was an Ulster Unionist who was involved with the Portstewart
branch, and when she would go out to do her door-to-door
collections, I would quite often go with her. She would take me to
various meetings and I think she took me to the first Annual
General Meeting.[26]

Armitage's mother was instrumental in her political socialisation and
the whole family was involved in unionist politics and culture, so, in
this case, it certainly was a 'foregone conclusion'. There was a similar
situation too for Joan Carson (UUP), whose 'father was up to his ears
in politics as a local councillor, and I knew nothing else as a small
child growing up, there was always things called elections and politics
and registers'.

Family socialisation is also a significant motivator for those
involved in a more 'cultural' way. The 'foregone conclusion' state-
ment could be made about this respondent, whose involvement has
been something of a family affair:

I lived in [a flat on one side of] the Orange Hall. My mother and
father moved to the Orange Hall [as caretakers] when I was 6 years
old and Mum and Dad lived in for forty-one years. The trustees of
the Orange Hall owned the house next door and when that lady
died, we moved into it, but Mum and Dad still continued to be
caretakers. I lived there until I was 23 and I married from there . . .
Dad was a very staunch Orangeman, so was Mum. Mummy was
Worshipful Mistress of the Lodge until this year, she's now 80.[27]

Involvement with Orangeism has been handed down through the
generations. This respondent's brother is spokesperson for
Portadown District and her son is the chief marshal for parades in
the district. She and her family have all been members of a local
marching band. Another interviewee's father was an Orangeman, and

she met her husband when he was a member of the junior organisation. This points to the social side of the Orange Order. Her interest developed over time through watching the parades. She noted: 'When we were younger we hadn't much to look forward to as regards holidays and things like that. What we really looked forward to was the Eleventh Night for the bonfires, the Twelfth Day for the bands and the parades and the banners and everything. It was really like looking forward to a carnival.'[28] It is understandable that she decided to become a part of the Orange Order herself because her family and social background is so defined by it.

A respondent who 'always had the intention of joining [the Orange]', followed her father and two of her uncles into the organisation. She joined the Women's Orange in her teens and it was through this that she became more politically active in the UUP as she 'was elected as a delegate to go to meetings to represent the Orange'.[29] In contrast, another respondent became active in the UUP first and then went on to join the WOAI. In both cases she was motivated to join through the influence of her peer group but her family background helped in her politicisation.

> I just floated into it, I have to say. It was encouragement from other people that brought me into it to start with, then I discovered I was interested in it once I was there . . . It was the same friends that interested me in the Young Unionists that introduced me to the Orange Order, although I knew more about it than a lot of people because my father has been an Orangeman all his life . . . I mean it was part of my life going out on the Twelfth of July to watch him.[30]

So this woman was already sympathetic to the political ideas and culture of unionism, and all that was required was a nudge from friends for her to become more active. In this case both family and social background were important.

Some of the respondents within this category revealed that their social background had been more influential in motivating them

politically than had their family background. An example was a woman whose father was a 'passive politician' who would explain political events to her. However, it was not until her late teens when there were:

> neighbours next door who were members of the Ulster Unionist Party which was the party my family had always voted for. They said to me, 'There's an election coming up, why don't you come down and give us a hand?' That was September 1959, so come this September I'll be forty years in the party. I went down to help them at that election and I've been helping them at every election ever since.[31]

For another respondent, it was the influence of her peer group in that her friends at school were members of the Young Unionists.[32] In a similar vein, another interviewee first got involved with the party because friends asked her 'if I wanted to come over and help, would I like to go to a meeting and see what it was like'.[33] However, doing community work and being aware of the needs of her community also motivated her. In this case, then, the social background was very important motivator to political action. Prior involvement with the community was important for a number of respondents who had used the skills they had developed in a more formal political way. For example, a respondent felt that she 'had all the answers to all the problems' having worked for many years in the trade union movement. She noted that, 'Some years ago there was a realisation that if things were going to be sorted out it had to be done in the political arena'.[34] Similarly, another woman stated, 'We very quickly saw that decision-making, whether you like it or not, was in the political arena'.[35] Here is the recognition that despite the attractiveness of working in the community because of the feeling that one is 'doing' something, there is no real power at this level.

Being the girlfriend or wife of someone who is politically active has, in some cases, led to the women's own politicisation. One

interviewee started out helping her husband who was doing research for the Ex-Prisoners Interpretative Centre (EPIC). She typed up his interviews and:

> hearing first-hand experience from all those people—what they went through—definitely changed my attitude . . . When my husband joined the PUP, first I went along and I seen their policies and I seen what they were trying to do and this to me was another way of getting the loyalist cause across, but in a way I wanted to do it. So that's why I became involved.[36]

So this woman's husband's involvement acted as an incentive to discover more about the party, which led to her decision to become politically active. She noted that: 'Once you get your mind opened to what's going on in your society, you want to learn more and participate more.' Another respondent's political interest also began with working on behalf of her husband, who was standing for election. She was 'his election agent and canvassed and did all the usual stuff'.[37] It was a similar situation for another who was initially motivated to political action through the 'enthusiasm and interest in politics' of her boyfriend (and future husband), which piqued her curiosity and led to her 'attending meetings and rallies'.[38] Throughout the years she provided secretarial support as he became an MP, before standing for election in her own right.

Finally, there were two respondents in this category who could also be included in the 'direct or indirect effect of "the Troubles"' category, and one who could also fit into the 'dissatisfaction' category. These are discussed here by way of an indication that many of the respondents have had more than one motivator to political action. This falls into step with their situational identities and the often multiple forms of participation, and underlines the folly in viewing unionist and loyalist women as homogeneous groups. The social background and indirect effect of 'the Troubles' were sources of motivation for the first respondent, who explained:

It happened just by chance. I wasn't community or politically orien-
tated at all, I was a housewife, I had two young kids. A girl came
knocking on my door one day and says, 'I hear you can type . . . you
wouldn't come along to a few meetings and type up the minutes?' So
I got involved in the Tullyally community association, which was
formed out of two bombs going off in the middle of our housing
estate. One man was killed and a few people were injured. The police
and the housing executive and the agencies that had a vested interest
in that area decided that what the area needed was a community
group.[39]

Had it not been for the indirect effect of 'the Troubles', she may not
have become politically active. The second respondent started out as a
young unionist but was against the power-sharing agreement that
split the party under the leadership of Brian Faulkner. The direct
effect of 'the Troubles' combined with her family background helped
to form her political views:

My father was in the B Specials those days, and when the
government of the day allowed the B Specials to be disbanded
when I knew how much my father had taken . . . I never saw my
father for weeks because he was lying in ditches fighting the IRA.
You never knew where he was because they weren't allowed to tell
you where he was going.[40]

Here we see resentment that the sacrifices made are seemingly taken
all too lightly by the state.

The third respondent initially had no interest in politics because
the established politicians were not speaking for her. Her dissatisfaction
meant that she was open to new perspectives, which she found with the
spokespersons of the PUP. They 'didn't see Northern Ireland through
rose coloured glasses, they saw it as it was, which was an awful mess and
a can of worms. They were also speaking from a working class back-
ground, which appealed to me.'[41] However, it was this combined with

her social background that led to her political involvement, as it was a 'male friend . . . [who] harassed me to join for six weeks until I did'.

The family and/or social background of a person are often pivotal in terms of the political attitudes held and the type of political activity engaged in. Other factors may provide greater motivation, however. The next section will consider those women who were motivated by their 'dissatisfaction' with the politics and mainstream politicians of Northern Ireland.

DISSATISFACTION

This category encapsulates those who felt frustrated by the politics of Northern Ireland, and that the mainstream politicians did not represent them, leaving them without a political voice, i.e., they were effectively disenfranchised. The political affiliations of the respondents that fall into this category were: three Ulster Democratic Party (UDP), three PUP, one Northern Ireland Women's Coalition (NIWC) and one Northern Ireland Unionist Party (NIUP). Therefore six of those within this category have expressed their 'dissatisfaction' by becoming active in the smaller 'loyalist' parties, which have a working-class constituency. Of the two remaining respondents, one has opted for a party that employs a consensual form of politics in an attempt to move beyond the deadlock of the past, while the other has not moved so very far from traditional unionism.

The women interviewed from the NIWC both came from unionist backgrounds but did not feel represented by unionist parties. In this regard, both could fit into this category, although one in particular emphasised her dissatisfaction with established politicians and parties. She got involved with the party after going to a public meeting organised by the founder members:

> I went to the meeting and I was sort of sceptical at the idea of a women's party, but I thought I'd go along for the interest. It was what people said, basically the way people saw the need for a peace process, how it needed to happen and what needed to be in it, was

exactly what I thought and it was the first time ever that I'd heard a party, well not yet a party, but what was to become a party, understanding what was going on in the same way that I did. It was amazing but there was something depressing about it as well because I know a lot of people who think similarly to me who haven't joined the Coalition. It made me think how many people are out there with all sorts of interesting views but because they don't find a party that matches them, their voices never get heard.[42]

So despite her initial scepticism she found that those forming the party were like-minded people. She had been previously dissatisfied because she felt the political system 'allows people to float to the top because they're the least conservative, the most reactionary, the least progressive'.

A respondent involved with another small party initially got involved in politics as a reaction to the state of Northern Ireland politics. She explained her motivation thus:

I only really came to politics because of the appalling things that were happening. We had a brief look at the Ulster Unionist Party and found them to be vastly out of date, not well organised, not coherent and in my view they weren't putting forward well researched, visionary policies. Bob McCartney [UKUP] was in the press at the time and it rang a bell so my husband and I got involved with supporting what he was doing and joined his party . . . That was my initiation into politics.[43]

Since then the UKUP has split due to disagreements over policy that led to the formation of the NIUP. Describing herself as a 'liberal conservative', this respondent's dissatisfaction is more with the policies rather than the general ethos of the established parties.

The majority of those who fall into this category were dissatisfied with mainstream traditional unionism that no longer appeals to the predominately working-class and loyalist constituency. The Anglo-Irish Agreement (1985), which created a shockwave throughout

unionism and loyalism because it was signed without reference to the people of Northern Ireland, led to the development of more positive and forward-looking approaches to politics. This is particularly the case with the UDP and PUP, who have tried to move away from the 'Ulster Says No' approach of traditional unionism, which has so often resulted in deadlocked negotiations. This proved attractive to some of the respondents, as one explained:

> when the children were small, I was watching the news constantly and all I could hear from the mainstream politicians was 'no', they were saying no to everything. And I just got so down and just, you know, they weren't speaking for me when they were saying no. They were saying no to absolutely everything. And then the UDP, which was ULDP [Ulster Loyalist Democratic Party] at the time, had a public meeting and the 'Common Sense' document was produced, and I took it home and I read it and I liked what was in it. And that's why I decided to join the UDP because they were a party that weren't saying 'no', they were forward-thinking and forward-looking.[44]

So the UDP represented a refreshing change for this respondent, who previously felt she did not have a political voice. Another respondent from the same party also felt that the mainstream politicians did not speak for her. She recalled: 'I had a look to see who was running the country and the input—it wasn't representing me, not correctly, not my culture. My identity and who I was, was being misrepresented'.[45]

One respondent was motivated to get involved with the UDP after spending ten years as a member of the DUP. She had been very dissatisfied, as she did not have a real voice in the party:

> A couple of times myself, I suggested something, and at one point I was told the Doctor [Ian Paisley] was the leader of the party, and I said but if we weren't here there wouldn't be a party to lead . . . One person doesn't make a party . . . I became very disgruntled

with them because no matter what was suggested, it was 'no', 'no', it was 'no' all the way. It was very seldom that I heard a 'yes, we'll go along with that and give it a try', it was always a firm stance.[46]

Through being active in the UDP, this respondent now feels she has a real political voice.

The women respondents from the PUP were equally dissatisfied with the politicians and parties of traditional unionism. The approach taken by the leadership of the PUP in the late 1980s struck a chord with them and encouraged them to get involved. One woman had returned to the Shankill Road area of Belfast after living in England for ten years and had found it to be 'stuck in a time-warp'. She said:

> The PUP was like a voice for the loyalist people . . . [N]one of the other unionist parties I could identify with. I never heard any policies on housing, education, equality issues. PUP was the only party that espoused those kind of things. Most of the unionist parties concentrated on the constitution . . . that's very important but there's a lot more other issues that are really important.[47]

In returning to the area she was brought up in she could see the needs of the community. Hence the policies of the PUP that addressed socio-economic issues acted as a motivator. The feeling that parties such as the UUP and DUP do little for the constituents of working-class areas was summed up by one respondent who refers to the MP for her area as the 'absentee landlord' who comes around at election time to collect his votes.[48]

The paramilitary connections of the smaller loyalist parties had not dissuaded two respondents from becoming active in the PUP. One woman explained:

> I kept coming across either individuals from the Progressive Unionist Party or else pieces in papers . . . quoting Gusty Spence or David Ervine or Billy Hutchinson. I thought, 'I can't believe this thinking—how have I not noticed these people before?' I'd

been totally unaware of their existence other than they appeared to represent various Protestant paramilitaries, I wasn't even sure which ones.[49]

She had previously been disgusted by the lack of leadership from mainstream unionism. For another respondent, it was also policies rather than connections that motivated her. Her reason for joining the party was:

> I am a socialist and they were the only ones talking about socialist issues at that time. And as well as that I felt very strongly about victims' issues and I felt that the only place to go with the victims' issue was to one of the parties who would have been responsible for a lot of those victims and who would have been victims themselves before they joined paramilitary organisations.[50]

By being on the inside of the party this respondent could have some input into the formation of policy on an issue that she was also working on within the community.

Through the experience of not having a political voice, these women have found the determination that has motivated them to either establish or join a new party, or to be open to the development of the ideas of existing parties. All of them were dissatisfied with the approach of the UUP and DUP to the political problems of Northern Ireland.

EFFECT OF 'THE TROUBLES'

This motivational category could be applied to all the respondents, as it would be difficult to find a person who has not been affected by the conflict in one way or another. At a minimum it will have coloured political opinion. This section draws particularly upon six of the interviewees, for whom the conflict was instrumental in their politicisation and subsequent activism. However, as with the other

categories it will also refer to those who can be described as having multiple motivations. Of the six there were three members of Families Acting for Innocent Relatives (FAIR), two EPIC, and one UUP. The broad brush of this category is reflected in the political persuasions of the respondents.

One respondent became aware of the differences between the unionist and nationalist communities at the age of eight when her father, who was in the RUC, was shot and injured. Following this, her family had to move to a safer place away from the border area. She joined the party while a student at Queen's University, but it was her childhood experience that was influential in her politicisation.[51] University politics seems to have been a route into formal politics for men rather than women. The majority of respondents had not taken this route, but this could be a factor of generation and traditional attitudes towards gender roles.

The effect of 'the Troubles' had motivated some of the respondents to become involved in a very specific way. For the two members of EPIC, their interest and participation in community politics on behalf of loyalist ex-prisoners and their families, and support for the PUP, was informed by their own experiences of the conflict. One had a brother who had been a life-sentence prisoner.[52] The other explained that her husband:

> is an ex-prisoner and specially in this area the like of the unionist parties here will actually have put down ex-prisoners. Prisoners, ex-prisoners weren't wanted by them. They weren't given any help or support. So it wasn't until the PUP came along and until they started, as I felt, actually looking at the issues that are affecting the working-class people and affecting everybody's everyday lives, and the not just the normal run of unionism, about the border and being British, and all . . . The PUP came along and they . . . were really talking about the issues that was affecting me and my family . . . As regards EPIC . . . when my own husband came out of prison seven years ago there was no help, no support, especially up in this area and it was difficult.[53]

Both respondents could also fit into the 'dissatisfaction' category, because they had been affected by 'the Troubles' and felt that the politicians were doing nothing to help them. Of the PUP, one commented: 'We never had that before, you know, people speaking for ordinary working-class people.'[54] Their own activism, however, was targeted at addressing the issues they had had direct experience of. Another respondent was also 'dissatisfied', but her community activism was motivated more by the direct effect of 'the Troubles'. She explained that the Shankill Stress and Trauma Group (SSTG) is 'first, foremost and almost obsessional in my life. It's from where I came from in being a victim on numerous occasions from both loyalist and republican paramilitaries.'[55]

The members of FAIR were motivated to join their group because of the impact the conflict had had on their lives and through the perception that they (the victims) were being 'completely ignored'. Through being active they could draw attention to this issue and support each another. One of the members explained that:

> FAIR has been the first help we have had. In all these years of enduring, its just been like an onslaught where we have to live . . . you just keep the house locked up all the time . . . There's another member along the road here who was shot in his kitchen . . . FAIR was a godsend. It enabled us to talk to people who knew and really the only people who do know are the people who have been right through it, we are all the products of our own experience . . . As soon as we heard about it we knew that it wasn't a choice to join, it was just something that we had to do.[56]

Living with the feeling of being under siege has fostered deep-rooted suspicions. This extends to not going 'for official help, for example, in the hospital because that would be largely republican' and that would mean 'providing information for people who may come back and do the same again'.[57] In this sense, this respondent is indeed a 'product' of her own experience in that the initially

unofficial group is trusted because its members are known. Another member said that she joined the group because she 'thought it was time that . . . it was brought to the eyes of the world, how much they'd been forgotten about and how much they'd suffered and no one seemed to care about them'.[58]

The interviewees who fall into this motivational category demonstrate that the effects of living in a conflict society can act to form and reinforce political convictions. The evidence indicates that the direct or indirect effect of 'the Troubles' can act to propel an individual into becoming more active in politics, broadly defined.

<p style="text-align:center">ANALYSIS</p>

The motivation to act politically is informed by the way individuals perceive themselves within the community, and how the status of that community group is deemed to be affected by the 'other'. Therefore the responses indicate feelings towards the next generation of the community, a sense of belonging, notions of cultural distinctiveness, perceptions of being under threat from the 'other', and allusions to defence of the status of the community. This builds up a picture of a far from 'banal nationalism'[59] through which the respondents have been motivated into political participation.

The qualitative approach of this book means that the focus is upon the specifics of the self-selecting élites in the case study group rather than general aspects of unionist and loyalist women. However, it should be noted that the level of formal political participation of both women and men in Northern Ireland is small, with the former at 2.1 per cent and the latter at 1.6 per cent.[60] Therefore it would seem that nationalism is not very effective in motivating the general population into formal political action. Nationalism remains latent in the majority until times of mass mobilisation in war, at which time 'normal' politics are suspended. During 'the Troubles' national identity placed individuals on one side or the other, but the majority

of the population have not been active in either formal, community or 'extra-constitutional' politics. Nationalism is the tool of the vanguard, the intellectuals and self-selecting élites who deliver the message, which in turn will strike a chord with some in the population. Some of these will join a legal party or organisation and others will join illegal paramilitary organisations. The majority of the population will be mobilised by their latent nationalism only if the political situation deteriorates, as was seen in the large demonstration in Belfast following the signing of the Anglo-Irish Agreement (1985).

In explaining their motivations to political action, the respondents discussed their family and social backgrounds, their own particular perspectives on the political situation, the input they have into it as political actors, and their views on cultural practice and religion, all of which are influenced by nationalism. Those who are active in their communities work to tackle problems that have been ignored, caused or exacerbated by national conflict. Party representatives and activists are engaged with party politicking that has implementation of policy to the advantage of unionism or loyalism as its *raison d'être*.

Within the family, socialisation of the next generation takes place and is constantly reinforced through cultural practice and the daily diet of national symbols and use of language that demarcates community boundaries. Family and social background is inherent to the identities of the members of the community group. This arena is therefore of fundamental importance if there is to be any sense of belonging to a national group. The statements included in the 'family and/or social background' category can be viewed through the lens of nationalism. The respondents legitimise the identities they are motivated to defend by saying that unionism is not what they chose, but part of them and their history. Unionism is viewed as totally benign in its compatibility with family life. They have a 'home' for their politics so there is no question that they are unionists.

Those who were dissatisfied with the politicians and policies of political parties, along with those who had been affected by the conflict, were relating a different kind of legitimacy. In the former,

there had been no real 'home' for their politics; hence they had been motivated to rectify this situation. In both categories, the respondents appeared to have made a conscious decision to get actively involved, rather than it having been a 'foregone conclusion'. They were, in effect, responding to the perceived threat posed by the 'other'; they *needed* to do something to protect their community. The stories often relate a personal trial or individual initiation before taking their place within their particular sub-group of unionism.

A common thread in the literature on the mobilisation of 'ethnic' groups is that of instrumentalism. Nationalism acts to reinforce the sense of distinctiveness of a group of individuals who perceive their individual interests in terms of the group interest, especially when there is potential for the group interest to be threatened by another group. Group interests may be economic but they may also be psychological in that the way individuals within the group understand themselves stems from being part of the group. The latter interest is significant in so far as group mobilisation is cross-class; the rational interest of the working classes would be to mobilise in an inter-group rather than intra-group fashion. Horowitz argues that: 'economic theories cannot explain the extent of the emotion invested in ethnic conflict. As Ed Cairns has pointed out for Northern Ireland, in terms that apply more generally, the passions evoked by ethnic conflict far exceed what might be expected to flow from any fair reckoning of "conflict of interest"'.[61] While the class differences of the respondents revealed intra-group differences concerning life experiences and political persuasion, the emotional investment in their over-arching national identity was evident.

Individuals see their self-interest as being part of the group, and sacrifices for the group happen because 'there is a stepwise progression from identification with a group, to mobilisation of still stronger identification, to implicit conflict with another group, and finally to violence, particularly when both the group and the other group are faced with increasing incentives for pre-emptive action'.[62] The group is more powerful than the individuals who comprise it

standing alone, and by being active on its behalf the individuals stand to benefit. It is through coordination that the group is powerful as the more individuals that are mobilised the less risk involved for individual members. Hence the important role of élites, as group coordination 'might turn in part on whether there is someone urging us to recognize our identity and co-ordinate on it'.[63] The leaders of the national group draw upon the 'sunk costs' of individuals within it, which are latent feelings of identification.[64] If the culture disappears, the 'self' disappears because self-perception and identity can no longer be grounded in a reality. History and culture have to be kept live by commemoration, interaction with others from the group, rituals and maintenance of group boundaries. Nationalism acts to reinforce fears so that the group may act in a pre-emptive way.

Fears of the 'other' are not necessarily based in fact and such fears are magnified through being part of the group in which she 'may never encounter anything resembling a test of her knowledge of her community's moral superiority. Nevertheless, the world may give her some confirmation of her beliefs. In daily life she comes to know far more about her group than about any other, she is naturally comfortable in it, and she is uncomfortable in strange groups.'[65] Such fears were evident in the respondents who spoke about their distrust of the EU, membership of which posed a threat to the distinctiveness of the nation. It was also clear from the respondent who, at the age of seventeen, began to challenge the myths about Catholics that she had grown up believing.

The rhetoric of nationalism that is communicated via the media, political parties and community and cultural organisations provides an interpretation of events which acts to reinforce beliefs. Indeed, mass communication makes nationalism a distinctly modern phenomenon. With the individuals secure in the knowledge of *who* they are, it is then the presence of the 'other' group against which the group will mobilise. Guibernau points to the importance of the media in the mobilisation of the group. She writes:

> [N]ationalist leaders in Western nations without states struggle to avoid being presented as 'tribal' and 'backward'. The cause they endorse is often portrayed by the defenders of the nation-state's hegemony, as a threat to the state's integrity which could unleash atavistic forces which are impossible to control. Nationalist leaders require high skills and expert communications advisers to help them to counteract such accusations and project a positive self-image in which their commitment to modernization and democracy is a crucial element.[66]

The perception of the respondents was that the 'other' had been so successful at projecting a 'positive self-image' that the media were now presenting them, the national group *with* a state, as 'tribal' and 'backward'. This, for some of the respondents, was a factor of their cultural differences.

Horowitz notes the significance of the family in the longevity of the group in that a 'strong sense of ethnic identity is difficult to maintain without strong family ties. These include, most prominently, marriage within the group, for completely free choice of marriage partners would undermine the birth basis of the ethnic group.'[67] Living within a constrained political geography reduces the likelihood of mixing with those external to the group who might challenge ideas held about the 'other'. A number of responses suggested that the centrality of the family was a reason for the low participation of women in politics. This accords with Yuval-Davis and Anthias's perspective on women in the national project having specific roles, including 'reproduction' of the next generation, of group boundaries and of group ideology.[68] Many of the respondents had in fact gone into politics after their children had grown up. One respondent recalled a politician who had exhorted women to have babies, which reveals a certain demographic anxiety. Indeed, '[i]n a conference on "Women in Deeply Divided Societies" [at Queen's University, Belfast] in October 1993, some participants expressed the opinion that the pressure for finding a solution to the Northern

Ireland problem was going to mount due to the fact that Catholics are going to become, before too long, the majority there.[69] The Belfast Agreement (1999), with its provision for a poll to ascertain whether the majority wishes Northern Ireland to remain part of the United Kingdom, could only have exacerbated this anxiety.[70]

For many unionist and loyalist women, responsibility for the family is a key role, and the private sphere is an important site for the reproduction of ethnic and national group boundaries and the transmission of culture. Stavenhagen refers to the significance of the intergenerational transmission of group culture. He argues that: 'Ethnic identity and continuity are maintained as a result of the transmission within the group (through the processes of socialization, education, internalization of values) of the basic norms and customs which constitute the central core of the ethnic culture.'[71]

Much of the literature on group mobilisation takes the starting position that nationalism lies with the group that wants secession from the existing state. This does not fit the case study group, so the literature has been utilised to help explain some of the responses with this in mind. Consistent with the instrumentalist theme, Gilbert contends that the notion of a distinctive national character is not based on facts, in a 'chicken and egg' argument—what came first, individual identity or national character? He argues that it is 'the fact that nationality can contribute to individual identity that leads to the supposition that it is founded upon individual characteristics of, or is at least typical of, members of the nation'.[72] Appeals to national memory, national identity and the need to preserve the culture of the national group by the élite are a means of mobilising the masses in the group's political interest. Furthermore, the 'stability required for statehood must spring from some common interests or presumed interests. Nothing that makes people similar culturally can guarantee this . . . It would not be ethnicity as such . . . that generated a right to statehood, but the desirability of preserving or protecting some ethnic group in the way that statehood might.'[73] In applying Gilbert's perspective to the case study group, it could be argued that

fostering a sense of national character and national identity serves the political interests of unionism and that defensiveness of their existing statehood is a rational response to external threat.

In reflecting upon the respondents' statements, it seems that the main way they fit into Yuval-Davis and Anthias's framework is as participants in national political struggles.[74] They are political actors involved in the interests of their national community, rather than the stereotypically passive 'tea-makers'. While they have in many cases been motivated because of their family and social background and in the interests of the next generation, they are political participants. Whether the respondents were motivated by their background, their dissatisfaction or the effect of the conflict, at the root of their political activism was their nationalism. The evidence presented in this chapter helps to build a picture of why this group of political actors had become politically active. The motivations are connected to the women's national identities outlined and discussed in the previous chapter. While gender identity had a low priority for the majority of respondents, when discussing motivations an implicit gender role is revealed in the significance of family and/or social background. This relates to the perspective that nationalism is inherently gendered. Moreover, gendered nationalism helps to explain the form and extent of the political participation of women. Hence the next chapter examines evidence of unionist and loyalist women's political action.

NOTES

1 M. Levinger and P. Franklin Lytle, 'Myth and mobilisation', *Nations and Nationalism*, 7, 2 (2001), p. 178.
2 G. Parry, G. Moyser and N. Day, *Political Participation and Democracy in Britain* (Cambridge: Cambridge University Press, 1992).
3 Ibid.
4 Ibid.
5 Ibid.
6 May Steele, UUP.
7 Ruth Allen, DUP.
8 Elizabeth Watson, WOAI.

9 Pauline Armitage, UUP.
10 Dawn Purvis, PUP.
11 Joy Fulton-Challis, UDP.
12 Dawn Purvis, PUP.
13 Sylvia McRoberts, UUP.
14 Willie Ross was UUP MP for Londonderry (1974–1983) and East Londonderry (1983–2001).
15 Elizabeth Watson, WOAI.
16 Joan Carson, UUP.
17 Anonymous, FAIR.
18 Myreve Chambers, DUP.
19 May Blood, NIWC.
20 Anonymous, DUP.
21 Susan Neilly, WOAI.
22 Sarah Cummings, UUP.
23 Irene Cree, UUP and UWUC.
24 I. Paisley Jnr, 'The political career of Dame Dehra Parker', unpublished MSSc thesis (Belfast: Queen's University, 1994), p. 31.
25 Ruth Allen, DUP.
26 Pauline Armitage, UUP.
27 Elizabeth Watson, WOAI.
28 Susan Neilly, WOAI.
29 Olive Whitten, UUP and WOAI.
30 Sharon McClelland, UUP and WOAI.
31 May Steele, UUP.
32 Sylvia McRoberts, UUP.
33 Anonymous, DUP.
34 May Blood, NIWC.
35 Eileen Bell, APNI.
36 Joan Crothers, PUP and EPIC.
37 Irene Cree, UUP and UWUC.
38 Iris Robinson, DUP.
39 Catherine Cook, PUP and PRG.
40 Myreve Chambers, DUP.
41 Dawn Purvis, PUP.
42 Barbara McCabe, NIWC.
43 Elizabeth Roche, NIUP.
44 Norma Coulter, UDP.
45 Joy Fulton-Challis, UDP.
46 Lily McIlwaine, UDP.
47 Eileen Ward, PUP.
48 Dawn Purvis. PUP.
49 Olwyn Montgomery, PUP.
50 Mina Wardle, PUP and SSTG.
51 Arlene Foster, UUP.
52 Marion Green, EPIC.
53 Marion Jamison, EPIC.

54 Marion Green, EPIC.
55 Mina Wardle, PUP and SSTG.
56 Anonymous, FAIR.
57 Ibid.
58 Lena Spence, FAIR.
59 M. Billig, *Banal Nationalism* (London: Sage, 1995).
60 R. Miller et al., *Women and Political Participation in Northern Ireland* (Aldershot: Avebury, 1996), p. 160.
61 D. L. Horowitz, *Ethnic Groups in Conflict* (California and London: University of California Press, 1985), pp. 134–5.
62 R. Hardin, *One for All* (Princeton, NJ: Princeton University Press, 1995), p. 23.
63 Ibid., p. 51.
64 Ibid., p. 69.
65 Ibid., p. 63.
66 M. Guibernau, *Nations Without States* (Oxford: Polity Press in association with Blackwell, 1999), p. 110.
67 Horowitz, *Ethnic Groups in Conflict*, p. 61.
68 N. Yuval-Davis and F. Anthias, *Woman-Nation-State* (London: Macmillan, 1989).
69 Yuval-Davis, 'Women and the biological reproduction of "the nation"', *Women's Studies International Forum*, 19, 1/2 (1996), p. 19.
70 See *http://cain.ulst.ac.uk* for the full text of the Agreement.
71 R. Stavenhagen, *Ethnic Conflict and the Nation State* (London: Macmillan, 1996), pp. 19–20.
72 P. Gilbert, *Terrorism, Security and Nationality* (London and New York: Routledge, 194), p. 108.
73 Ibid., p. 118.
74 Yuval-Davis and Anthias, *Woman-Nation-State*.

Political Actions

The relative invisibility of unionist and loyalist women's political actions masks a long history of involvement and conveys the impression that they do not feel strongly about the national question. In this chapter, I redress the balance by firstly discussing the historical context from the time of the Home Rule crises, and then by moving on to outline the forms of participation in the late twentieth century. I draw upon the interview and participant observation evidence to show that the women participate in varied ways and at different levels, from party or group member through to elected office or spokesperson.

UNIONIST WOMEN, NATIONALISM AND POLITICAL PARTICIPATION: HISTORICAL CONTEXT

The history of unionist women's political participation shows that the perceived threat to their country has been an important motivator. It demonstrates that unionist women have been politically active in defence of their perception of the British nation and the particularity of their region of the UK since before the partition of Ireland. In 1886, when the threat of Home Rule first manifested, 'a branch of the London based Women's Liberal Unionist Association was instituted in Belfast. Despite the establishment of this association, the efforts of female unionists during the first and second home rule crises remained both sporadic and largely dependent upon individual initiative.'[1] Alvin Jackson concurs with this view in his study of unionist politics in mid-Armagh during the Edwardian era. He argues that although women were not franchised and were not allowed membership of the Mid-Armagh Constitutional Association, there

was political activity, but through 'temporary, individual initiative, and not through any systematic leadership'.[2] Regardless of the level of their politicisation, women were prevented from taking part in the Unionist Convention of 17 June 1892 due to gender stereotyping. The Convention was a serious business, so '[t]o dampen any suggestion of frivolity women were excluded altogether from the proceedings'.[3] However, unionist women 'were involved in the Convention primarily in organizing a "Grand Converzatione"'.[4] They decorated balconies with slogans and reminded visitors that 'women felt the danger of Home Rule as acutely as men'.[5] Unionist women demonstrated *en masse* in Armagh in June 1893. Jackson notes that the '*Armagh Guardian* warmly endorsed the work of those whom local nationalists dubbed the "shrieking sisters" of Unionism—but the constitutional association offered little active encouragement; and, although male opinion varied greatly about the role of women in politics, from arch-conservatism through to support for the cause of suffrage, women themselves were often conspicuously modest about their political ambitions'.[6]

The threat of Home Rule justified women's political activism, although they were also 'conscious of their role as promoters of Union and Empire within the home'.[7] The women did not want to be seen as neglecting their duties but the prospect of Home Rule was an even greater evil, so political agitation was a means of protecting their homes and maternal obligations. While the motivation to participate may stem from the perceived threat to home and family, the way in which domestic life and culture are understood is bound up with the wider national 'family'.

The political allegiance of unionist women could also be demon-strated through membership of organisations outside formal politics such as the Women's Orange Order, the Daughters of Empire ('a rare and comparatively short-lived body'), the Women's Temperance Association, the YWCA and the Girls' Friendly Society.[8] In January 1894, members of the latter group 'posed in *tableaux vivants* which included depictions of "Erin" and "Rule Britannia"'.[9] Hence they brought to life the nation as the allegorical female.

In 1911 the Ulster Women's Unionist Council (UWUC) was established.[10] An auxiliary movement to the Ulster Unionist Council (UUC) and led by women from the aristocratic élite, the UWUC became a broad-based organisation attracting members from all classes.[11] It was a 'conservative organisation with few pretensions of influencing policy and with no ambition to shake the status quo'.[12] At this time local Women's Unionist associations were becoming more widespread.[13] The first one had been established in 1907 in North Tyrone and activities included 'electioneering both in its own locality and in English constituencies, updating electoral registers, distributing unionist propaganda and fund-raising'.[14] These were also the sorts of activities of the UWUC, which by 1912 had between 115,000 and 200,000 members, and thus compared favourably with the membership of Cumann na mBan[15] and that of the Irish suffragists, at approximately 4,425 and 3,500 respectively.[16]

At this time of the third Home Rule crisis, women unionists interpreted the prospective constitutional change as a threat to the 'sanctity of their homes and well-being of their children . . . James Craig publicly referred to the members of the UWUC as the "motherhood of Ulster"'.[17] The extent of the politicisation of unionist women at the time is evidenced in mass demonstrations and petitions. For example, 'a demonstration held in Belfast in October 1912 was attended by 10,000 women and in 1913 Sir Edward Carson was met on his first visit to West Belfast by the largest assemblage of women that had ever taken place in Ireland, the attendance being estimated at over 25,000'.[18] An anti-Home Rule petition was signed by 20,000 women in 1893. The UWUC gathered 104,301 signatures against the *Ne Temere* papal decree and Home Rule in a petition that they presented to Parliament in June 1912. A further petition against Home Rule, begun in May 1912, was signed by 100,000 women. Women were not allowed to sign the Ulster Covenant so the UWUC organised a women's declaration. While 218,206 men signed the Covenant the 'comparative strength of women's unionism' is indicated by the 234,046 signatures on the women's declaration.[19]

The UWUC was heavily involved with publicising the unionist cause. Not only did its members send out leaflets and newspapers, but they also went to England and Scotland to give speeches in person. Women also volunteered for the Ulster Volunteer Force (UVF) to work in an auxiliary capacity. More than five thousand are estimated to have taken nursing training and some were involved in dispatch, intelligence work and gun-running. Following the outbreak of the First World War, the UWUC engaged in war work such as fund-raising, sending food parcels and supporting the UVF hospitals in Belfast and France.[20]

Despite the important role played by unionist women, they did not have any representation on the UUC until after female enfranchisement in 1918, when the UWUC was allowed to appoint twelve delegates to the Council. To ensure full advantage was taken of the franchise, the UWUC saw to it that those entitled to vote were on the electoral register. Women were viewed as voters rather than prospective parliamentary candidates. However, the UWUC supported and encouraged its members to stand for urban district and county council elections. In the 1920s it 'funded scholarships to train unionist women in politics, economics and citizenship and took female trainees into their headquarters for tuition', although this was not in the interests of feminism, but was 'a means to preserve the unionist cause'.[21] Indeed, the UWUC had a specifically gendered understanding of unionism: in 1919 it 'claimed that there were social and domestic aspects to unionism "which none but women can understand"'.[22]

The UWUC continued to engage in propaganda work during the inter-war years, along with advocating the 'purchase of empire produced goods, and the enforcement of licensing legislation'.[23] The perception of the appropriate role for women remained focused upon the domestic sphere. Indeed, the women 'did not want to assert their political rights too firmly, fearing loss of favour with male unionists'.[24]

A minority of unionist women have asserted their political rights by standing for and being elected as representatives of their party.

Between 1921 and 1972, there were six Ulster Unionist women members of the Northern Ireland Parliament. They were: Dehra (Chichester) Parker (Londonderry County and City 1921–29, South Londonderry 1933–60), Julia McMordie (Willowfield 1921–25), Anne Dickson (Carrickfergus 1969–72), Bessie Maconachie (Queen's University 1953–69), Dinah McNabb (North Armagh 1945–69) and Margaret Waring (Iveagh 1929–33).[25] There were also two women senators: Marion Greeves (Independent) was the first and Edith Taggart (Unionist), elected in 1970, was 'the second Senatrix to serve since 1921'.[26]

One of the most remarkable women members of the Northern Ireland parliament was Dehra Parker. Her initiation into political activism occurred during the Home Rule crisis, when she took part in gun-running.[27] During the First World War she organised UVF nursing units, and 'worked for the Soldiers and Sailors Families Association and the War Pensions Department in East Belfast'.[28] In addition to serving as an MP in Northern Ireland, she was the first woman to hold government office in the UK and the first woman member of a Northern Ireland cabinet. In 1938 she became Parliamentary Secretary to the Ministry of Education, and she served as Minister of Health between 1949 and 1957.[29] Unlike other women MPs in Northern Ireland, she was a regular contributor to parliamentary debates on all subjects. Although she was reluctant to confine herself to gender issues and 'consistently refrained from contributing any feminist agenda to the house', at times she spoke on behalf of women and children.[30]

The Northern Ireland Assembly of 1973–74 had four women members, three of whom were Ulster Unionists.[31] The most notable of the three was Anne Dickson. She succeeded Brian Faulkner as leader of the Unionist Party of Northern Ireland (UPNI) in 1976, thus becoming the first woman leader of a Northern Ireland political party. Another was Eileen Paisley, who represented the Democratic Unionist/Loyalist Convention. The same four women members populated the subsequent and equally short-lived Northern Ireland

Convention. The Northern Ireland Assembly of 1982–86 had just three women members, two Ulster Unionists and one SDLP, but because the latter boycotted the Assembly, the presence of women was even further diminished.

Three women members of the Ulster Unionist Party (UUP) have served as MPs at Westminster. Patricia Ford was MP for North Down from 1953 to 1955. Patricia McLaughlin represented West Belfast from 1955 to 1964.[32] Lady Sylvia Hermon was elected as the member for North Down in 2001 and 2005, and in the same elections Iris Robinson (Democratic Unionist Party—DUP) was the successful candidate in Strangford.

Although unionist women's participation in the sphere of elected representatives has been low, their involvement at the grassroots and behind the scenes has been more active. Three interviewees referred to this, one of whom argued that it was from the mid-1970s that unionist women became more prominent within political organisations. Before that time 'politics was done very much by the landed gentry'.[33] Another noted that in the 'nationalist community women were active far earlier, because there were people like Bernadette Devlin[34] that I can remember from when I was a child, and she was very active'.[35] In response to this point, the third respondent was quick to argue that:

> you would have got young women on the unionist side who would have been very active in the university as well, because the 1948 Education Act had changed the whole university scene, so that by the 1960s you had people like Bernadette Devlin . . . The reason [nationalist women] were able to take on this high profile was because they had a cause that people identified with, they had the civil rights movement—'one man, one vote'—they had that real goal and that issue that the world could identify with and then it brought all the women. *We would not have seen ourselves as being people who walked behind funerals or did any of those things, but that was all part and parcel of their culture.*[36]

The last point is an indication of a cultural boundary, the perception of a difference between women of the unionist community and their counterparts in the nationalist community. Etiquette would not countenance such public displays, which are considered distasteful and lacking dignity.

Unionist and loyalist women have continued to support campaigns such as the 'right to march'. The parade from Drumcree church in Portadown, which passes along the mainly Catholic inhabited Garvaghy Road, has been a flashpoint since 1995. Another contentious route is Lower Ormeau Road in Belfast. There have been demonstrations in Portadown and Belfast by women and children from loyalist areas.[37] However, the extra-political activity of loyalist women has not always been non-violent. The women's section of the Ulster Defence Association (UDA) was disbanded in 1974 following the murder of Ann Ogilby, who 'had apparently been taking parcels to an unmarried prisoner and she was "punished" for this by a number of Loyalist and known UDA members, all women'.[38] This would suggest that women's involvement in loyalist paramilitary groups is expected to begin and end in an auxiliary capacity. This is the norm: women have a clearly demarcated place in loyalist culture, which is informed by a traditional view of the role of women in society and is difficult to defy.

Women are involved in the organisation of events such as the Maiden City Festival. While not expressly political, and in certain respects an extension of the domestic role, this form of participation in community culture is not passive. Behind the scenes, a group of women called the Crimson Caterers provide food and drinks. Women are also involved in the organisation of cultural events during the festival. As a participant observer it was clear that the operation was highly organised and that women played a vital role in its success. More visibly, there are women members of the Crimson Players Drama Group, which re-enacted the Relief of Derry in a pageant on the morning of 14 August 1999. They also took part in the parade. One respondent noted that: 'although there are no females in the

Apprentice Boys, they seem to have come into their own identity because of the pageant [etc.] . . . They work very much behind the scenes, behind the men, and I suppose that's true, they're always making the tea . . .'.[39] So although the women are involved in an auxiliary capacity and are limited in what they can do because there were no 'Apprentice Girls', through taking part in the re-enactments they can demonstrate that it was a whole community that was under siege. Such activities enhance a sense of community.

Another form of participation that is largely cultural but has a political connotation is through the Orange Order. While Orange women operate mainly within their lodges, since 1994 there has been an annual Women's Orange Day, which in 1999 took place on 19 August in West Belfast. The day began with a parade accompanied by two bands that started out from the Orange Hall on the Shankill Road. The 'sisters' were wearing a uniform of white blouse, blue skirt and jacket, white gloves and orange collarette. Some were also wearing a little orange ribbon, which represented support for Drumcree. The parade went around the back streets off the Shankill Road and then came back onto it to stop at the Remembrance Garden, for a service conducted by a local vicar and wreath-laying. The Remembrance Garden was for the victims of a bomb on the Shankill Road in 1993 and also for the war dead. Despite this being an Orange Women's parade, the Deputy District Master seemed to be directing the proceedings. He acted as an escort for the women who laid wreaths and told the colour party when to fall out. As a participant observer, the involvement of an Orangeman with the Orange Women's Day seemed rather peculiar. The explanation for this was that when they started in 1994, they were 'novices' unsure of procedure and did not want to appear amateurish or cause any embarrassment to the Orange Order. They asked him to show them what to do and since then he had gone with them each year.[40] The subordination of Orange women to a male authority figure rather than stepping out on their own was not viewed as being at all incongruous.

After the service, the parade returned to the Orange Hall, and the bands moved off, playing as they marched back down the road. Then the women all went upstairs to partake of tea, sandwiches and cakes. The vicar said grace, and after some time Susan Neilly, the Deputy Grand Mistress, addressed the gathering, thanked those who had helped prepare the tea, and the vicar and Deputy District Master for coming along. After tea, there was an opportunity for conversation with some of the 'sisters'. A number of women from Portadown talked about the nightly intimidation of Protestants who live at the end of the Garvaghy Road. They had been invited to join the parade in Portadown by the Orangemen, in recognition of their work and support. Participation by women in Orange parades is by invitation only.

For unionist women active in community politics, intra-community feminism has developed through their activism in women's and community groups. This has fostered inter-community feminism through cross-community endeavours such as Women's Information Days, made increasingly possible during the 'peace process'.[41] However, there has been a tendency to focus upon 'bread and butter' issues, such as unemployment, health, education and housing, and avoidance of 'politics', which is a by-word for the constitutional question and is therefore potentially divisive.

While frustration with the intransigence of formal politics has resulted in vibrant community politics, this has done little to counter the invisibility of women in the former. For those unionist women active in formal politics, there are cross-party groups such as the Northern Ireland Women's Political Forum and an Assembly Women's Network, but some unionist women and especially those from the DUP refuse to take part as they are seen as 'sexist' because men are not included. There are women's groups within some of the unionist parties, but these are of varying degrees of activism, ethos and effectiveness. Women's groups and networks appear to be something of a double-edged sword for unionist women. Although they can help to counter the patriarchal and conservative nature of unionism, they can also represent marginalisation and enduring auxiliary status, as with the UWUC.

Party	
Joan Crothers (PUP/EPIC)	Pauline Armitage (UUP)
Lily McIlwaine (UDP)	Norma Coulter (UDP)
Olwyn Montgomery (PUP)	Joy Fulton-Challis (UDP/PAPRC)
Eileen Ward (PUP)	Eileen Bell (APNI)
	May Blood (NIWC)
	Irene Cree (UUP/UWUC)
	Barbara McCabe (NIWC)
	May Beattie (DUP)
	Joan Carson (UUP)
	Anonymous (DUP)
	Valerie Kinghan (UKUP)
	Myreve Chambers (DUP)
	Margaret Crooks (UUP)
	Iris Robinson (DUP)
	Arlene Foster (UUP)
	Sarah Cummings (UUP)
	Dawn Purvis (PUP)
	Ruth Allen (DUP)
	May Steele (UUP)
	Sylvia McRoberts (UUP)
	Elizabeth Roche (NIUP)
	Sharon McClelland (UUP/WOAI)
	Olive Whitten (UUP/WOAI)
	Myna Wardie (PUP/SSTG)
	Catherine Cooke (PUP/PRG)
Activists	*Representatives*
Elizabeth Watson (WOAI)	Reatha Hassan (FAIR)
Lena Spence (FAIR)	Marion Green (EPIC)
Anonymous (FAIR)	Marion Jameson (EPIC/PUP)
	Susan Neilly (WOAI)
	Jeanette Warke (SCP)
Community	

Figure 5.1. Quadrant of political participation

THE POLITICAL ROLES PLAYED BY UNIONIST AND
LOYALIST WOMEN

Analysis of the interview data revealed that the form and extent of participation fell into distinctive categories, although many respondents were engaged in more than one role. Figure 5.1 is a graphic representation of where the political activity of the respondents falls in relation to party and community, representative and activist. It shows clearly that the majority of respondents are in the 'party representative' category.

Women participate in many and varied ways, and a number of interviewees maintained that women could progress as far as they wanted to in political party structures: in their view there was no 'glass ceiling'. This was because the respondents in question felt that because they had not encountered any difficulties themselves, then it would be the same for all women. That women are still a distinct minority in the upper echelons of political parties and as political representatives was perceived to be a matter of choice for the women themselves, who simply 'preferred' to stay in the 'background'. This may be so, but it is difficult to accept that all unionist and loyalist women who are political animals have all 'decided' not to set their political ambitions higher than local government or the Assembly. As the earlier discussion on the historical context of unionist women's political activism indicated, these women have been and continue to be under-represented in the formal political sphere. The factors that inhibit women's political advancement have been discussed at length elsewhere.[42] Family responsibilities, education, self-confidence, prejudice against women subverting their designated role, opportunity and interest in particular forms of politics—all contribute to the lack of a Northern Irish female presence in national politics. The evidence presented in this chapter will debunk the stereotype of unionist women as mere 'tea-makers', however. In the subsequent analysis, I will use the perspective of nationalism to consider why unionist and loyalist women tend to be active in certain political roles.

PARTY REPRESENTATIVES

Twenty-five of the women interviewed are categorised as 'party representatives' because they are engaged in more than the routine work of a political party. This is either through holding a position in the party structure, or externally on behalf of their party, which entails being a 'representative' in the classic understanding of the term. These women tend to engage in multiple roles in that in some cases they hold more than one elected position as well as holding at least one office within their party (see Biographical Details). Four were members of the Legislative Assembly (MLAs), as well as being local councillors. Eleven other respondents were also local councillors. The remaining ten had responsibilities at various echelons throughout their parties, from chairperson of a committee to party spokesperson and/or party officer. The latter position is significant, as party officers formulate party policy. They are closest to the party leader and represent an 'inner circle' distinct from the party executive.

The four respondents who are MLAs at Stormont talked about their experiences of being part of regional government, although at the time of interview there was a somewhat 'unreal' quality to it because power was still held at Westminster. One respondent who was on the Health and Social Services Committee noted: 'to begin with we were meeting doctors, nurses, surgeons and different health boards and trusts, and trying to see where we could go in the Assembly . . . At the end of the day we would shake hands and say, "Yes, we've got your point of view but we're not quite sure when we'll be able to do anything for you."'[43] Therefore, although they held office and could see the potential of it, their hands were tied. However, each woman is an experienced politician and it was this that they referred to during the interviews. They outlined how they view their role as representatives. One respondent adopts a pluralist approach and argued: 'All my ideas, all my projects, all my beliefs, attitudes, perceptions are based on the people and the rights of people to live, to work, to travel without fear and with freedom.'[44] So

in coming from the middle ground of Northern Ireland politics she is focusing on basic human rights. The others, who come from explicitly unionist parties, also stated that they saw themselves as working for the people of Northern Ireland. For example, one stated: 'Anyone that comes through my door or any of the other members' doors for help are not asked, "Are you a Catholic, did you vote 'yes', would you have voted for my party?.'"[45] Another was 'in there to work, to make something work in Northern Ireland and get democracy back here'. As a politician she felt she had broad appeal: 'I have found that the relationship hasn't just been with the unionist community, it has been with the spectrum of women and people I know from the nationalist community'.[46]

A respondent who voted against the Belfast Agreement decided that, as a democrat: 'I'm going to have to live with it, and I think I'd better get to the Assembly and make sure that I get the best deal I can for Ulster Unionists and pro-unionist people.' Of her role as a politician she stated: 'I don't particularly want to be a social worker. If along the way I can do a good turn for somebody . . . I'm happy to do that but basically the most important thing to me is . . . the constitutional position of Northern Ireland and where we go forward and look after our own finances.'[47] In contrast is a respondent who argues that she is not a 'high-profile politician' because she leaves matters regarding the constitution to her male colleagues and concerns herself with 'bread and butter issues'. She believes her work within the constituency is where she feels she can make the greatest contribution 'fighting housing problems, planning problems, social security problems'.[48] This is the sort of 'social work' that, for the previous respondent, was what many unionist women politicians focused their attentions on.

Women have made the biggest impact as representatives on district councils. There are unionist women councillors, aldermen, deputy mayors and mayors. The forty-seven unionist women councillors (as at 2001) represent 8 per cent of the total number of councillors. Hence, even at this tier of government, representation is skewed in gender terms.

Particularly when Northern Ireland is under direct rule from Westminster, the role of the local councillor is important because councillors work on behalf of their constituents who may have problems with housing, social security, planning, and so on. They liaise on behalf of their constituents with the relevant minister at the Northern Ireland Office. The invisibility of unionist women politicians can be partly attributed to the lack of real power at this level of government and the fact that there is little glory in much of the work they do. Indeed, this was clear from the response of one interviewee who highlighted the limitations of being a councillor. In dealing with the housing and other problems of constituents and acting as a 'go-between' on government bodies, she noted: 'All we have now is representation on those boards, we don't actually have any control over them. The only thing we have control over is . . . anything to do with the environment of the city, street sweeping, bin collection, parks.'[49]

Respondents discussed the extent of their work and the difficulties they face. One described her commitments as: lobbying the 'DoE, roads, the planning office or the housing executive'; giving feedback to her constituents regarding the success or otherwise of her endeavours on their behalf; attending 'planning meetings, site meetings, council meetings and committee meetings'; and 'there's a lot more community projects up and running too who would be wanting to know could you give them any help there'.[50] Another said: 'I never have a day off . . . I've been secretary of the branch and the association, I'm kept busy there as well . . . There are quite a few committees as an offshoot of the council—I usually have to attend something most nights.'[51] The amount of work involved was quite a shock to one interviewee, elected in 1997, who 'knew councillors worked hard, I was under no illusion about that, but I didn't realise *how* hard they had to work. It was an eye-opener, it took me down roads that I never thought I'd go down . . . I don't think a councillor can learn everything in four years.'[52] This points to the educative potential of political participation. The realisation that the role of councillor is multi-faceted gave this respondent the determination to stand for

re-election. A number of respondents also pointed to participation in local government as a means of learning necessary skills to facilitate a career in politics. Local government is 'often viewed as a training ground for aspirants to national office and as a base on which to build support for parliamentary elections. It is, therefore, a key site for the development of women's political careers, but one that remains largely unexploited.'[53]

The interviews showed that the role of councillor requires a lot of commitment and utilises skills of advocacy, diplomacy and negotiation. It also requires a certain tenacity, dedication and selflessness for a political job which is very demanding and offers little obvious reward.

Unionist and loyalist women are also office holders within their parties. They may be spokespersons, members of policy committees, treasurers, chairs, vice-chairs, secretaries of local branches or constituency groups, delegates to party council, members of the party executive, party officers and party whips. For example, one respondent was a member of the party executive, the Women's Commission, the Constitutional Affairs Policy Group and the Culture, Arts, Sports and Equality Policy Group. In addition to this, her 'main role at the minute is coordinator of the Assembly Party . . . but I also coordinate between our Assembly members and our policy groups, since we only have two Assembly members and they can't do everything . . . I also liaise with headquarters and other members of the party, keeping them up to date on current political developments and non-developments.'[54]

Another woman of influence, who was given a life peerage in 1999 in recognition of her years of work in the community, is an executive member of her party, has the role of treasurer, and hence is involved in policy decisions. She had been asked to stand for election but has 'never been into politics in that way. I'm a back-room person. I like to work in the background and make it possible for someone else.'[55] An interviewee who is also one of the 'decision-makers' in her party as the only woman party officer, has 'worked her way up' and

attributes her political advancement to her party being 'new' with a 'young' leader, whereas in 'the mainstream unionist parties there aren't the same opportunities for women to progress through. It takes an awful lot longer because they have been male dominated for so long.'[56]

Many of the respondents' political experiences comprised different facets of the 'representative' role. For example, one woman, who has been a local councillor, mayor and party officer, is involved heavily in an organisational capacity. This is through being: 'Chairman of the Association in North Down, that's eight branches and we have a management meeting every month, I chair that, then we have social meetings or fund raising meetings or political meetings'.[57] She also chairs the UWUC. Hence, she has experience of local government and different levels of the party hierarchy. The importance of the role of party officer was highlighted by a respondent who explained:

> there are only two of us [women] out of the fourteen officers . . . Any position I have ever stood for I have won. The position I am holding, the head of the Orange Order was put up against me at our executive meeting in April and I beat him. There's 101 members of the executive and I'm a step above that as a party officer. We would have meetings separate from the executive and we would make recommendations to the executive to act on them with the Leader.[58]

The respondents generally referred to themselves as 'politicians', emphasising their unionism or loyalism and what their political roles entail. However, there was an awareness of gender politics, to which this section will now turn.

The questions that focused on 'women' within unionism and loyalism drew, in some cases, a rather 'tight-lipped' response. Indeed, there is a tendency towards rejection of positive discrimination measures, because instituting quotas would leave the women open to accusations of tokenism, thus devaluing their contribution as political individuals. In this sense the women respondents appeared

to be acting as liberal individualists. There was also the implication that gender inequality in formal politics was not the most pressing problem. One respondent summed up this position very well by stating: 'I play the very same role as a man . . . if equality does not exist that equality is not there because of the women themselves, it's not imposed on you . . . If they are always prepared to put the kettle on and make the tea, that's what will always be expected.'[59] Here there appears to be no patience with women engaged in traditional roles or any feeling that the inequality is at all problematic. This respondent claimed to have not encountered any problems in jumping the hurdles to her place in the Legislative Assembly; therefore neither should any woman who is determined enough, and so there should be no preferential treatment.

Another respondent took a similar stance in terms of her determination and self-assurance regarding her ability as a politician. However, she is aware of the effect of the male dominance of formal politics:

> In 1985, I was the first lady councillor for the DUP in Castlereagh —there were ten of us, nine were men and I had to fight for myself. You had to win the confidence of the men that you had the ability to do what they could do. You weren't looked down on by any means but to be treated as an equal you had to show you could do the job as well as they could, and I did show them that. I'm whip of our group within the council, although not this year because I was mayor, but I've been whip and as a result of that I have a fairly high profile within the council and within the group. I think that nowadays women are more accepted particularly with the intake of women Labour MPs . . . long gone are the days when the women stayed at home and washed the dishes. My husband regrets that I have to say but, he's not so fond of women's lib I'm afraid.[60]

Despite having seen the impact of the election of 101 women Labour MPs at the 1997 Westminster elections, which had been facilitated by all-women shortlists, she would still not advocate positive

discrimination. From her statement, the inference can also be drawn that to be treated with respect, a woman has to demonstrate her ability to her male colleagues with the assumption that the latter are *unquestionably* able politicians.

A number of respondents took the position that women have a different approach to politics although they desire the same outcomes. Although many preferred to adopt a 'gender-neutral' approach in terms of their candidacy, or viewed their gender as a potential handicap, for one there had been a positive effect. She had been persuaded to stand for the Assembly elections because party colleagues believed that under the STV electoral system a woman candidate could 'sweep up added votes that were obviously going to be needed because [they] could see a split coming' after the referendum on the Belfast Agreement.[61] Furthermore, there is evidence of a gender difference in voting on the referendum. Although 71.2 per cent of the population voted 'yes' to the Belfast Agreement, it is estimated that between 51 and 53 per cent of the unionist and loyalist population was in favour of it.[62] The Northern Ireland Referendum and Election Study 1998 found that Protestant women were slightly more likely to vote 'yes' than Protestant men because they felt that they had responsibilities to future generations. Indeed, had those Protestant women 'waverers' voted differently, the final result would have been 64 per cent in favour, thus giving the Belfast Agreement much less weight.[63] The reason for this respondent's candidacy elevates her gender as a potential vote-winner over her political abilities. Why was it deemed that a woman could 'sweep up added votes'? There is a suggestion that STV has a positive impact on gender representation.[64] Perhaps the stereotype of the 'nature' of women led to the view that she would have provided a 'softer' candidate that would appeal to a wider constituency. But, as she went on to elaborate, the abilities and network of contacts that she held made her an ideal candidate, regardless of her gender:

I have a wide spectrum of friends and acquaintances in [Fermanagh and South Tyrone], I'm quite well known in all sorts

of areas from politics, to ornithology, to flower-arranging, so I could gather in and did gather in a wide spectrum. It was actually quoted in the *Irish Times* that I was the first Ulster Unionist politician that got a broad consensus of votes because I swung in quite a few SDLP women behind me . . . I think they . . . knew that I was honest in what I wanted to do. I was in there to work, to make something work in Northern Ireland and get democracy back here . . . Some of them did come and say, 'We're glad you're elected because you're a woman and we feel you'll be able to do more.'

So some members of the electorate believe that women politicians could make a difference to political outcomes. In this case, the UUP had capitalised on the gender of their candidate with a view to picking up second- and third-preference votes to ensure the UUP took another seat in the Legislative Assembly. This suggests that gender will be used in a somewhat cynical fashion when there is political advantage to be had; otherwise a gender-neutral approach will be adopted.

Respondents were asked why they thought unionist and loyalist women were generally still so invisible. In the ensuing discussion the interviewees highlighted the existence of a number of 'hurdles' that women may encounter. The hurdles may be of a personal nature, they may be institutional or they may be political. Some manage to jump over them all, while others may face only a number of the hurdles, and appear to take a short cut to formal politics. Many stop at the earlier part of the assault course because they are content to remain behind the scenes or because the hurdles are too big. Are those who make it to the end of the course better at politicking, are they political superwomen?

The hurdles may act to reinforce each other. For example, in this section the issues highlighted as potential barriers to political advancement are time, family responsibilities, money, stereotypical attitudes and being in a minority. The stereotypical attitudes held by both men and women regarding what is the proper role for women, and the view that men are better politicians than women, is informed

by largely traditional conservative political attitudes. The onus is on women to be homemakers and caregivers, while the formal political institution is not organised with child- and/or elder-care in mind. Meetings may go on late into the night when they could be arranged to coincide with school hours. That women remain in a minority in the formal political sphere means that it is difficult to challenge stereotypical attitudes and many have no choice but to remain stoical and adopt the strategy of proving they are 'just as good'.

Women politicians tend to be concentrated in the less powerful positions as councillors, although even at this level they remain in a minority. As was indicated earlier, being a councillor is viewed as a valuable learning experience that will equip women with the political skills necessary to stand for higher office. However, what may dissuade women from standing for election as a councillor is that, in addition to the timing of council business, it is not a salaried position, so many will have to engage in paid work, while also juggling the unpaid work of caring for their families. Hence it may constrain their political ambitions. One respondent relinquished her position as the party's environmental spokesperson because:

> [B]eing a councillor, still having to work, still trying to look after a home and children, it was hard to get it all together . . . I think with the level that I'm doing at the minute, I can cope with it . . . I would rather do less and do it better than be spread too thinly over too many things . . . I did run for the Assembly elections . . . it would have then been a job on its own without having to go and work as well . . . but it wasn't meant to be, I wasn't elected.[65]

This quote demonstrates the need for both time and financial resources to facilitate greater participation. Because such positions are salaried, securing regional, national or supra-national election means that a person can dedicate themselves full-time to their political objectives.

The time-consuming nature of local government was confirmed by a respondent who stated she attends meetings 'nearly every night

of the week' from September through to the summer.[66] Another interviewee finds it

> [V]ery difficult, I work full time . . . and I also have a home life and family, so I thought it was a bit much, but anyway, I've done it this year and I'm rather enjoying it, trying to juggle work and being a mayor, but as long as the work's done . . . I love my borough and anything in my power to help my constituents I do.[67]

So the problems of time, family responsibilities and money act to form barriers to greater political involvement. Even if the women manage to overcome such barriers, they still have to deal with stereotypical attitudes, however.

An interviewee described the problems she faced regarding standing for council election. She had found that sons were invited to stand when their fathers retired or died. Furthermore,

> when a vacancy did come on Dungannon council I was invisible . . . [T]hey went to somebody's son whose father had been on the council thirty years ago . . . I was a 'backstop' for so many years, [but when there was] . . . a visible position on the council, one that was possible to win, I wasn't even seen for it.[68]

This quote suggests that male dominance of politics is so entrenched that it has become part of the institution. The opportunities for election to higher office are rather limited and are affected by the attitudes of the members of local parties who manage the selection process. In outlining the problem women politicians face, one respondent stated:

> in this constituency it would be very very difficult for a woman to be selected . . . I have already told our Ulster Unionist councillors on two occasions that they are all male chauvinist pigs, and whether the delegates think that women can't do the job as well as men, I just don't know . . . For the Assembly elections, in the

selection meeting, we did have two members, two ladies and two men, and both men were selected. And also for the Forum we had the same two ladies, one was Sylvia [McRoberts] and one was Elaine McClure, and the two men came out first and second, and the two ladies third and fourth.[69]

Another difficulty faced by women who want to take on a higher political profile was outlined by a respondent whose experience was that 'women will not vote for women' and that '70 to 80 per cent' of women members will vote the way her husband does. She argued that:

the wee woman goes to the meeting with her husband and there's three men and a woman up there for maybe selection or something, and he's, 'Oh, I'm taking John, Dick and Harry and you do the same.' . . . [T]he Assembly, now North Down for example, three women went forward and seven men and there was fifty-two per cent women in the meeting, and three men got in, the reserve was a man, the fifth one was a woman.[70]

However, voting in selection meetings for male candidates is not necessarily because the women do not want to see more women representatives. It can be a matter of tactics, as another respondent explained:

If by voting for a woman you let the less capable of the two male candidates get in, you'll vote tactically, even if it means not voting for the women candidates. Of the two male candidates there would have been a better one and we couldn't just all go out like women's libbers and vote for both women candidates, and to heck with the two male candidates because we knew that if we didn't vote in the proper way the less capable, as we saw it, would get in . . . It hurt me to do it, but we had to do it in the end because in our heart of hearts we knew we weren't going to get women elected so it was pointless to throw caution to the wind for the principle.[71]

The perception that men are better politicians than women persists in certain areas, and particularly in rural areas where 'the farming community, they always see the man as being the person who will be able to represent them best, and the man's going to know all about pig subsidies or whatever it may be'.[72] A similar point was made by a respondent who had stood in the June 1999 by-election to Lisburn council. Part of the Lisburn council area are rural and so,

> you were up against the farmers who don't vote for women . . . There's a saying in Northern Ireland—put a collarette on a donkey and people will vote for it, put a collarette on a woman and they won't. I'm also a member of the Orange Order and I played my Orange card and it still didn't work.[73]

The evidence suggests that the odds are stacked against greater female representation in the formal political sphere, particularly at the regional, national and supra-national levels. Election to local councils has a great educative potential and may develop the confidence to stand for higher office. However, women face difficulty getting through selection processes due to prejudiced views regarding their political acumen. If this hurdle is overcome there is then the pressure of the demands placed on an individual's time along with the potential financial constraints of being an unsalaried councillor. This combines to make some women feel that they are unable to *do* any more. But there are other women politicians who are engaged in many and varied roles, who have not had any difficulties in getting elected. Unionist and loyalist women as political representatives deal with many and varied responsibilities and negotiate obstacles to their political activism. The chapter will now move on to consider those other respondents who are politically engaged in their parties: the party activists.

PARTY ACTIVISTS

Four of the respondents fell into the party activist category but, as
noted earlier, there was much overlap between this and the party
representative category. The former role is where the women tend to
begin their political careers, and will then continue to carry out
'activist' functions, such as attending meetings, fund-raising and
electioneering, despite having taken on a higher profile. In light of
this, testimony from both categories of respondents will be drawn
upon to illuminate this particular political role. Party activists face
the same sorts of hurdles outlined in the previous section, hence they
are largely invisible.

Party activists are engaged in the sort of work that ensures
political parties function. This work is vital to the political parties,
which would not be able to operate as effectively without it. They are
involved with much of the practical organisational work, such as
arranging and attending meetings, ensuring fundraising events are
successful, the collection of party subscriptions, providing adminis-
trative support (often in a voluntary capacity), and holding social
occasions, which includes the catering side. They are part of the
party machine that swings into action to support candidates for
election, and this work includes door-to-door canvassing and
leafleting.

Many respondents acknowledged that without the input from
women party activists, there would be no 'party'. One argued that:

> At grassroots level and in the constituencies the women are the
> backbone of the party. I would say that if the women pulled out of
> the unionist party, the unionist party would fall completely. The
> women are really the power base and it's a power base that's never
> been recognised . . . They do everything, absolutely everything . . .
> they collect money, the party subscriptions, they are the treasurers
> in some cases, in most cases they are the secretaries, and if [the]
> husband is the chairman, I can guarantee it's the woman at home

that does the bits and pieces and reminds him about meetings and everything else. And at all levels throughout the rest of the constituency a lot of the active workers in [party] offices . . . are women and they are very able. So . . . it's not just tea and buns and opening up halls.[74]

This suggests that the women are more than capable of taking on a higher political profile, and, as was indicated in the earlier section, that some women who have managed to jump the hurdles do not feel they have been held back. This raises the question of whether it is partly to do with women not considering themselves to be political animals.

One respondent talked about her perception of women in the unionist parties. Of women in the DUP, she said: 'Generally speaking they are there to be supporters in all the very domestic ways. They rarely take part in strategic or policy committees.' With regard to the UUP women, she argued that there are many

very capable unionist women, they're mostly working, like in our own party, behind the scenes, mostly working in the councils or local organisations. There's a lot of them and maybe this is the traditional Northern Ireland attitude, they feel it's a man's place to be in the political arena and that's not taking away from themselves—they don't see that—they just see that that's their natural role, to support the men.[75]

This traditional attitude suggests the sense that the male dominance of the formal political sphere is not at all problematic.

The women make a contribution to the general work of the party, but in a way that replicates the domestic role of the private sphere. A respondent confirmed that this was where the political activity of women was concentrated, by referring to the words of her party leader:

We do have more women in branches throughout the province, and Dr Paisley has said this time and again, without the women

our party would be nothing because they are the ladies dedicated to knocking the doors, selling the party on the doorstep at each election, making the tea . . . it's important —an army works on its stomach and they need fed. Everybody is cherished for what they can contribute.[76]

Again, there is the view here that the party could not survive if the women did not devote so much of their time to it, along with the reference to the domestic role, but with the assurance that such work is 'important'. The 'domestic' element of being a party supporter was also noted by a respondent who 'used to work fairly behind the scenes in the Party before I came to the fore. Like all women they seem to start making tea and serving tea and making sandwiches.'[77] It is understandable that unionist and loyalist women are seen as 'just tea-makers' and tend to be derided for it, and such a perception explains the entrenched nature of the attitude that women do not make good politicians.

In describing social events and the contribution that women make, one interviewee noted: 'We would run wine and cheese and table quizzes and things like that and I can guarantee it's women who organise it. So we probably, without realising it, we are taking quite a weight off the organisation.'[78] Another added:

I don't mean to say that women just sit back and make tea and sandwiches and sponge cakes, but I think that's a role that women take on more easily than men . . . [Y]ou get a lot of men who sit and look at each other and they haven't the foggiest idea of how to start to organise something like that . . . [It's] like an extension of getting the family meal at home, really.[79]

Not all respondents had had to jump the hurdle of being viewed in a domestic capacity, however. For example, one described her role within the party and there was no mention of serving beverages. She was:

a member of [the local] branch. That has been my arena for
learning political debate, and for any sort of activism . . . I was . . .
asked to join [the PUP] arts, culture and equality policy making
group, and I wrote their arts policy for them and worked on their
cultural policy. I'm also a member of the Women's Commission
and we wrote the policy which particularly relates to women's
issues, a range of things from women's conditions at work to
child-care, to healthcare, to abortion.[80]

Despite being relatively new to the party, this respondent's
involvement included input into policy formation and engaging in
political debate with her local branch. Another respondent, who was
conscious of the view of unionist women in politics, stressed her
involvement in political debate: 'I love fighting elections, meeting
with people, some you don't have to persuade, others you try to
persuade and others you'll never persuade . . . But certainly I never
made the tea, neither for the Ulster Unionists nor the Democratic
Unionists.'[81]

Being out of the public gaze of the formal political sphere was
considered by some respondents to be a positive thing: better to be
invisible and making a contribution than to be in the limelight and
take the glory along with possible vilification. The women who form
the 'backbone' of unionist and loyalist parties were, for one respondent,
engaged in the most important role. From her experience of politics
in the PUP, she had come to the conclusion that women could draw
upon their life experiences and hence contribute to the political
thinking behind party policies:

Unionist women are the people in the background, the people
who make things work and we do push the men to the front, but . . .
personally speaking I wouldn't want to be there in the front
because I think the influence in the background is much bigger . . .
The front image is all right and you need a good spokesperson,
but in the background there has to be the thinkers of the real

issues . . . The women in politics now, from my own party are
some of the greatest thinkers in the party because we've been
there, done it, we know what we're talking about and the men
don't get off with very much.[82]

If this were the case, then surely more women would be elected to
higher positions within the parties—for example, as party officers—
so that they have more direct input into the policies adopted by their
parties. The hurdles must come into effect here to prevent the
advancement of women within the party structures.

As noted earlier, the respondents who have been categorised as
party representatives have been and still are party activists, and it is this
educative experience that has enabled them to take on a higher profile.
One respondent was active in student politics at Queen's University
Belfast, and then 'got more involved in the party, canvassed a lot for the
party, worked at party headquarters and got to know everybody . . . I
think I built up a reputation as a hard worker, someone who was
dedicated to what they were doing and John Taylor, MP for Strangford,
phoned me and asked me to stand for Castlereagh council.'[83] Despite
being a representative, the supportive role remains an important
element of political activity. This was certainly the case for another
respondent who described her role as 'trying to raise money, talking
to people, going to party conferences. It's difficult to know whether
you're playing a role or not but you're there and you're supporting
the party, and I suppose that's the main thing.'[84]

Although the 'party activist' category remains the predominant
political role that unionist and loyalist women engage in, there is a sense
that this picture is changing. The unionist and loyalist political parties
are more aware of the gender imbalance in politics along with policy
that affects women. The media interest in the Northern Ireland
Women's Coalition (NIWC) in the lead up to the elections to the 'All-
Party Talks' in 1996 created the impression that Northern Ireland
politics is an exclusive boys' club. While the majority of women remain
invisible, they are most certainly politically active, and the extended

period of time known as the 'peace process', during which tensions have not been so high, has created the space for discussion about representation, and has encouraged more women to risk a higher profile. A number of respondents were guardedly optimistic. For example, one respondent talked about the future of women's political participation:

> Speaking just about the Ulster Unionist Party, historically women's roles were as they were in society, sort of backroom supporters, fund-raisers, caterers, holding public-speaking competitions for schools . . . and that was historically the right thing to do at that time. Society has changed and I think there are women who want to become involved politically. I've always said, if women want to make the tea and be fundraisers then that's their choice and they're happy with that, fine, I'm not saying that is wrong. But I think the choice should be there and people should be able to progress through the system to elected office if that's what they want or to office within the party.[85]

Another respondent also felt that there were changes in terms of women's participation, but did not think they would happen at a particularly fast pace.

> [A]t one time unionist women wouldn't have been involved in politics at all. They would have been the ones who would have made the tea and tidied up the office, saw their men off in nice clean shoes, and they weren't really interested. It wasn't the thing to do to be seen to be involved in nasty things like politics. It's changing slightly but the bottom line is . . . it takes a long time to convince some of the men that some women can in fact think every bit as rationally and do things every bit as well as they can, and they still have a mind set that because you're a woman there's certain things you can't do. I think that is changing.[86]

It would seem that among some party activists there is a certain reluctance to take on an additional role, and that among others the

desire to do more is there but there may be obstacles in their path. The chapter now turns to consider the respondents who appear to prefer to direct their political energies more specifically in the community.

COMMUNITY REPRESENTATIVES AND ACTIVISTS

This section considers both the community representatives and activists because of the small number of respondents who were included in these categories. The section will explain the sort of activities that community representatives and supporters engage in, to develop an understanding of the breadth of political activity in which unionist and loyalist women are involved.

In many cases, women community representatives have worked for years in their community and are now able to use their experience as leaders and representatives, and act as spokespersons and lobby on behalf of their community. The community supporters are members of community organisations such as single-issue politics groups, residents' associations, and cultural and religious groups. They volunteer their time and energy to support their community group.

For some, community politics is the most important form of politics, and this opinion is born of a frustration with the deadlocked and blinkered approach of 'big P' politics. Previous research has shown that women have become actively involved because of issues affecting them, their families and their community that have not been addressed by their politicians. Through women's and community groups they have secured funding from organisations such as the European Union to deal with the matter.[87] Community politics includes socio-economic problems, which are also described as 'bread and butter' issues; victims of the conflict such as bereaved families or those who have survived paramilitary attacks; 'women's issues' such as inadequate child-care, access to education and domestic violence; support for (ex)-prisoners and their families; and support for community culture such as bands, the Loyal Orders, murals and the organisation of festivals.

One respondent summed up the view that community politics addresses the problems that people face on a daily basis, and is therefore more valuable and realistic than the narrow focus on the issue of the constitution:

> prior to the Agreement being signed I spent two months up in Stormont and I was terribly impatient, waiting and waiting for something to happen, and I actually did leave very early on one morning. I thought, my God, what am I doing here, when I could be out in my community actually working with people and doing something to ease the pain. So I left and did just that and felt all the better for it. I wasn't there when the Agreement was signed. Community politics is much more important than the displays we're seeing up here at the minute. You see an awful lot of childishness on all sides. It's like everybody owns a football and, 'If you don't play with me and my way, I'm going home.'[88]

Frustration with the inaction of formal politics is evident here. The conflict has meant that (mainly working-class) women have had to get on and deal with the problems around them. Another interviewee talked about her experiences of working in the community during 'the Troubles', when she was involved with 'women—on both sides of the divide, because the men were in the Long Kesh or whatever. You found most women were doing the work and looking after bread and butter issues, trying to keep the community together.'[89] Managing in this way means that many women are equipped with the practical skills invaluable to the development of policy.

Aside from socio-economic problems, the impact on communities living in a protracted conflict situation is serious and enduring. Intra-community groups have been established to alleviate some of the pressures and provide counselling and advice, and as they are formed by and for members of the community affected, there is less suspicion from those who feel vulnerable. For example, the chairperson of Families Acting for Innocent Relatives (FAIR) felt that the victims of

her community had been ignored and that 'no official counselling has been offered to members'.[90] Through meeting regularly, the group has given its members a chance to talk about how their lives have been affected. She is involved with organising the group, liaising with other groups, and speaking about victims within the Protestant community. Approximately three-quarters of the members of FAIR are women, a lot of whom are widows. A woman member described their activities:

> We would support them in whatever way we can, [at] meetings and [through] fund-raising, and when meetings are planned to go to Stormont . . . we like to be there to show [our] support . . . I have been interviewed several times and we have that morning programme that's on, there's been a lot of stories told there. And they've had the FAIR lunch at Stormont and a lot of stands up with photographs of the bombs and the murders, funerals and that type of thing has been displayed there.[91]

Another woman revealed the risks that she is taking through being a member. She stated: 'I wouldn't be a leader like Reatha [Hassan], but I would be a supporter. I would have the courage of my convictions . . . it's a delicate balancing act here, because we all think its going to start up again and if you put your head above the parapet you're liable to be picked off.'[92] This quote shows the level of fear and suspicion held by some within this community and suggests another hurdle to be overcome before taking on a more public role.

Some projects have the funds to employ community workers. There is a need for people to be able to devote themselves full-time to matters such as the problems of those who live in deprived areas, and fostering cross-community development to facilitate conflict resolution. One of these community workers argued that women are 'there on the ground. We want to see things happening and to be honest with you sometimes I think the politicians are sitting in Stormont doing nothing . . . [W]e're too busy on the ground working and getting things done.'[93] Another noted that being active in the

community had been an educative experience that led her to going to Magee College to do a community development course:

> I started to become very active within the community. It was hard because there was nobody else in our community doing it, but it was easy because people are crying out to get Protestants on courses so there was always a space if you wanted it . . . I felt like I was moving on and I was leaving a wee bit of my community behind. It takes along time to realise that you're not leaving them behind, you're bringing them with you.[94]

In effect, taking the step of getting more involved and then developing skills further is a bold one and requires at least a modicum of self-confidence.

The conflict affects the perpetrators as well as the victims of paramilitaries. One of the respondents works to understand the prison experience from the loyalist prisoner's perspective, by doing research such as interviews with ex-prisoners and family members. She noted that the wives had to cope with bringing up their families and because, at the time, their husbands were political prisoners, 'they were entitled to wear their own clothes and have their own money. So the wife [had] a big responsibility to supply him with his clothes and food and everything, Christmas parcels . . . I seen women going up there [to the prison] with busted shoes and that, and yet they had to get the most expensive pair of trainers for their husband.'[95] Another is responsible for supporting ex-prisoners and their families through advice regarding benefits, housing, employment, training and counselling. She is also involved in work in the broader community through a youth group and cross-community work. Their work has shown how the conflict has affected women family members. She noted that if a woman's husband 'wanted something you felt you had to get it for them because they were in there. I was lucky, Ralph [husband] didn't ask, he was very good, he wasn't one that demanded a lot of clothes but yet at the same time,

you like them to have what everybody else was having. It was very difficult.'[96] Another respondent also noted the pressure on families that such groups attempt to alleviate. She explained that one of their functions was: 'to support the family and try to keep [it] together—too many cases you'll find that on release the marriage will break up, or it will break up while he's inside'.[97] Such groups provide an important focal point for those members of the community who are both perpetrators and victims of the conflict.

An aspect of unionist and loyalist culture is expressed through the Loyal Orders. While they are largely—and, in the case of the Apprentice Boys of Derry and the Royal Black Preceptory, exclusively—male, there are the 'sisters' of the Women's Orange Association of Ireland. There are approximately 450 women from Northern Ireland in the Orange Order.[98] There are also women members in the Republic of Ireland, Scotland, England and Wales, but there are no centrally held records of membership numbers.

The focus of this organisation is cultural and religious, with a very traditional outlook. For one respondent it was a social rather than political organisation, although there are links between the Orange Order and the Ulster Unionist Party, to which some of the sisters are 'delegates to their local constituency association and we do have, I think maybe it's about twelve members who would be delegates to the Ulster Unionist Council. And we have members as delegates to the executive committee . . . At the [Orange] meetings there wouldn't be anything political.'[99] While the Orange Order is perceived as a political organisation because of its connection to the UUP, the women's association avoids the 'political' aspects of Orangeism. For one respondent, her lodge was 'more like a social club'.[100] Another described the sort of activities that Orange women engage in. The women's associations meet on the first Wednesday of each month and:

we always open with prayer and a Bible reading . . . Then we have our business and then we close with prayer and the singing of the

National Anthem. And then afterwards we always have a cup of tea . . . The Orange women can be affiliated to the Unionists, there are delegates elected for that, but I'm not a delegate or anything like that, you know, I just think it's cultural.[101]

As Lodge Secretary, she is responsible for 'taking minutes, writing notes, replying to letters and just doing mostly the business matters'. Women like this respondent support community activities such as cultural evenings, rallies and church services.

Another Orange woman summed up the ethos of the women's Orange Order by explaining that: 'There's a great friendship and rapport, and it's very much based on Christian principle . . . They do an awful lot of good works in terms of charities, etc., that go on in the background, which obviously isn't highlighted when it comes to contentious issues that have pertained over the last number of years.'[102] The 'contentious issues' are the politicised annual parades. So while the sisters are involved from a social and cultural per-spective, membership does have an underlying political connotation. Participation in this sort of community organisation has an 'expressive' quality, in that through being part of the group the members are making a statement regarding their political and cultural allegiances. They wear the orange collarette and may take part in parades if invited to do so by the men's lodges.

In a society as fragmented as Northern Ireland, the work of women in the community can be a positive force in addressing or highlighting particular needs and thus gaining the attention of the formal political sphere. It can also ensure the continuity of the cultural identity of the community.

ANALYSIS

While nationalism can explain the motivation to political action it does not so easily illuminate the roles in which the women are engaged. However, society is shaped by nationalism, and this in turn

contributes in some way to the hurdles that the women face to taking on a more public political role. In addition, boundary-marking behaviour is an important part of nationalism and may influence the decision to act politically in the public sphere.

Gendered national symbolism works to convey the sorts of roles suitable for men and women to engage in in the national project, and in unionist nationalist discourse there is a lack of positive female imagery. This can help to explain the relative invisibility of unionist women in formal politics. The conservative concern to maintain traditions has evidently spilled over into attitudes, and hence many unionist women remain in the background of politics, taking up a supportive, auxiliary position, 'doing their bit' but remaining relatively invisible to the public sphere. While some such women are challenging conventional understandings of the role of women, for others there is an acceptance of the status quo in which women are the primary carers. There are patriarchal pressures to conform to a traditional gender role due to influential politicians, clergy and even husbands' expectations of women.

According to Joanne Nagel, 'all nationalism tends to be conservative, and "conservative" often means "patriarchal"'.[103] Although there are examples of progressive developments for women in nationalist movements, these have often been short-lived.[104] The purpose of the national project is to maintain national identity and, in the case of unionism and loyalism, which are bound up with reacting against change, there is little room for questioning the status quo. Conservative views on respect for the institution of marriage and the family correspond very well with patriarchal society. When mixed with a defensive nationalism, women may be called upon to support the nation in a manner that befits their societally determined role. This relates back to the point raised in Chapter 4 about women being exhorted to 'breed for their country'. For many women participants, the activities of the 'back room' mean that their contribution does not challenge the status quo. Again there is the sense that there is nothing wrong in this, that things have always been this

way. Men are the candidates for election, the ones who do 'big P Politics', and the ones who parade. For those women who are prominent in the public sphere, they are there for their country and the people of Northern Ireland.

The evidence refers to the unwillingness of the women to support any form of positive discrimination to increase women's political participation. Instead they showed signs of a liberal individualism mixed in with their nationalism, and some used the language of liberal feminism. The paramilitary ceasefires and the ongoing political process created an 'opportunity space'. The establishment of the NIWC in 1996 and the subsequent reaction of the political parties— notably greater receptivity to gender issues—has maintained that 'opportunity space'. While Wilford[105] argues that women need power to take advantage of such spaces, these can still be utilised to remind society that women have inadequate representation. Therefore change is incremental rather than dramatic. Women who take advantage of the opportunities are a strategic vanguard. Another 'opportunity space' has been created in an organisation with a traditional outlook, the Orange Order. Women have been invited to parade because there is a need for numbers to enhance visibility. They are therefore being brought in from their cosy social sphere to fulfil a political need, which could be utilised in future.

Male dominance of politics could be explained in terms of political expediency, or in terms of the patriarchal and conservative nature of society. But as Nagel argues, the latter traits are linked with nationalism. The literature on women and political participation refers to issues such as structure, education and so on, which also must be drawn upon to understand the position of unionist and loyalist women.[106] Used in conjunction with an exploration of the gendered nature of nationalism, however, it will provide a deeper explanation of their political roles. If the stereotype that 'unionist women just make the tea' had greater veracity then the lack of positive female nationalist symbolism might have explained such a phenomenon. However, as the empirical evidence has shown,

unionist women participate at all levels of formal and community politics. They also make up a substantial part of political party membership: 50 per cent of the (UUP),[107] 60 per cent of the DUP and 33 per cent of the Progressive Unionist Party (PUP).[108] That women are in a distinct minority in the upper echelons of formal politics and engage largely behind the scenes could be explained from the perspective of gendered nationalism. Although unionist women are not exceptional in their political under-representation, the percentage of women elected to political institutions is lower in Northern Ireland than in other regional political institutions in the UK and in the European Parliament. The representation of women in the member states of the European Union is in some cases approaching parity, while in others there is a long way to go before political equality is reached.

There are several reasons for the different levels of gender representation. There are varying electoral systems, with proportional representation (PR) tending to produce a greater gender balance. Clearly the system in place is not the only factor, because Northern Ireland elections are by PR. In Scotland and Wales, the Additional Member System (AMS) is used. In both cases a twinning mechanism is used by the Labour Party, which resulted in women making up half of the Labour members of the Scottish Parliament,[109] and just over 50 per cent of Labour Assembly Members in Wales.[110] Twinning is the selection of one man and one woman to stand in twinned neighbouring constituencies. The level of representation at Westminster was almost doubled in 1997 due to the Labour Party's use of all-women shortlists in the selection of candidates, until the practice was challenged on the grounds of sex discrimination in an industrial tribunal.[111] The number of women MEPs in the UK increased from 18 per cent in 1994 to 24 per cent in 1999, following the introduction of PR. The Liberal Democrats used a zipping mechanism for this election, which involves arranging the candidates on the party list alternately by gender, and the Labour Party also 'made a concerted effort to place women in electable positions on their lists'.[112]

Political institution	No. of male representatives (%)	No. of female representatives (%)
European Parliament	510 (69.7)	222 (30.3)
[of which, UK MEPs]	59 (75.6)	19 (24.4)
(2004 election)		
British House of Commons	517 (80.2)	128 (19.8)
[of which, Northern Irish MPs]	15 (83.3)	3 (16.7)
(2005 election)		
Scottish Parliament	78 (60.5)	51 (39.5)
(2003 election)		
Welsh Assembly	30 (50.0)	30 (50.0)
(2003 election)		
Greater London Authority	15 (60.0)	10 (40.0)
(2004 election)		
Northern Ireland Assembly	90 (83.3)	18 (16.7)
(2003 election)		
Northern Ireland Councils	460 (79.3)	120 (20.7)
(2005 election)		

Table 5.1. Comparison of male and female political representation

Research into gender and political participation has shown that there is a supply-side deficit in women candidates.[113] This is due to the differential access between women and men to the resources that facilitate political selection. Time, money, political experience and relevant occupational experience may be constrained by family responsibilities. There is also a question of differences in political style that has been identified by women politicians.[114] These generalised differences may act to dissuade women from standing for election. Indeed, '[p]olitical practices involving demagoguery, ruthlessness and aggression require qualities which are culturally accepted in men but not women'.[115]

Eileen Bell (Alliance Party of Northern Ireland—APNI) argued that women work mostly in the background because there is a 'traditional Northern Ireland attitude' that their role was to support the men. So

Member state (date of election)	Lower or single house No. of female representatives (%)
Austria (2002)	62 (33.9)
Belgium (2003)	52 (34.7)
Cyprus (2001)	9 (16. 1)
Czech Republic (2002)	34 (17.0)
Denmark (2005)	66 (36.9)
Estonia (2003)	19 (18,8)
Finland (2003)	75 (37.5)
France (2002)	70 (12.2)
Germany (2002)	197 (32.8)
Greece (2004)	42 (14.0)
Hungary (2002)	35 (9.1)
Ireland (2002)	22 (13.3)
Italy (2001)	71 (11.5)
Latvia (2002)	21 (21.0)
Lithuania (2004)	31 (22.0)
Luxembourg (2004)	14 (23.3)
Malta (2003)	6 (9.2)
Netherlands (2003)	55 (36.7)
Poland (2001)	93 (20.2)
Portugal (2005)	49 (21.3)
Slovakia (2002)	25 (16.7)
Slovenia (2004)	11 (12.2)
Spain (2004)	126 (36.0)
Sweden (2002)	158 (45.3)
UK (2005)	128 (19.8)

Table 5.2. Political representation of women in the member states of the EU (figures from the Inter-Parliamentary Union: http://www.ipu.org/wmn-e/classif.htm)

with this 'traditional attitude', there is the sense that the male dominance of the formal political sphere is not at all problematic for many unionist women. The women make a contribution to the general work of the party but in a way that replicates the domestic role of the private sphere. Wilford suggests there is no significant difference in the political participation of men and women at non-élite levels. Rather, he argues: 'irrespective of sex, religious beliefs, or

stated national identity, people who are politically active and politically interested tend also to be highly educated, to have a high occupational status, and to be in their middle years'.[116] However, this argument is from a quantitative perspective and is not specific to unionism and loyalism. Also, as noted earlier, the differential access to the resources of education and relevant occupational experience represents a handicap in the political selection process.

In Northern Ireland, the numbers of women representatives in local councils has increased over time, but this is due largely to their being persuaded to be candidates; men are reluctant to stand for a relatively powerless body.[117] Women politicians tend to be concentrated in the less powerful positions as councillors, although even at this level they remain in a minority. Being a councillor is viewed as a valuable learning experience that will equip women with the political skills necessary to stand for higher office. However, problems of time, family responsibilities and money can act to form barriers to greater political involvement.

The respondents reported that they had faced prejudiced views regarding their political acumen and hence have had difficulties in being selected as political candidates. Wilford et al. found that 36 per cent of the population believe that 'women candidates lose votes'.[118] However, they also found that 60 per cent supported the view that political parties were to blame for the low numbers of women in politics because they 'do not provide the opportunities that enable women to enter the public realm'.[119] The evidence suggests that the odds are stacked against greater female representation in the formal political sphere, particularly at the regional, national and supranational levels. However, election to local councils has great educative potential and may develop confidence to overcome the hurdles and stand for higher office.

In order to understand the reasons for the ongoing invisibility of unionist women in the politics of Northern Ireland, the literature on gender and political participation can be used to gain further insight than theories of nationalism afford by themselves. In light of the

different levels of female representation in the member states of the EU and the regional parliaments of the UK, the structure of electoral systems can ensure women have better representation. However, this in and of itself will not necessarily mean great changes in public policy. In conflict situations women, who have in common their biology and a patriarchal society, are politicised by issues that divide them. While they may be motivated by nationalism, the political structures that restrict their access to power are a factor of patriarchal society.

NOTES

1 D. Urquhart, 'In defence of Ulster and the empire: the Ulster Women's Unionist Council, 1911–1940', *UCG Women's Studies Centre Review*, 4 (1996), p. 31.

2 A. Jackson, 'Unionist history', in C. Brady, *Interpreting Irish History: The Debate on Historical Revisionism 1938–1994* (Dublin: Irish Academic Press, 1994), p. 852.

3 P. Gibbon, *The Origins of Ulster Unionism* (Manchester: Manchester University Press, 1975), p. 135.

4 P. Ollerenshaw, 'Businessmen and the development of Ulster Unionism, 1886–1921', *Journal of Imperial and Commonwealth History*, 28, 1 (2000), p. 42.

5 Ibid.

6 Jackson, 'Unionist history', pp. 852–3.

7 Ibid., p. 853.

8 Ibid, p. 860.

9 Ibid., p. 861.

10 N. Kinghan, *United We Stand: The Story of the Ulster Women's Unionist Council, 1911–1974* (Belfast: Appletree, 1974).

11 Urquhart, 'In defence of Ulster and the empire'.

12 Urquhart, '"The female of the species is more deadlier than the male"? The Ulster Women's Unionist Council, 1911–40', in D. Urquhart and J. Holmes (eds), *Coming Into The Light: The Work, Politics and Religion of Women in Ulster, 1840–1940* (Belfast: Institute of Irish Studies, Queen's University, 1994), p. 94.

13 Jackson, 'Unionist history', p. 852.

14 Urquhart, 'In defence of Ulster and the empire', p. 32.

15 The League of Women, an organisation formed to support the Irish Volunteers. See for details M. Ward, *Unmanageable Revolutionaries: Women and Irish Nationalism* (London: Pluto Press, 1995).

16 Urquhart, 'In defence of Ulster and the empire', p. 32.

17 Ibid., p. 33.

18 Ibid., p. 34.

19 Urquhart, '"The female of the species is more deadlier than the male"?', p. 100. See also A. T. Q. Stewart, *The Ulster Crisis: Resistance to Home Rule 1912–14* (London: Faber and Faber, 1967), pp. 58–68.

20 Urquhart, '"The female of the species is more deadlier than the male"?', and 'In defence of Ulster and the empire'.

21 Urquhart, 'In defence of Ulster and the empire', p. 38.

22 Ibid.

23 Urquhart, '"The female of the species is more deadlier than the male"?', p. 111–12.

24 Ibid., p. 115.

25 Centre for the Advancement of Women in Politics (CAWP), 'Former women members of the Northern Ireland Parliament and Assemblies' (2001), http://www.qub.ac.uk/cawp.

26 J. F. Harbinson, *The Ulster Unionist Party, 1882–1973: Its Development and Organisation* (Belfast: Blackstaff, 1974), p. 208.

27 I. Paisley Jnr, 'The political career of Dame Dehra Parker', unpublished MSSc thesis (Belfast: Queen's University, 1994), p. 22.

28 Ibid., p. 23.

29 Harbinson, *The Ulster Unionist Party, 1882–1973*, p. 200.

30 D. Urquhart, *Women in Ulster Politics, 1890–1940* (Dublin: Irish Academic Press, 2000), p. 198.

31 G. Lucy, *Northern Ireland Local Government Election Results* (Lurgan: Ulster Society, 1994).

32 Harbinson, *The Ulster Unionist Party, 1882–1973*.

33 Olive Whitten, UUP and WOAI.

34 Bernadette Devlin is a well-known socialist republican.

35 Sharon McClelland, UUP and WOAI.

36 My emphasis. Sylvia McRoberts, UUP.

37 K. Torney, 'Up to 200 women and children staged an hour long protest', *Belfast Telegraph Online*, archive, 29 July (1998).

38 Fairweather et al., *Only the Rivers Run Free*, p. 283. See also G. Bell, *The Protestants of Ulster* (London: Pluto Press, 1976), p. 55.

39 Anonymous, DUP.

40 Susan Neilly, WOAI.

41 R. Ward, 'The impact of women on the contemporary politics of Northern Ireland', unpublished MA thesis (University of Salford, 1997).

42 R. Miller et al., *Women and Political Participation in Northern Ireland* (Aldershot: Avebury, 1996).

43 Pauline Armitage, UUP.

44 Eileen Bell, APNI.

45 Iris Robinson, DUP.

46 Joan Carson, UUP.

47 Pauline Armitage, UUP.

48 Iris Robinson, DUP.

49 Margaret Crooks, UUP.

50 Ruth Allen, DUP.

51 May Beattie, DUP.

52 Anonymous, DUP.

53 Y. Galligan and R. Wilford, 'Women's political representation in Ireland', in *Contesting Politics: Women in Ireland, North and South* (Boulder, CO and Oxford: Westview, 1999), p. 136.

54 Dawn Purvis, PUP.
55 Baroness May Blood, NIWC.
56 Norma Coulter, UDP.
57 Irene Cree, UUP.
58 May Steele, UUP.
59 Pauline Armitage, UUP.
60 Myreve Chambers, DUP.
61 Joan Carson, UUP.
62 M. Melaugh and F. McKenna (2000), *The 1998 Referenda on 'The Agreement'* http://cain.ulst.ac.uk/issues/politics/election/ref1998.htm.
63 R. Wilford and S. Elliott, 'Targeted voters and the referendum', in *Agreeing to Disagree? The Voters of Northern Ireland*, CREST/QUB Conference in association with the British Academy (Queen's University, Belfast, 1999).
64 A. Lijphart, *Patterns of Democracy* (New Haven and London: Yale University Press, 1999).
65 Ruth Allen, DUP.
66 Sarah Cummings, UUP.
67 Myreve Chambers, DUP.
68 Joan Carson, UUP.
69 Olive Whitten, UUP.
70 Irene Cree, UUP and UWUC.
71 Sharon Mclelland, UUP and WOAI.
72 Sylvia McRoberts, UUP.
73 Norma Coulter, UDP.
74 Joan Carson, UUP.
75 Eileen Ball, APNI.
76 Iris Robinson, DUP.
77 Anonymous, DUP.
78 Sylvia McRoberts, DUP.
79 Sharon McLelland, UUP and WOAI.
80 Olwyn Montgomery, PUP.
81 Myreve Chambers, DUP.
82 Mina Wardle, PUP and SSTG.
83 Sarah Cummings, UUP.
84 Margaret Crooks, UUP.
85 Arlene Foster, UUP.
86 Valerie Kinghan, UKUP.
87 Ward, 'The impact of women on the contemporary politics of Northern Ireland'.
88 Mina Wardle, PUP and SSTG.
89 Baroness May Blood, NIWC.
90 Reatha Hassan, FAIR.
91 Lena Spence, FAIR.
92 Anonymous, FAIR.
93 Jeanette Warke, SCP.
94 Catherine Cook, PRG.
95 Marion Green, EPIC.
96 Marion Jamison, EPIC.

97 Joy Fulton-Challis, UDP and Prisoners' Aid, Post-Conflict and Resettlement Centre.

98 Personal conversation with Olive Whitten, WOAI, July 1999.

99 Olive Whitten, UUP and WOAI.

100 Susan Neilly, WOAI.

101 Elizabeth Watson, WOAI.

102 Iris Robinson, DUP.

103 J. Nagel, 'Masculinity and nationalism: gender and sexuality in the making of nations', *Ethnic and Racial Studies*, 21, 2 (1998), p. 254.

104 C. Cockburn, *The Space Between Us* (London: Zed Books, 1998); L. West, *Feminist Nationalisms* (London and New York: Routledge, 1997).

105 R. Wilford, 'Women, ethnicity and nationalism: surveying the ground', in R. Wilford and R. L. Miller (eds), *Women, Ethnicity and Nationalism: The Politics of Transition* (London: Routledge, 1998).

106 Norris, 'Gender differences in political participation in Britain'; Lovenduski and Norris, *Gender and Party Politics*; Norris and Lovenduski, *Political Recruitment*; Lovenduski, 'Sex, gender and British politics'; and Lovenduski, 'Gender politics'.

107 Galligan and Wilford, 'Women's political representation in Ireland'; and Walker, 'Gail Walker talks to unionist women demanding parity of esteem'.

108 Figures confirmed by the parties, 2004.

109 W. Alexander, 'Women and the Scottish Parliament', in A. Coote (ed.), *New Gender Agenda* (London: IPPR, 2000).

110 V. Feld, 'A new start in Wales: how devolution is making a difference', in Coote, *New Gender Agenda*.

111 M. Stephenson, *The Glass Trapdoor: Women, Politics and the Media during the 1997 General Election* (London: Fawcett, 1998). See also R. Ward, 'Invisible women: the political roles of unionist and loyalist women in contemporary Northern Ireland', in K. Ross (ed.), *Parliamentary Affairs* (special edition: *Women and Politics Revisited*), 55, 1 (2002), pp. 167–78.

112 J. Freedman, 'Women in the European Parliament', in K. Ross (ed.), *Women, Politics, and Change* (Oxford: Oxford University Press, 2002), pp. 181–2.

113 Lovenduski, 'Sex, gender and British politics'.

114 Arlene Foster, UUP. See also Miller et al., *Women and Political Participation in Northern Ireland*.

115 Lovundeski, 'Sex, gender and British politics'.

116 Wilford, 'Women and politics', p. 203. See also Norris, 'Gender differences in political participation in Britain'.

117 R. Wilford, 'Women and politics in Northern Ireland', *Parliamentary Affairs*, 49, 1 (1996), pp. 41–54.

118 R. Wilford et al., 'In their own voices: women councillors in Northern Ireland', *Public Administration*, 71 (1993), p. 352.

119 Ibid.

6

Conclusion: It's Not Just Tea and Buns and Opening Up Halls

In this chapter, I draw together the themes that have run throughout the book, rehearse the main elements of the argument presented and consider the extent to which my hypothesis is supported by the evidence. I argue that the approach I have taken provides a useful but partial picture of unionist and loyalist women in Northern Ireland, and that a synthesis between the literature on gender and nationalism and gender and political participation is needed. I also consider whether broad generalisations can be drawn between unionist and loyalist women and women from other national projects.

THEMES

The key themes of national identity, motivation and political action have been explored in this book with a view to developing understanding of unionist and loyalist women in Northern Ireland, who are relatively under-researched. Ideas from the literature on gender and nationalism, particularly those of Yuval-Davis and Anthias,[1] were used in the analysis of the interview and participant observation data. This was because I adopted the perspective that the political action of unionist and loyalist women would be structured by nationalism.

The consideration of the literature on gender and nationalism showed that ideas of gender and nation are closely bound up in identity formation. The nation is often symbolically a woman who needs defending by her brave sons against the enemy invader who would violate her. Certainly in the case of Northern Ireland much of

the unionist/loyalist symbolism found in murals, songs and poems is of the active male. While there are exceptions, such as the image of a strong warrior such as Britannia, the depiction of women UVF members in 1912 and the woman-as-Ulster standing against the threat of home rule in 1914, the female in unionist and loyalist symbolism is usually passive. Furthermore, there is a notion of appropriate behaviour of the women of Ulster that marks the difference between Protestant and Catholic women, thus symbolising group boundaries.[2] Evidence from the interview data showed that this lack of an active symbolisation of the women of Ulster was either not an issue of concern for the respondents as things had always been that way, or that this absence had not been recognised until it was raised in the interview. The male active and female passive in unionist and loyalist symbolism reflects the male dominance of political and paramilitary structures.

The majority of respondents prioritised their British national identity. Identity was used in a situational way, with unionism, loyalism, secular or religious Protestantism and gender identities referred to along with Ulster or Northern Ireland. Drawing upon Billig[3] in the analysis of unionist and loyalist women's national identities, it was noted that the daily rhetoric of 'banal nationalism' strikes a chord with both men and women but directs them to act in different ways in accordance with traditional gender roles. The culture that informs national identity is reproduced and transmitted to the socialisation of the next generation, and this is a key role for women in the national project.[4]

The literature on the ways in which nationalism acts to motivate individuals to become politically active refers to examples of state policies that act to control women's reproduction and their access to political power. It also records that women campaign against the national project because of the negative impact it has upon women, and that traditional gender roles may be subverted by the actions of women participating in a national conflict.[5] The motivation and political action of the respondents cited in this book must be seen in

a different context because they have been motivated to act politically in defence of the established nation-state. However, there is some commonality in that the women have been politicised by the threat to the domestic sphere, to their families and to the wider community through which cultural cognisance is reinforced. There is no overt state policy controlling women's reproduction or restricting their access to political power, hence wider structural explanations must be sought.

All the respondents have been motivated to become politically active through nationalism, heightened by perception of the difference of the 'other' and the threat it represents to their culture and national identity. There was also a perception of being distinct from other nations within the UK. Related to their gender role within the national project was the concern for the next generation. Respondents were also motivated by categories of family and/or social background, dissatisfaction with politicians or political parties, and the direct or indirect effect of the conflict, and these were related to nationalism. In separating these categories out, I presented greater depth to the explanation of nationalism as a motivator to political action.

In the analysis of the respondents' motivations from the perspective of nationalist theory, a key notion was that of instrumentalism, whereby individual interests are perceived in terms of group interests. The respondents had an interest in Northern Ireland remaining part of the UK because their understanding of themselves was reinforced through national culture.

In terms of political action, the literature on gender and nationalism shows that women are politically active on behalf of their nation but that this may be in specifically gendered ways. Raising children for the nation, rebelling against state nationalism, and fighting for national liberation while campaigning for the emancipation of women are ways in which gender and nationalism collide. In this case, while the women respondents may have been in part motivated by family reasons, because of the conflict or through dissatisfaction with the established politicians, their interests as

members of an established nation-state have resulted in political participation of a less romantic nature. The evidence showed participation at a number of different levels within formal and community politics. National interests have tended to be prioritised over gender interests. Those active within political organisations who do not hold any elected role or party office indicated that their participation was viewed as an extension of the domestic sphere.

The political action of unionist and loyalist women can be partly explained through nationalist theory with reference to the ways in which women participate, as outlined by Yuval-Davis and Anthias,[6] and the notion of the connection between conservative nationalism and patriarchy.[7] However, the explanatory value of this approach is limited and here there is a need to draw upon the literature on women and political participation.

HYPOTHESIS AND EVIDENCE

I used a qualitative approach to facilitate access to a relatively invisible group of political actors at both the formal and community levels of political action. This resulted in a depth of evidence that provides a better insight into the identities, motivations and political actions of unionist and loyalist women. The evidence enabled me to test the hypothesis that theories of gender and nationalism will explain the position of unionist and loyalist women more clearly, which was formed in reaction to the stereotype that they 'just make the tea'. The hypothesis is partially supported by the evidence. The respondents identified themselves in predominately national terms and had a sense of being distinct from the Catholic/nationalist 'other'. From the discussion with McRoberts (Ulster Unionist Party—UUP), Whitten (UUP and Women's Orange Association of Ireland—WOAI) and McClelland (UUP and WOAI) came the notion that this distinctiveness went some way to explaining the difference in political participation. Cultural differences made it more acceptable for nationalist women to make a public display of their views. This is a

stereotype that is not supported by the political history of unionist women's political action; however, such stereotypes act to inhibit action as they represent cultural boundaries at an ideational level. Unionist and loyalist women's political action takes place at many different levels in formal and community politics. This suggests that the notion of 'tea-making' is too sweeping and simplistic. However, politically active unionist and loyalist women are not well represented at the higher levels of politics and hence wield less power and have less direct influence. Many respondents who held elected office or positions of responsibility within their organisations described their role in terms of helping people, and this was dismissed by Armitage (UUP) as a 'social worker role'. A number of respondents had cited their family and/or social background as a reason they were motivated into becoming politically active. Within such responses included concern for the 'next generation'. Hence it could be argued that for many unionist and loyalist women, their political activity is in part a replication of their role in the domestic sphere.

The 'gender issue' did not seem to have a particularly high priority for many of the respondents. They were politicians first and women second. Sexist attitudes were acknowledged among the selectorate and certain sections of the electorate. In rural areas, the perception was that the electorate would not vote for women, as farmers believed male politicians to be more knowledgeable about farming subsidies. That aside, and even among the most 'feminist' of respondents, there was a reluctance to adopt positive discrimination because it would undermine those elected in this way.[8] However, sexist attitudes about women's ability to deal with politics beyond the social worker role need to be challenged if more women are to be able to reach powerful political positions by their own merit. Positive action strategies to train and support women and develop their confidence at public speaking are necessary. The work done by the Progressive Unionist Party's (PUP's) Women's Commission is a good example of positive action, while the UUP and Democratic Unionist Party (DUP) both recognise the importance of equality of opportunity.[9]

When the level of participation of women in politics across the UK and Europe is considered there are clearly other factors at work aside from nationalism that militate against the participation of women. A comparison of the proportion of women politicians shows that Northern Ireland is not so far behind other countries where national conflict is much less salient. It could be argued that the political participation of unionist and loyalist women is relatively high within a context of national conflict and that the defensive and reactive form of the nationalism in question is partly responsible for their political mobilisation. While the evidence in this book illuminates the reasons the women became politically active and the form and extent of their participation, it does not go far enough. In Chapter 5 reference was made to the 'hurdles' that the women respondents faced in relation to their participation in political parties. Here there is clearly a need for a synthesis in theoretical approach, particularly with the literature on political participation literature.

While there is some crossover in the literature on women's political participation and gender and nationalism in Northern Ireland, there has been a tendency to view unionist and loyalist women's political participation as passive, representing no challenge to the establishment, and inimical to a feminist agenda. Research has focused on what appears to be a richer seam: republican/nationalist women, and cross-community endeavour to move beyond entrenched political positions. In quantitative terms, the picture of unionist and loyalist women is one of relative invisibility. While I have taken a qualitative approach to attempt to understand why this is the case, future research should utilise both qualitative and quantitative methods to enable greater generalisability. Building upon this research, it should investigate how the national project motivates women to become politically active and ask whether there is something within it that would enable or constrain certain forms of participation. Furthermore, it should consider whether this is peculiar to the national project in question or whether there are commonalities when compared with other nations. It is with regard

to the latter question that the literature on political participation can be drawn upon in synthesis with gender and nationalism, to ask how strongly linked are nationalism and patriarchy, and the extent to which women challenge and/or are complicit within it.

GENERALISATIONS

In researching a group of political actors who are motivated into political action in defence of the established nation, there is little within the literature from which to draw generalisations. There is one key issue, however, that can be seen as being relevant to the experience of unionist and loyalist women and common to women of other nationalisms. This is putting the interest of the nation before the interests of gender equality. Yuval-Davis notes that the 'liberal definition of citizenship constructs all citizens as basically the same and considers the differences of class, ethnicity, gender, etc., as irrelevant to their status as citizens'.[10] The defensive and reactive nationalism of unionist and loyalist women calls not for radical changes regarding the role of women but for a gradualist approach. As 'citizens' they have the same basic rights as men; however, the liberal definition masks structural inequalities and power differentials. Indeed, some women, 'especially older women', defend the status quo of gender relations in the nation. They also have a certain amount of power in the 'roles of the cultural reproduction of "the nation"', through ruling over 'what is "appropriate" behaviour and appearance', and through exerting 'control over other women who might be constructed as "deviant"'.[11]

Another area of generalisation is that of maternalism, and this can be seen in the history of unionist women's political action motivated by the perceived threat to their homes and way of life. The interviews showed that concern for family is still potent. It is also a key motivator for women of other nationalisms.[12] Therefore, while there is some potential for generalisation, and certainly the roles played by women in the nation identified by Yuval-Davis and Anthias[13] can be

seen in the actions of unionist and loyalist women, it is necessarily broad due to inter- and intra-national group differences.

SUMMARY

This book has shown that unionist and loyalist women are more politically active than the 'tea-making' stereotype. The interview and participant observation data analysed in the context of nationalist theory indicate that the relative invisibility of the women is in part a factor of the form of political action in which they engage. However, the gender and nationalism perspective does not fully explain the extent of the women's political participation because the evidence shows that unionist and loyalist women are active at many different levels.

Developing greater synthesis between theories of gender and nationalism and gender and political participation will add an extra dimension to future research. Women may be motivated into political action through the national project, but the form their political participation takes may be structured by gendered nationalism as well as factors such as education, class, occupational background and family responsibilities. Such issues are explored by the literature on political participation. Taking an inter-disciplinary approach in future research will result in empirical evidence of greater explanatory value.

During the course of this research, there has been some evidence that issues surrounding gender and unionist and loyalist politics are becoming increasingly salient in academic circles.[14] For example, Alan Bairner's account of the Northern Ireland Women's Coalition (NIWC) is preceded by an overview of masculinity and violence. Brian Graham and Peter Shirlow argue that loyalist working-class areas are a 'laboratory' for the formation of identity that is not only counter-hegemonic to the unionist Britishness but is also primarily masculine. However, family and locality are crucial elements in identity formation in arenas of national conflict. In this respect, a

consideration of gender in all its aspects—female as well as male—is
central in a complete account of national identity and political action.

<div align="center">NOTES</div>

1 N. Yuval-Davis and F. Anthias, *Woman-Nation-State* (London: Macmillan, 1989).
2 G. Bell, *The Protestants of Ulster* (London: Pluto Press, 1976).
3 M. Billig, *Banal Nationalism* (London: Sage, 1995).
4 Yuval-Davis and Anthias, *Woman-Nation-State*.
5 See, for example, B. Aretxaga, *Shattering Silence* (Princeton, NJ: Princeton University Press, 1977); C. Cockburn, *The Space Between Us* (London: Zed Books, 1998) and L. A. West, *Feminist Nationalisms* (London and New York: Routledge, 1997).
6 Yuval-Davis and Anthias, *Woman-Nation-State*.
7 J. Nagel, 'Masculinity and nationalism', *Ethnic and Racial Studies*, 21, 2 (1998), pp. 242–69.
8 R. Ward, 'It's not just tea and buns: women and pro-union politics in Northern Ireland', *British Journal of Politics and International Relations*, 6, 4 (2004), pp. 494–506.
9 R. Ward, 'Gender issues and the representation of women in Northern Ireland', *Irish Political Studies*, 19, 2 (2004), pp. 1–20.
10 Yuval-Davis, *Gender and Nation* (London: Sage, 1997), p. 8.
11 Ibid., p. 37.
12 See, for example, Aretxaga, *Shattering Silence*; L. Dowler, 'The mother of all warriors: women in west Belfast, Northern Ireland', in Lentin Ronit (ed.), *Gender and Catastrophe* (London: Zed Books, 1997); E. Porter, 'Identity, location, plurality', in R. Wilford and R. L. Miller (eds), *Women, Ethnicity and Nationalism: The Politics of Transition* (London: Routledge, 1998); and C. Roulston, 'Women on the margin', in L. A. West (ed.), *Feminist Nationalism* (London: Routledge, 1997).
13 Yuval-Davis and Anthias, *Woman-Nation-State*.
14 A. Bairner, 'Masculinity, violence and the Irish peace process', *Capital and Class*, 69 (1999), pp. 125–43; B. Graham and P. Shirlow, 'The Battle of the Somme in Ulster memory and identity', *Political Geography*, 21, 7 (2002), pp. 881–904.

Biographical Details

The interviewees differed in age, class and politics, so the details of the organisations and short biographical outlines provided here will help to build a multi-dimensional picture. The ages and details of those respondents who were happy to disclose this information were correct at the time of interview.

ULSTER UNIONIST PARTY (UUP)

Formed in 1905, the UUP is the largest political party in Northern Ireland. It is largely conservative in its politics; in 1922 the Conservative and Unionist Party was formed, and up to 1974 its MPs at Westminster accepted the Conservative Whip. One of the party's key aims is to 'ensure Northern Ireland remains British, an integral part of the United Kingdom. For us, Britishness is a living, organic relationship with our fellow citizens in the rest of the United Kingdom. We intend to see Northern Ireland fully involved in all aspects of the national life of the United Kingdom.'[1]

Joan Carson (mid-sixties) is a member of the Legislative Assembly (MLA) at Stormont, one of two women UUP representatives out of a total of twenty-eight in the Assembly. She has been a party member for forty years and is involved in local politics in Dungannon. Carson is also a delegate to the Ulster Unionist Council (UUC) and a member of the Executive.

Pauline Armitage (mid-fifties) has been a party member for thirty-five years and is the second UUP woman MLA. In the early 1970s, she was a soldier in the Ulster Defence Regiment (UDR). Prior to her election to the Assembly she was a local councillor for sixteen years in Coleraine. She has been chair of the Portstewart branch of the UUP, delegate to the UUC and member of the Party Executive.

May Steele (early sixties) has been a party member for forty years. She was a UUP representative during the Multi-Party Talks, which resulted in the Belfast Agreement. An unsuccessful candidate for the Assembly, Steele now works part-time for the party in their office at Stormont. She is one of two women party officers, out of a total of fourteen, who form an 'inner circle' in the 101-strong UUP Executive and make recommendations to it.

Arlene Foster (late twenties) is the second woman party officer. She joined the party at 19 when at Queen's University Belfast (QUB), became chair of the Young Unionist Association and represented them on the Executive. At 25, she was the election agent for the UUP during the Forum election.

Sarah Cummings (mid-twenties) is a councillor in Castlereagh and the youngest woman deputy mayor in Northern Ireland. She joined the Young Unionists when at QUB and has been a UUP member for six years.

Sylvia McRoberts has been a party member for over thirty years and is a councillor in Armagh. She is also the branch secretary for the UUP in Armagh, a delegate to the UUC and, as branch secretary, attends the Party Executive.

ULSTER WOMEN'S UNIONIST COUNCIL (UWUC)

The UWUC was established in 1911 and had auxiliary status to the Ulster Unionist Council (UUC). Within two years its membership had grown to an estimated 115,000–200,000. Its initial *raison d'être* was to support the men of the UUC in their campaign against Home Rule. In this regard they appealed to 'women's maternal and protective sensibilities with the claim that the security of their homes and well being of their children would be endangered by home rule'.[2] UWUC activities included fundraising, rallies and dissemination of political propaganda, and today the organisation's role remains an auxiliary one. The UWUC is linked to the UUP and sends delegates to the UUC. As an organisation, it does not challenge traditional conceptions of the role of women in politics.

Irene Cree (early sixties) is chair of the UWUC and the North Down Unionist Association. She has been a member for twelve years, was a councillor for eight years in North Down and was mayor in 1996–97. As chair of the UWUC, she is a member of the Party Executive. She was a party officer when Jim Molyneux was party leader and then for a few months under David Trimble.

Margaret Crooks is a councillor in Belfast and is treasurer of the Ulster Women's Unionist Council (UWUC). She is also treasurer of her branch, vice-chair of her unionist association and a member of the Party Executive. Her experience of local politics spans over twenty years and she has been a party member for thirty years.

THE WOMEN'S ORANGE ASSOCIATION OF IRELAND (WOAI)

The WOAI was originally formed in the mid-nineteenth century. Following a lapse it was reinstituted in 1911 due to concerns regarding the incidences of mixed marriages. It is a religious organisation and engages in charitable works. Women's lodges will parade providing their 'brethren' from men's lodges have written to invite them and the Women's Grand Lodge has given approval.[3]

Olive Whitten (late fifties) is Grand Mistress of the WOAI. She has been a member of the Orange institution for over thirty years. She is also a councillor in Armagh, a delegate to the UUC and, as chair of her local branch, is a member of the Party Executive.

Susan Neilly is Deputy Grand Mistress of the WOAI and District Mistress of 'Number Four District', which uses the Orange Hall on the Shankill Road, Belfast.

Sharon McClelland (mid-thirties) joined the WOAI in 1992. She is also a councillor in Armagh, a delegate to the UUC and has been a member of the UUP for seventeen years.

Elizabeth Watson has been in the WOAI since she was 18. She is the Lodge Secretary for Portadown.

DEMOCRATIC UNIONIST PARTY (DUP)

Originally designated the 'Protestant Unionist Party', the party was formed to present a more hardline stance than that of the 'moderate' Captain Terence O'Neill, leader of the UUP (1963–69). It has continued to take a hard line regarding power sharing in that it refuses to deal with Sinn Féin unless the IRA is 'stood down'.[4]

Iris Robinson (early fifties) has been a party member for over thirty years. She is the only woman member of the DUP in the Assembly out of a total of twenty, and has recently joined the Orange Order. In 1989 she was elected as a councillor in Castlereagh, and was mayor in 1996–97. In 1997, she was the DUP's general election candidate for the Strangford constituency. She was successful in the 2001 general election.

Myreve Chambers (late fifties) is currently mayor of Castlereagh. She has been a party member for twenty years. Prior to that she was in the Official Unionist Party. She joined the Vanguard movement as a supporter, then she supported Ian Paisley and joined the DUP in 1979. She has been secretary of her local branch. In 1985, she was elected to Castlereagh council, the first time a woman had represented the DUP there.

May Beattie (mid-fifties) is a councillor on Carrickfergus council. She has been a DUP member for twelve years, prior to which she helped the party with elections. She was elected to the Forum at Stormont, where she was on the health committee. She is also secretary of the local branch and of the East Antrim Imperial Association, a member of the Women's Loyal Orange Association of Ireland and has been involved with organising a resident's association.

Ruth Allen (late thirties) has been a member for twelve years. She is a councillor in Craigavon and was the party's environmental spokesperson. She ran unsuccessfully as a candidate for the Assembly.

A fifth woman member of the DUP, who preferred to remain anonymous, is a councillor and was also informally involved with working for her community.

PROGRESSIVE UNIONIST PARTY (PUP)

The PUP was established in 1979 to represent loyalist working-class people. It has connections to the paramilitary Ulster Volunteer Force. Its policies are 'Labour-orientated' and the party believes in 'commonality, equality and plurality'.[5]

Dawn Purvis (early thirties) has been a party member for five years. She is the coordinator of the Assembly Party and also coordinates the policy groups and the two PUP Assembly Members. She also liaises between the party headquarters and party Members and is a member of the Party Executive, the Women's Commission, the policy group on culture, arts, sports and equality, the constitutional affairs policy group, and party spokesperson on equality.

Eileen Ward (late thirties) has also been a party member for five years. She is the party secretary and secretary of the Party Executive. She has also been the secretary of the Women's Commission.

Olwyn Montgomery (early forties) has been a PUP member since February 1998. She is a member of the arts, culture and equality policy-making group, where she wrote the arts policy and worked on the cultural policy. She is a member of the Women's Commission and represented the party at a 'Women Envisaging Peace' conference in Boston. She is a Quaker and pacifist and was involved in the counter-demonstrations in support of Catholics attending chapel at Harryville.

Catherine Cooke (mid-thirties) is the project clearing officer for the Peace and Reconciliation Group in Londonderry. She has been a PUP member for a year and is currently chair of the local branch. She does 'single identity work' with young loyalists and has also set up a single identity group for young nationalists, which she hopes to run in parallel. She has also been involved with setting up a version of Women Into Politics, a group previously established in Belfast to encourage greater participation by women in politics.

ULSTER DEMOCRATIC PARTY (UDP)

The UDP was originally known as the Ulster Loyalist Democratic Party and was formed in 1989 as the political wing of the paramilitary Ulster Defence Association (UDA). Like the PUP it represented the loyalist working class, but in 2002 the party disbanded.

Lily McIlwaine (late sixties) was been a member of the party for five years. Prior to that she was in the DUP for ten years, but left as she felt she had no real input. She has been chair of the Northern Ireland Forum and attends the Northern Ireland Women's Political Forum.

Norma Coulter (early forties) has been in the UDP for ten years. She has been vice-chair and secretary of the Lisburn branch. She was on the Party Executive and was a party officer. She was an unsuccessful candidate for the June 1999 by-election in Lisburn.

Joy Fulton-Challis was a member of the Executive Party of the UDP. She is also the chair of the Prisoners' Aid, Post-Conflict and Resettlement Centre. She became involved with politics because she felt she was being 'misrepresented' by the established politicians.

UNITED KINGDOM UNIONIST PARTY (UKUP)

The UKUP stands for equal citizenship, pluralism and sovereignty. The party was established in 1996 as a breakaway group from the UUP and took a strong stance against devolution and the notion of having Sinn Féin representatives in government.

Valerie Kinghan (early sixties) has been a UKUP member for five years. She previously worked as the secretary and election agent for James Kilfedder MP, an independent unionist in North Down. She is currently deputy mayor of North Down.

NORTHERN IRELAND UNIONIST PARTY (NIUP)

The NIUP was formed in 1998, following a split from the UKUP over the decision regarding at what point party representatives would leave the talks. It is an anti-Agreement party.

Elizabeth Roche was a member of the UKUP and a support worker for the party. She was elected as a UKUP councillor in North Down, and continued in the role as an NIUP representative. She works as a researcher for her husband Pat, who is an Assembly member and economics spokesperson for the party.

ALLIANCE PARTY OF NORTHERN IRELAND (APNI)

The APNI is a centre-ground party with a largely middle-class following. Formed in 1970, it is neither unionist nor nationalist, and inhabits the rather narrow centre ground of politics in Northern Ireland with an emphasis on community development and power-sharing.

Eileen Bell has been an Alliance member for over fifteen years. She was involved in community politics in West Belfast and decided she wanted to be where the decisions were made. She married a Protestant and did not want to be 'labelled Catholic or nationalist, so we both joined the Alliance Party as that was the one which put people first'. She is Assembly member and councillor for North Down and is part of the leadership team. She has been involved 'in the talks initiatives from Peter Brooke right through to the present day'. Previously she was chair and vice-chair of the party.

NORTHERN IRELAND WOMEN'S COALITION (NIWC)

The NIWC was formed in 1996 to contest the elections to All-Party Talks because there was a concern that no women's voices would be heard at the talks table. The party appeals to a spectrum of political opinions and backgrounds and, like the APNI, is neither unionist nor nationalist. Policies are guided by three core principles: equality, inclusion and respect for human rights.[6]

May Blood (early sixties) has been a member of the NIWC for three years and the Greater Shankill Partnership for six years. Her

background is trade union politics and socialist values. She has also
worked in the community. Currently she is the treasurer of the
NIWC and a member of the Executive Committee, but prefers to
work behind the scenes.

Barbara McCabe (late thirties) has also been a party member for
three years. She joined after going to a public meeting to discuss
whether a 'grouping of women should stand for the Forum elections
in 1996'. She was a member of the talks team and the party executive
and is currently policy coordinator.

EX-PRISONERS' INTERPRETATIVE CENTRE (EPIC)

EPIC began in 1991 following discussions between loyalist ex-
prisoners and some Quakers, both of who were concerned about the
reintegration of ex-prisoners and their families.

Joan Crothers (mid-thirties) is a voluntary worker for EPIC, North
Belfast, a drop-in and advice centre for loyalist political ex-prisoners
and their families. She has been a member of the PUP for two years
and worked voluntarily doing administration for the party during the
peace talks.

Marion Green (late thirties) became involved with EPIC, Armagh,
in 1997. She is also a supporter of the PUP. She is the research
coordinator and has been looking at the prison experience and how it
affects people, and organising an exhibition of art and craft produced
by loyalist prisoners.

Marion Jamison (early forties) has been involved with EPIC,
Armagh, for a year, initially through a family group in Belfast and
then as development officer in Armagh. She is also a member of the
PUP, which she joined two years ago.

FAMILIES ACTING FOR INNOCENT RELATIVES (FAIR)

FAIR is a support group that was established in 1998 in South
Armagh, where many Protestant families had suffered due to the

conflict. The group believes their interests were being overlooked by the peace process.

Reatha Hassan is chair. She started the group in September 1998 along with Dorothy McConnoll, Edna Kearns and Norma West. It began as a few meetings in Reatha's home and grew from there. Hassan was in the Ulster Defence Regiment (UDR) for twenty-one years. She was one of the first Greenfinches to join. She was the welfare and recruiting officer and in the former capacity had to inform relatives of murders by the IRA. She was awarded the Queen's Jubilee medal for services to welfare and soldiering in the South Armagh area. As chair of FAIR, she is involved with organising the group and liaising with other groups.

Lena Spence became a member of FAIR because she wanted to give support to those who had suffered and been forgotten. A third respondent from FAIR did not want to be identified, because she was afraid of making herself a target in the case of renewed republican militancy. She joined because the group provides support to victims of the conflict that she felt had not been forthcoming from official channels.

SHARED CITY PROJECT (SCP), LONDONDERRY

The SCP assists the development of communities that are mainly Protestant or unionist.

Jeanette Warke (late fifties) works as a women's development officer for Protestant women in deprived Protestant areas on the Waterside. She started as a part-time youth worker in the Fountain Estate and is involved in cross-community and cross-border projects. Politically, her sympathies lie with traditional unionism but she confesses an admiration for John Hume because 'he's a great person for the city', and would even consider giving the SDLP a third or fourth preference vote.

SHANKILL STRESS AND TRAUMA GROUP (SSTG)

The SSTG was established in 1988 to help and support those affected by the conflict through counselling, self-help groups and courses.

Mina Wardle (late fifties) is director of the SSTG. She has also been a member of the PUP for eight years and currently sits on the Executive.

NOTES

1 *http://www.uup.org*
2 D. Urquhart, 'Political herstories', Fortnight (16 June 2000) p. 16.
3 D. Williamson, *www.orangenet.org/womenhistory.htm*
4 *DUP.org.uk*
5 *http://www.pup-ni.org.uk/*
6 *www.niwc.org*

Bibliography

Alexander, W., 'Women and the Scottish Parliament', in A. Coote (ed.), *New Gender Agenda* (London: IPPR, 2000).

Anderson, B., *Imagined Communities: Reflections on the Origins and Spread of Nationalism* (London: Verso, 1991).

Aretxaga, B., 'Dirty protest: symbolic overdetermination and gender in Northern Ireland ethnic violence', *Ethos*, 23, 2 (1995), pp. 123–48.

— *Shattering Silence: Women, Nationalism and Political Subjectivity in Northern Ireland* (Princeton, NJ: Princeton University Press, 1997).

Aughey, A., *Under Siege: The Unionist Response to the Anglo-Irish Agreement* (Belfast: Blackstaff, 1989).

— 'Unionism and self-determination', in P. J. Roche and B. Barton, *The Northern Ireland Question: Myth and Reality* (Aldershot: Avebury, 1991).

Bairner, A., 'Masculinity, violence and the Irish peace process', *Capital and Class*, 69 (1999), pp. 125–43.

Beissinger, M., 'Nationalisms that bark and nationalisms that bite: Ernest Gellner and the substantiation of nations', in J. A. Hall (ed.), *The State of the Nation: Ernest Gellner and the Theory of Nationalism* (Cambridge: Cambridge University Press, 1998).

Bell, C., 'Women, equality and political participation', in J. Anderson and J. Goodman (eds), *Dis/agreeing Ireland: Contexts, Obstacles, Hopes* (London: Pluto Press, 1998).

Bell, G., *The Protestants of Ulster* (London: Pluto Press, 1976).

Billig, M., *Banal Nationalism* (London: Sage, 1995).

Bracewell, W., 'Rape in Kosovo: masculinity and Serbian nationalism', *Nations and Nationalism*, 6, 4 (2000), pp. 563–90.

Brubaker, R., 'Myths and misconceptions in the study of nationalism', in J. A. Hall (ed.), *The State of the Nation: Ernest Gellner and the Theory of Nationalism* (Cambridge: Cambridge University Press, 1998).

Bruce, S., *The Edge of the Union: The Ulster Loyalist Political Vision* (Oxford: Oxford University Press, 1994).

Campbell, A., 'Let us be true each to the other: a covenant for a new Ireland', *Irish Reporter*, 16, 4 (1994), pp. 12–14.

Carr, E. H., *Nationalism and After* (London: Macmillan, 1965).

Centre for the Advancement of Women in Politics (CAWP), 'Former women members of the Northern Ireland Parliament and Assemblies' (2001), *http://www.qub.ac.uk/cawp*

Cochrane, F., *Unionist Politics and the Politics of Unionism since the Anglo-Irish Agreement* (Cork: Cork University Press, 1997).

Cockburn, C., *The Space Between Us: Negotiating Gender and National Identities in Conflict* (London: Zed Books, 1998).

Colley, L., *Britons: Forging the Nation 1707–1837* (London: Vintage, 1996).

Coulter, C., 'Feminism and nationalism in Ireland', in D. Miller (ed.), *Rethinking Northern Ireland: Culture, Ideology and Colonialism* (Essex: Addison Wesley Longman, 1998).

Curtice, J. and T. Gallagher.,'The Northern Irish dimension', in R. Jowell, S. Witherspoon and L. Brook (eds), *British Social Attitudes: the 7th Report* (Aldershot: Gower, 1990).

Dargie, C., 'Observation in political research: a qualitative approach', *Politics*, 18, 1 (1998), pp. 65–71.

Democratic Unionist Party website, *http://www.DUP.org.uk* (accessed June 2005).

Douglas, S., 'Loyalism: male, macho and marching?' *Irish Reporter*, 14, 2 (1994), pp. 12–13.

Douglass., W. A., 'A critique of recent trends in the analysis of ethno-nationalism', *Ethnic and Racial Studies*, 11, 2 (1988), pp. 192–206.

Dowler, L., 'The mother of all warriors: women in West Belfast, Northern Ireland', in R. Lentin (ed.), *Gender and Catastrophe* (London: Zed Books, 1997).

Edgerton, L., 'Public protest, domestic acquiescence: Women in Northern Ireland', in R. Ridd and H. Callaway (eds), *Caught Up in Conflict: Women's Responses to Political Strife*, (London: Macmillan, 1986).

Enloe, C., *Does Khaki Become You? the Militarization of Women's Lives* (London: Pandora, 1988).

— *Bananas, Beaches and Bases: Making Feminist Sense of International Politics* (London: Pandora, 1989).

Fairweather, E., R. McDonough and M. McFadyean, *Only the Rivers Run Free. Northern Ireland: the Women's War* (London: Pluto Press, 1984).

Feld, V., 'A new start in Wales: how devolution is making a difference', in A. Coote (ed.), *New Gender Agenda* (London: IPPR, 2000).

Finlayson, A., 'Nationalism as ideological interpellation: the case of Ulster loyalism', *Ethnic and Racial Studies*, 19 (1996), pp. 88–112.

Foster, P., 'Observational research', in R. Sapsford and V. Juppor (eds), *Data Collection and Analysis* (London: Sage, 1996).

Freedman, J., 'Women in the European Parliament', in K. Ross (ed.), *Women, Politics, and Change* (Oxford: Oxford University Press, 2002).

Galligan, Y. and R. Wilford., 'Women's political representation in Ireland', in Y. Galligan and R. Wilford (eds), *Contesting Politics: Women in Ireland, North and South* (Oxford: Westview, 1999).

Gellner, E., *Nations and Nationalism* (Oxford: Blackwell, 1983).

— 'The coming of nationalism and its interpretation: the myths of nation and class', in G. Balakrishnan (ed.), *Mapping the Nation* (London: Verso, 1996).

Gibbon, P., *The Origins of Ulster Unionism*, Manchester: Manchester University Press, 1975).

Gilbert, P., *Terrorism, Security and Nationality: An Introductory Study in Applied Political Philosophy* (London and New York: Routledge, 1994).

Graham, B. and P. Shirlow., 'The Battle of the Somme in Ulster memory and identity', *Political Geography*, 21, 7 (2002), pp. 881–904.

Greenfeld, L., *Nationalism: Five Roads to Modernity* (Cambridge, MA: Harvard University Press, 1992).

Guibernau, M., *Nationalisms: The Nation-State and Nationalism in the Twentieth Century* (Cambridge: Polity Press, 1996).

— *Nations Without States: Political Communities in a Global Age* (Oxford: Polity in association with Blackwell, 1999).

Hammersley, M., *The Dilemma of the Qualitative Method: Herbert Blumer and the Chicago Tradition* (London: Routledge, 1989).

Harbinson, J. F., *The Ulster Unionist Party, 1882–1973: Its Development and Organisation* (Belfast: Blackstaff, 1974).

Hardin, R., *One For All: The Logic of Group Conflict* (Princeton, NJ: Princeton University Press, 1995).

Hayes, B. and I. McAllister., 'Sowing dragon's teeth: public support for political violence and paramilitarism in Northern Ireland', Political Studies Association UK, 50th Annual Conference (2000).

Hechter, M., *Internal Colonialism: The Celtic Fringe in British National Development, 1536–1966* (London: Routledge, 1975).

Heywood, A., *Political Ideologies: An Introduction* (Basingstoke: Macmillan, 1998).

Hobsbawm, E. J., *Nations and Nationalism Since 1780: Programme, Myth, Reality* (Cambridge: Cambridge University, 1990).

Horowitz, D. L., *Ethnic Groups in Conflict* (California and London: University of California Press, 1985).

Jackson, A., 'Unionist history', in C. Brady (ed.), *Interpreting Irish History: The Debate on Historical Revisionism 1938–1994* (Dublin: Irish Academic Press, 1994).

Kaplan, G., 'Feminism and nationalism: the European case', in L. A. West (ed.), *Feminist Nationalisms* (London: Routledge, 1997).

Kearney, R., *Postnationalist Ireland: Culture, Politics, Philosophy* (London: Routledge, 1997).

Kellas, J. G., *The Politics of Nationalism and Ethnicity* (London: Macmillan, 1998).

Kinghan, N., *United We Stand: The Story of the Ulster Women's Unionist Council, 1911–1974* (Belfast: Appletree Press, 1974).

Knight, D. B., 'Afterword: nested identities—nationalism, territory, and scale', in G. H. Guntram and D. H. Kaplan (eds), *Nested Identities: Nationalism, Territory, and Scale* (Oxford: Rowman and Littlefield, 1999).

Korać, M., 'Understanding ethnic-national identity and its meaning: questions from women's experience', *Women's Studies International Forum*, 19, 1/2 (1996), pp. 133–3.

Leach, R., *British Political Ideologies* (Hemel Hempstead: Prentice Hall, 1996).

Levinger, M. and P. Franklin Lytle, 'Myth and mobilisation: the triadic structure of nationalist rhetoric', *Nations and Nationalism*, 7, 2 (2001), pp. 175–94.

Loughlin, J., *Ulster Unionism and British National Identity Since 1885* (London: Cassell, 1995).

Loughran, C., '10 years of feminism in N.I. part 4: 1980–85', *Women's News*, March/April 15 (1986), pp. 6–7.

— 'Armagh and feminist strategy: campaigns around Republican women prisoners in Armagh Jail', *Feminist Review*, 23 (1986), pp. 59–79.

Lovenduski, J., 'Sex, gender and British politics', *Parliamentary Affairs* 49, 1 (1996), pp. 1–16.

— 'Gender politics: a breakthrough for women?' *Parliamentary Affairs*, 50, 4 (1997), pp. 708–19.

Lovenduski, J. and P. Norris, *Gender and Party Politics* (London: Sage, 1993).

Lowry, D., '"New Orangemen of a greater Ireland": Ulster Loyalism, settler nationalism and the preservation of the British Empire', Irish History Seminar, Hertford College, Oxford (7 March 1995).

Lucy, G., *Northern Ireland Local Government Election Results* (Lurgan: Ulster Society, 1994).

McBride, I., 'Ulster and the British problem', in R. English and G. Walker (eds), *Unionism in Modern Ireland: New Perspectives on Politics and Culture* (Basingstoke and London: Macmillan, 1996).

McGarry, J. and B. O'Leary, *Explaining Northern Ireland: Broken Images* (Oxford: Blackwell, 1995).

Maanen, J. V., P. K. Manning and M. L. Miller (eds), 'Series introduction', in N. J. Fielding and J. L. Fielding, *Linking Data: The Articulation of Qualitative and Quantitative Methods in Social Research*, (London: Sage, 1986).

Macdonald, E., *Shoot the Women First* (New York: Random House, 1991).

Mangaliso, Z. A., 'Gender and nation building in South Africa', in L. A. West
(ed.), *Feminist Nationalisms* (London: Routledge, 1997).

Mason, D., 'Nationalism and the process of group mobilisation: the case of "loyalism" in Northern Ireland reconsidered', *Ethnic and Racial Studies*, 8, 3 (1985), pp. 408–25.

Melaugh, M. and F. McKenna (2000), *The 1998 Referenda on 'The Agreement'*, http://www.cain.ulst.ac.uk/issues/politics/election/ref1998.htm

Meyer, M. K., 'Ulster's red hand: gender, identity and sectarian conflict in Northern Ireland', in S. Ranchod-Nilsson and M. A. Tétreault (eds), *Women at Home in the Nation?* (London: Routledge, 2000).

Miller, R., R. Wilford and F. Donoghue, *Women and Political Participation in Northern Ireland* (Aldershot: Avebury, 1996).

Mitchell, P. and R. Wilford (eds), *Politics in Northern Ireland* (Boulder, CO: Westview, 1999).

Montgomery, O., 'Mad dogs eating their own', *Fortnight*, 9 (2000), pp. 39–40.

Moore, R., 'Proper wives, orange maidens or disloyal subjects: situating the equality concerns of Protestant women in Northern Ireland', unpublished MA thesis (Dublin: National University of Ireland, 1993).

Morgan, V., *Peacemakers? Peacekeepers? Women in Northern Ireland 1969–1995*, Occasional Paper 3 (Londonderry: INCORE, 1996).

Morgan, V. and G. Fraser, 'Women and the Northern Ireland conflict: experiences and responses', in S. Dunn (ed.), *Facets of the Conflict in Northern Ireland* (London: Macmillan, 1995).

Morrow, D., 'Suffering for righteousness' sake? Fundamentalist Protestantism and Ulster politics', in P. Shirlow and M. McGovern (eds), *Who are 'The People'? Unionism, Protestantism and Loyalism in Northern Ireland* (London: Pluto Press, 1997).

Moxon-Browne, E., *Nation, Class and Creed in Northern Ireland* (Aldershot: Avebury, 1983).

— 'National identity in Northern Ireland', in P. Stringer and G. Robinson (eds), *Social Attitudes in Northern Ireland* (Belfast: Blackstaff, 1991).

Nagel, J., 'Masculinity and nationalism: gender and sexuality in the making of nations', *Ethnic and Racial Studies*, 21, 2 (1998), pp. 242–69.

Nelson, S., *Ulster's Uncertain Defenders* (Belfast: Blackstaff, 1984).

Norris, P., 'Gender differences in political participation in Britain: traditional, radical and revisionist models', *Government and Opposition*, 26, 1 (1991), pp. 56–74.

Norris, P. and J. Lovenduski, *Political Recruitment: Gender, Race and Class in the British Parliament* (Cambridge: Cambridge University Press, 1995).

Northern Ireland Women's Coalition website, *http://www.niwc.org* (accessed June 2005).

O'Dowd, L., 'Coercion, territoriality and the prospects for a negotiated settlement in Ireland', *Political Geography*, 17, 2 (1998), pp. 239–49.

— '"New Unionism", British nationalism and the prospects for a negotiated settlement in Northern Ireland', in D. Miller (ed.), *Rethinking Northern Ireland: Culture, Ideology and Colonialism* (Essex: Addison Wesley Longman, 1998).

Ollerenshaw, P., 'Businessmen and the development of Ulster Unionism, 1886–1921', *Journal of Imperial and Commonwealth History*, 28, 1 (2000), pp. 35–64.

Paisley Jnr, I., 'The political career of Dame Dehra Parker', unpublished MSSc thesis (Belfast: Queen's University, 1994).

Paisley, R., 'Feminism, Unionism and "the brotherhood"', *Irish Reporter*, 8 (1992).

Parry, G., G. Moyser and N. Day, *Political Participation and Democracy in Britain*, (Cambridge: Cambridge University Press, 1992).

Porter, E., 'Diversity and commonality: women, politics and Northern Ireland', *European Journal of Women's Studies*, 4 (1997), pp. 83–100.

— 'Identity, location, plurality: women, nationalism and Northern Ireland', in R. Wilford, and R. L. Miller (eds), *Women, Ethnicity and Nationalism: The Politics of Transition* (London: Routledge, 1998).

— 'Risks and responsibilities: creating dialogical spaces in Northern Ireland', *International Journal of Feminist Politics*, 2, 2 (2000), pp. 163–84.

Progressive Unionist Party website, *http://www.pup-ni.org.uk* (accessed June 2005).

Racioppi, L. and K. O'Sullivan See, 'Ulstermen and loyalist ladies on parade: gendering Unionism in Northern Ireland', *International Feminist Journal of Politics*, 2, 1 (2000), pp. 1–29.

Ridd, R., 'Powers of the powerless', in R. Ridd and H. Callaway (eds), *Caught up in Conflict: Women's Responses to Political Strife* (Basingstoke: Macmillan, 1986).

Robson, C., *Real World Research: A Resource for Social Scientists and Practitioner Researchers* (Oxford: Blackwell, 1993).

Rooney, E., 'Political division, practical alliance: problems for women in conflict', *Journal of Women's History*, 6, 4/7, 1 (1995), pp. 40–8.

— 'Women in political conflict', *Race and Class*, 37, 1 (1995), pp. 51–6.

— 'Women in Northern Irish politics: difference matters', in C. Roulston and C. Davies (eds), *Gender, Democracy and Inclusion in Northern Ireland* (Hampshire: Palgrave, 2000).

Roulston, C., 'Equal opportunities for women', in A. Aughey and D. Morrow (eds), *Northern Ireland Politics* (Essex: Longman, 1996).

— 'Gender, nation, class: the politics of difference in Northern Ireland', *Scottish Affairs*, 18 (1997), pp. 54–68.

— 'Women on the margin: the women's movements in Northern Ireland 1973–1995', in L. A. West (ed.), *Feminist Nationalism* (London: Routledge, 1997).

— 'The new feminisms', *Fortnight* (March 1999), pp. 26–7.

— 'Inclusive others: the Northern Ireland Women's Coalition in the peace process', *Scottish Affairs*, 26 (1999), pp. 1–13.

Rynder, C. B., 'The women of '98: Gender and the 1998 Northern Ireland Assembly elections', paper presented to the American Conference of Irish Studies Annual Conference, Roanoke, VA (1999).

Sales, R., *Women Divided: Gender, Religion and Politics in Northern Ireland* (London: Routledge, 1997).

— 'Gender and Protestantism in Northern Ireland', in P. Shirlow and M. McGovern (eds), *Who Are 'The People'? Unionism, Protestantism and Loyalism in Northern Ireland* (London and Chicago: Pluto Press, 1997).

— 'Women, the peace makers?' in J. Anderson and J. Goodman (eds), *Dis/agreeing Ireland: Contexts, Obstacles, Hopes* (London: Pluto Press, 1998).

Sawyer, R., *'We Are But Women': Women in Ireland's History* (London: Routledge, 1993).

Shannon, C. B., 'Women in Northern Ireland', in M. O'Dowd, M. and S. Wichert (eds), *Chattel, Servant or Citizen: Women's Status in Church, State and Society* (Belfast: Institute of Irish Studies, Queen's University, 1995).

Smith, A., 'History and liberty: dilemmas of loyalty in Western democracies', *Ethnic and Racial Studies*, 9, 1 (1986), pp. 43–65.

— 'The myth of the "Modern Nation" and the myths of nations', *Ethnic and Racial Studies*, 11, 1 (1988), pp. 1–26.

— 'The origins of nations', *Ethnic and Racial Studies*, 12, 3 (1989), pp. 340–67.

— *National Identity* (London: Penguin, 1991).

— *Nations and Nationalism in a Global Era* (Cambridge: Polity Press, 1995).

— *Myths and Memories of the Nation* (Oxford: Oxford University Press, 1999).

Squires, M., 'Ulster unionism and women's issues: a political and historical overview', paper presented to the Women and Politics Study Group of the Political Studies Association of Ireland (Dublin: Trinity College, 1993).

Stavenhagen, R., *Ethnic Conflict and the Nation State* (London: Macmillan, 1996).

Stedward, G., 'On the record: an introduction to interviewing', in P. Burnham (ed.), *Surviving the Research Process in Politics* (London and Washington: Pinter, 1997).

Stephenson, M., *The Glass Trapdoor: Women, Politics and the Media during the 1997 General Election* (London: Fawcett, 1998).

Stewart, A. T. Q., *The Ulster Crisis: Resistance to Home Rule 1912–14* (London: Faber and Faber, 1967).

Todd, J., 'Two traditions in unionist political culture', *Irish Political Studies*, 2 (1987), pp. 1–26.

Torney, K. 'Up to 200 women and children staged an hour long protest . . .', *Belfast Telegraph Online*, archive (29 July 1998).

Ulster Unionist Party website, *www.belfasttelegraph.co.uk* (accessed October 2002).

Urquhart, D. 'The female of the species is more deadlier than the male'? The Ulster Women's Unionist Council, 1911–40', in D. Urquhart and J. Holmes (eds), *Coming Into The Light: The Work, Politics and Religion of Women in Ulster, 1840–1940* (Belfast: Institute of Irish Studies, Queen's University, 1994).

— 'In defence of Ulster and the empire: the Ulster Women's Unionist Council, 1911–1940', *UCG Women's Studies Centre Review*, 4 (1996), pp. 31–40.

— 'Political herstories', *Fortnight*, 6, 16 June 2000, p. 16.

— *Women in Ulster Politics, 1890–1940: A History Not Yet Told* (Dublin: Irish Academic Press, 2000).

Walby, S., *Gender Transformations* (London: Routledge, 1997).

Walker, G., 'Gail Walker talks to Unionist women demanding parity of esteem', *Belfast Telegraph* (29 March 2000), *http://www.belfasttelegraph.co.uk/cgibin/archive/showdoc?docloc =2000/March/29*

Ward, M., *In Their Own Voice: Women and Irish Nationalism* (Dublin: Attic, 1995).

Ward, R., 'The Northern Ireland peace process: a gender issue?' in C. Gilligan and J. Tonge (eds), *Peace or War? Understanding the Peace Process in Northern Ireland* (Aldershot: Ashgate, 1997).

— 'The impact of women on the contemporary politics of Northern Ireland', unpublished MA thesis (University of Salford, 1997).

— 'Invisible women: the political roles of unionist and loyalist women in contemporary Northern Ireland', in K. Ross, (ed.), *Parliamentary Affairs* (special edition—*Women and Politics Revisited*), 55, 1 (2002), pp. 167–78.

— 'Unionist and Loyalist women in Northern Ireland: national identity and political action', unpublished PhD thesis (Bristol: UWE, 2003).

— 'It's not just tea and buns: women and pro-Union politics in Northern Ireland', *British Journal of Politics and International Relations*, 6, 4 (2004), pp. 494–506.

— 'Gender issues and the representation of women in Northern Ireland', *Irish Political Studies*, 19, 2 (2004), pp. 1–20.

West, L. A. (ed.), *Feminist Nationalisms* (London and New York: Routledge, 1997).

Wilford, R., 'Women and politics in Northern Ireland', *Parliamentary Affairs* 49, 1 (1996), pp. 41–54.

— 'Women, ethnicity and nationalism: surveying the ground', in R. Wilford and R. L. Miller (eds), *Women, Ethnicity and Nationalism: The Politics of Transition* (London: Routledge, 1998).

— 'Women and politics', in P. Mitchell and R. Wilford (eds), *Politics in Northern Ireland* (Boulder, CO: Westview, 1999).

Wilford, R. and S. Elliott, 'Targeted voters and the referendum', paper presented to *'Agreeing to Disagree? The Voters of Northern Ireland'*, CREST/QUB Conference in association with the British Academy (Belfast: Queen's University, 1999).

Wilford, R., R. Miller, Y. Bell and F. Donoghue, 'In their own voices: women councillors in Northern Ireland', *Public Administration*, 71 (1993), pp. 341–55.

Williamson, D., *http://www.orangenet.org/womenhistory.htm* (accessed June 2005).

Yuval-Davis, N., 'Women and the biological reproduction of "the Nation"', *Women's Studies International Forum*, 19, 1/2 (1996), pp. 17–24.

— *Gender and Nation* (London: Sage, 1997).

Yuval-Davis, N. and F. Anthias, *Woman-Nation-State* (London: Macmillan, 1989).

Index

Page numbers in *italics* refer to picture captions

196 *Women, Unionism and Loyalism in Northern Ireland*

women (*cont.*)
 political involvement (*cont.*)
 patriarchal attitudes 11, 47, 68–9, 135,
 148
 political organisations 9, 114, 118
 political protests 9, 45
 regional government 123, 124, 130 *see
 also* Northern Ireland Assembly
 religious perspective 7–8, 11, 15, 68–9
 voting 68, 116, 130, 134, 150
 see also local government; loyalism;
 unionism
 symbolised
 female allegory 37–9, 41–5, 74, 114, 158
 as 'Maiden City' 43
 as mother of nation 37–9, 41, 44, 78,
 115
 in murals *40,* 41–2, 62, 159
 as passive victims 43–4, 78, 159
 women's stereotypes
 accepted 69
 as 'frivolous' 114
 as passive 43–4, 45–6, 78
 religious perspective 7–8, 68–9
 resented 1
 as supporters of men 15, 114, 151
 as teamakers, etc 1, 2, 9, 62, 129, 138
 'women's place' issues 7, 8, 131–2, 135
 see also under loyalism; unionism

see also women under Catholics and
 Protestants
Women for Peace 11
Women's Declaration 8, 115
Women's Information Days 121
Women's Information Group 11
Women's Liberal Unionist Association 113
Women's Orange Association of Ireland (WOAI)
 activities 146–7, 169
 background 169
 core principles 146, 147
 membership 63, 67, 74, 91, 146
 parades 120–1, 147, 149, 169
 political connections 4, 93, 146, 147
 Protestant membership 63
 UUP links 146, 147
Women's Support Network
 aims 12
 approach 12
 and community-based groups 11
 cultural imbalance 12
 in research 4
Women's Temperance Association 114
Women's Unionist associations 115

Young Unionists 93, 94
Yuval-Davies, Nira 45, 46, 48, 79, 108, 110,
 158, 161, 164–5
YWCA 114